Your '80s Movie Guide to Better Living
Volume 1
By Bryan Krull and Evan Crean

Your '80s Movie Guide to Better Living by Bryan Krull and Evan Crean

© 2016 by Bryan Krull and Evan Crean. All rights reserved.

No part of this book may be reproduced in written or electronic form without written permission from the authors.

Cover Design: Daniel Johnson
Editor: Ian Witherby
ISBN: 978-1-536878-38-7
First Edition

Bryan would like to dedicate this book to his mother, Sheila, for all her love and support...and for having Home Box Office (HBO) in the house and a TV in his bedroom. Little did she know, Bryan was actually doing research for a future book!

Evan would like to dedicate this book to his fiancé Shauna and his parents for all of their love and support in helping him bring this book to life. Without them, none of this would be possible.

Table of Contents

Introduction: Why '80s Movies?... 8
1. How to Choose the Right Vehicle..11
2. How to Give Your Life a Bitchin' Soundtrack20
3. How to Survive an '80s Horror Movie Part I:
The Spawning ..29
4. Tips on Dancing..35
5. Are Country Clubs Bastions of Tradition or
Elitist Institutions? ...43
6. Tips on Teaching..47
7. How to Survive an '80s Horror Movie Part II:
Unhappy Campers ..61
8. How to Deal with Life after College ..66
9. Tips on Home Improvement...75
10. How to Deal with Bullies (Cobra Kai).....................................79
11. Tips on Positive Thinking: A Perfect '80s Movie Day85
12. How to Survive an '80s Horror Movie Part III:
Dream Warriors...94
13. How to Deal with Ghosts .. 100
14. Tips on Being a Man ... 109
15. Nature or Nurture: Exeter or Racehorses?........................ 120
16. How to Succeed in Business... 123
17. Did Jake Ryan Give a Generation of Women
Unrealistic Expectations?... 133
18. How to Survive an '80s Horror Movie Part IV:
The Possession ... 138
19. Tips on Toughness: The 1980s Movie Bad-Ass Oscars ... 142
20. Tips on Romance ... 150
21. How to Get the Job Done ... 157

22.	Tips to Make a Good Restaurant	170
23.	How to Handle Social Standing	176
24.	How to Avoid the Perils of Time Travel	189
25.	How to Survive an '80s Horror Movie Part V: The Final Chapter	197
26.	How Video Game Skills Can Help You Save the World	203
Conclusion: Life Moves Pretty Fast		213

Introduction: Why '80s Movies?

As a nation, we are obsessed with self-improvement. We're awake at three in the morning watching *Snuggie*, *Thigh-Master*, and other infomercials on television. We commit to twelve-step programs to help us overcome our addictions to gambling, alcohol, sex, and other dependencies. We seek out motivational speakers to inspire us, build our self-esteem, and help us become rich. We spend like drunken sailors on Tony Little's *Gazelle*, Tony Horton's *PX-90* program, the *Ab Roller* and any exercise equipment that promises to get us in better shape and make us more attractive. We rush to the bookstore to purchase *The Secret*, *The Seven Habits of Highly Effective People*, *Men Are From Mars, Women Are From Venus*, and other self-help books that offer us happier and more successful careers, bank accounts, and personal lives. According to *Forbes*, Americans spent in excess of $11 billion on self-improvement in 2008, and that figure has only grown since then. A 2014 analysis of the self-improvement market by Marketdata Enterprises, a market research company, revealed that Americans spend $549 million a year on self-help books alone.

To borrow a line from self-help guru Susan Powter, we say, "*Stop the insanity!*" We would argue that this constant and expensive pursuit of self-improvement is misguided. All you really need to address those nagging personal issues is a Netflix account, which costs as little as $7.99 a month. What's more, you don't have to wade through all those tens of thousands of movies; you can focus your quest for self-improvement on movies from the 1980s.

What better decade to address self-improvement issues than the 1980s—the "me" decade? To be clear, we are not suggesting that the 1980s were the best decade for cinema. There were no *Citizen Kane*s, *Godfather*s, *Casablanca*s, or *Schindler's List*s in the 1980s. In the American Film Institute's (AFI) rankings of the greatest movies of all-time, there were only seven movies from the 1980s, as compared to twenty from the 1970s and eleven from the 1990s.

However, there's just something about '80s movies, and '80s pop culture in general, that refuses to go away. Respected icon National Geographic recently released a television mini-series

entitled *The 1980s: The Decade That Made Us*, and no one batted an eye at the hyperbole. Cable TV stations like American Movie Classics (AMC) and VH-1 Classic feature films from the 1980s as staples of their programming. In recent years, there has been an explosion of film festivals dedicated to classic '80s movies. An entire generation of youth that wasn't even *born* in the 1980s has embraced films by John Hughes and '80s movies starring Arnold Schwarzenegger, Eddie Murphy, and Patrick Swayze. Numerous 1980s movies have recently been remade, including *The Karate Kid*, *Footloose*, *Red Dawn*, and *Clash of the Titans*, with more on the way. Even Chuck Norris, '80s action movie hero, has become a wildly popular cult figure to a whole new generation.

Why the fascination with '80s movies? What is it about films from this decade that continues to resonate even in the 2010s? For those of us who lived through the 1980s, it's partly nostalgia, a longing for a simpler time when we could take off our Members Only jacket, pop a *Men at Work* cassette tape in our boombox, and play Atari video games in our basement.

But what about the younger generation who didn't experience the 1980s firsthand? In the popular 2010 movie *Easy A*, Olive (Emma Stone) wishes her life were more like an '80s movie: "What ever happened to chivalry? Does it only exist in '80s movies? I want John Cusack holding a boombox outside my window [*Say Anything*]. I want to ride off on a lawnmower with Patrick Dempsey [*Can't Buy Me Love*]. I want Jake from *Sixteen Candles* waiting outside the church for me. I want Judd Nelson thrusting his fist into the air because he knows he got me, just once [*The Breakfast Club*]. I want my life to be like an '80s movie, preferably one with a really awesome musical number, for no apparent reason [*Ferris Bueller's Day Off*]. But no, no, John Hughes did not direct my life." Apparently, nostalgia for the '80s isn't exclusive to those of us old enough to have lived through the decade.

We believe there's more to this '80s movie furor than simply nostalgia. Movies from the 1980s resonate because they deal with the same life issues people still wrestle with today. Do you have questions about life after college, romance, getting ahead in business, or raising a child? Of course you do. You wouldn't be human if you didn't worry about such weighty life issues. The good

news is that '80s movies tackle these important issues and provide advice on all these subjects. Even if you have more specific issues, like how to dance, dealing with ghosts in your home, choosing the right car, the perils of time travel, or how to survive a horror movie, '80s movies provide the answers you need. So fill your Netflix queue with '80s movies, grab your remote and a notebook, and pay attention. Or better yet, just read on, because we've done the work for you!

1. How to Choose the Right Vehicle
Car and Driver's 10 Best 1980s Movie Cars

Are you in the market for a brand new car? Of course you are, or you wouldn't be here. This is the perfect time to buy. We're offering unheard-of deals on some of the sweetest rides you're ever likely to see. So step right into our '80s movie car showroom and look around. We have something for everyone. Check out the specs, kick the tires, and maybe even take one for a spin. We'll do whatever it takes to get you into one of our cars today. We'll even throw in the floor mats for free!

Wagon Queen Family Truckster: *Vacation* (1983)

If you're looking to take the tribe across the country, the Wagon Queen Family Truckster is the right vehicle for the job. Forget that sporty new Antarctic Blue Super Sportswagon with C.B. radio and the optional "rally fun pack." That might be fine for other families, but not for yours, and not for the Griswolds.

The Wagon Queen Family Truckster is essentially a heavily modified Ford LTD Country Squire station wagon. The standard features of the Truckster include extensive faux wood paneling, not two or four but *eight* headlights, and huge chrome hubcaps with a crown logo.

There's plenty of room in the Family Truckster for the whole family to kick back, put their feet up, have a sing-along, and even get some sleep—though please, not the driver! There is ample storage in the rear, and the roof luggage rack is very sturdy. It can support all your luggage, and even Aunt Edna, but make sure you strap them down tight to avoid losses on those bumpy roads. Another helpful hint is to keep a close eye on the family pet. No one likes sandwiches soaked in dog urine, and no dog can keep up with a car going 65 if it's tied to the bumper.

One negative feature reported by buyers is the unusual location of the gas tank in the Family Truckster. Instead of being on the rear driver's side panel or behind the license plate, the gas tank door is located in the front passenger fender, so be warned!

Give the Wagon Queen Family Truckster a shot. While others might think you look like "HONKY LIPS" in this oversized station wagon, you'll know that the Family Truckster can keep up with a red Ferrari, and jump up to fifty yards (watch those air bags!). So just smile, with the knowledge that the Family Truckster is the car to get you and your family to Walley World and back.

1967 Chevy Camaro: *Better Off Dead* (1985)

Down in the dumps? Feel like the whole world is against you? Maybe your girlfriend left you for "someone more popular…better looking…drives a nicer car?" Well buck up camper—the solution to your problems is simpler than you think. All you need is a taste of self-confidence. Get out in the driveway and tune up that "tasty" black 1967 Chevy Camaro!

An ass-kicking muscle car like the Camaro is what you need to regain your self-confidence and show everyone what kind of man you truly are. Once you have your Camaro running, there's nothing you can't do.

Line up against those Japanese brothers who always want to race you, and blow their doors off! Show that bully who stole your girl that he doesn't intimidate you, and you'll race him anytime he wants. Prove to your ex-girlfriend that she made a mistake, and should want you back. On second thought, who needs her? She had her chance. Set your sights higher. How about that sexy French foreign exchange student who has eyes for you *and* knows her way around under the Camaro's hood?

Confidence is definitely a huge turn-on. Believe in yourself, and the world will believe in you too. Slide behind the wheel of your Chevy Camaro, put on your shades, and cruise the streets as Muddy Waters' "Mannish Boy" pumps out of your speakers. Self-confidence looks good on you!

1974 Dodge Monaco ("The Bluesmobile"): *The Blues Brothers* (1980)

At first glance, a used 1974 Dodge Monaco might not seem like the ideal vehicle for you. But if you demand a lot from your

vehicle, like backflips on the expressway or pinpoint handling in the mall, then the Bluesmobile may be the car for you. The black-and-white sedan was "gently used" by the Mount Prospect, Illinois police department prior to its current owner, who needed a vehicle after trading his old Cadillac for a microphone.

Consider the testimonial of current owner Elwood Blues (Dan Aykroyd): "It's got a cop motor, a 440 cubic-inch plant. It's got cop tires, cop suspension, cop shocks. It's a model made before catalytic converters, so it'll run good on regular gas." After Elwood demonstrated the car's capabilities to recently paroled brother Jake (John Belushi) with a jump over the rising sides of a lift bridge, Jake agreed, with an understated, "It's got a lotta pick-up."

Perfect for an active lifestyle, the Bluesmobile excels at outrunning law enforcement, country-and-western bands in Winnebagos, vengeful ex-fiancées, and Illinois Nazis. The Bluesmobile easily handles any road, from highways to country roads to Chicago's infamous Lower Wacker Drive. The Bluesmobile can also handle off-roading, whether you're advertising your upcoming gig in a field or on the beach, or just passing (literally) through your local mall.

Whatever you have to trade in, even if it's an old microphone, get on down to the dealership and pick up your very own Bluesmobile today. It might just keep you out of jail… for a little while anyway.

1972 Cadillac Sedan De Ville:
License to Drive **(1988)**

Worried about your teenager, who just earned his or her license and can't wait to hit the road? Of course you are. What parent isn't? Teenagers are inexperienced behind the wheel, easily distracted, and prone to risk-taking behavior. This is a recipe for vehicular mayhem. As Les Anderson's (Corey Haim) driver education instructor tells him, "It's punks like you that paramedics end up scraping off the road at four in the morning." You can't keep your teen locked in the house forever though, as tempting as that may sound. Your best bet is to teach your teenager defensive driving skills, and buy a safe car in which they can learn.

What car is a safe one to drive? Well, forget about fancy sports cars or small foreign models. They'll fold up like an accordion at the slightest contact. No sir, what your teen should be driving is a big, bold, sturdy American car. Our recommendation is the 1972 Cadillac Sedan De Ville. This big, sky blue American beauty takes a licking and keeps on ticking.

Running over the shrubs, pretty girls dancing in high heels on the hood, spilled drinks and vomit, a few fender benders? The Cadillac Sedan De Ville can handle all that your irresponsible teenager can dish out, and more.

Teenagers: don't think we've forgotten about *your* needs with this car selection. We understand that this is more than just a vehicle for you. Dean (Corey Feldman) puts it this way: "It's a license to live, it's a license to be free!" The Cadillac's a real looker, sure to impress that guy or girl you've had your eye on. It has plenty or room in the trunk for a spare tire, a blanket, and even one of your drunken friends. And it handles like a dream. As Billy Ocean sings over the closing credits of *License to Drive*, "get outta my dreams, get into my car!"

1964 Chevy Malibu: *Repo Man* (1984)

Are you fed up with society, convention, and generic consumerism? Do you want a car with some personality, one that defies convention, and one with a few secrets in its trunk? How about a 1964 tan Chevy Malibu?

The 1964 Chevy Malibu is a car that makes things happen, and is ideal for that man or woman that wants something more out of life. As veteran repo man Bud (Harry Dean Stanton) puts it, "An ordinary person spends his life trying to avoid tense situations… Not many people got a code to live by anymore." Not so in the Malibu; tense and interesting situations are sure to find you.

Be sure to act now, though. Whether it's the amenities, the "pick-up", its unique cool, or the two dead aliens in its trunk, the Malibu is in high demand, going for as much as $20,000 on the street. So beat the Rodriguez brothers to the punch, and get your hands on the Malibu today. Pop some punk music into the tape deck and go for a little spin. Just be careful not to look in the trunk; you don't want to know.

1961 Ferrari 250 GT California: *Ferris Bueller's Day Off* (1986)

Are you a man or woman of discriminating tastes? Sure you are. Sometimes any old car is good enough to get you from point A to point B. There are other times though that just any old car simply won't do. Some days, or days off, require that you be conveyed in a more stylish manner.

The red 1961 Ferrari 250 GT California is a car that will pamper you, and should be pampered in return. Fewer than 100 were made, so you don't have to worry about every Tom, Dick, and Harry copying your style. As one driver, Ferris Bueller (Matthew Broderick) told us, "If you have the means, I highly recommend picking one up." The question isn't what you're going to do in the Ferrari, but what *aren't* you going to do.

Not even paranoid principal Ed Rooney (Jeffrey Jones) will doubt you when you pull up in this beauty. Though the Ferrari looks beautiful sitting there all shiny in its custom garage, it's even better out on the open road or cruising the streets of Chicago.

A note of caution—this beautiful sports car will spur jealousy and arouse emotions. Be careful who you leave the car with, as few can resist the temptation to take it out for a joy ride. Once you've lost those miles, you can't get them back; the odometer can't be rolled back manually, even by running the car in reverse. The Ferrari also dents easily when repeatedly kicked or rolled out of a second-story garage window, as Cameron Frye (Alan Ruck) discovered.

Check out the 1961 Ferrari 250 GT California for your next day off. It will make you feel like you're atop a pageant float singing "*Danke Schoen*" to an adoring crowd. You'll love it more than life itself.

1958 Plymouth Fury: *Christine* (1983)

Men develop a special bond with their cars. We give them girls' names, we pamper them, we treat them like lovers. As Arnie Cunningham (Keith Gordon) says, "There is nothing finer than being behind the wheel of your own car." That is especially true

when you invest the time, money, sweat, and love to restore a classic American car like the red 1958 Plymouth Fury.

The Fury has been "bad to the bone" ever since it rolled off the assembly line in Detroit. As Arnie discovers, once you fix up the Fury, "she could really be tough." You're sure to develop a special bond that no one else can understand. Not your overbearing parents who can't let you enjoy "this one thing." Not your best friend Dennis (John Stockwell) who can't grasp how much your car means to you. Not your gorgeous girlfriend Leigh (Alexandra Paul) who is jealous of the time you spend with your car, and hates the classic rock and roll that plays on your car's radio. Not any of the "shitters" out there. Don't worry, it's not you, it's them. They're all jealous. They just don't appreciate the special relationship you have with your "girl."

But *she* understands. *She* will take care of you. No one will mess with you ever again. Not that bully Buddy Repperton (William Ostrander) or any of his buddies. Not that nosy garage owner Will Darnell (Robert Prosky). Nobody!

Detective Junkins (Harry Dean Stanton) says, "Some things can't be helped. Some people too." Maybe he's right. Perhaps you and the Fury are meant to be together forever. So slide behind the wheel of the Fury, crank up the rock-and-roll oldies, and burn on down the highway. They'll keep a-knockin', but they can't come in!

1959 Cadillac Eldorado Miller-Meteor: *Ghostbusters* (1984)

Americans pride themselves on their individuality. And what says more about the individual you are than the car you drive, and how you personalize it to your own tastes and needs. Racing stripes, Hemi engines, window tinting, even a pair of fuzzy dice—we love to customize our cars. Why not design your car to your own unique specifications?

If your tastes run closer to Tobin's Spirit Guide than Kelley Blue Book, then we have just the vehicle for you. Step right this way, and feast your eyes on the heavily modified 1950 Cadillac Eldorado Miller-Meteor. This is a combination car that was originally designed to be an ambulance, a hearse, or a limousine.

Its previous owner, Dr. Raymond Stantz (Dan Aykroyd) of New York City, invested a great deal of time and money into restoring and customizing this classic. When he found the car, it needed "some suspension work, shocks and brakes, brake pads, lining, steering box, transmission, rear end, new rings, mufflers, a little wiring." Stantz dropped $4800 on the old hearse, and transformed it into ECTO-1, a car specifically designed for his vocation as a Ghostbuster. Emblazoned with the famous Ghostbuster logo, this sleek red-and-white beauty is custom fitted with a rear rack to hold your proton packs, a must for any urban paranormal wrangler. Its roof is filled with other state-of-the-art equipment that is too complicated for us to try to explain here.

So don't risk being slimed! Pick up your very own customized 1950 Cadillac Eldorado Miller-Meteor, and strap on those proton packs. Gozer, Zuul, and giant Stay-Puft Marshmallow Men won't stand a chance against you once you're behind the wheel of ECTO-1. Make us an offer today, before this beauty disappears into thin air!

1965 Buick Riviera: *Road House* (1989)

Are you the kind of man who's hard on a car? Do your cars always seem to take a beating? Do you and your vehicle somehow attract a bad element? No need to apologize for your manly, rugged lifestyle. You do, however, need to take careful stock of the cars on the market, and choose one that is tough enough to keep up with your demanding adventures.

The 1965 Buick Riviera is a car that you can be proud to drive, confident in the fact that it's both stylish and tough. The rugged American-built Riviera can handle itself in a fight, just like you. Owner Dalton (Patrick Swayze) bought a used 1965 Buick Riviera because it matched his lifestyle. A bouncer by trade, Dalton has seen his share of black eyes, broken bones, and knife wounds. His Riviera was right there beside him, suffering slashed tires, broken antennae, busted windshields, and even impalement by an uprooted stop sign. No worries for the Riviera. Just stop over at Red's Hardware for some replacement parts, and the Riviera is back in action. Those winking headlights will let your enemies

know that a few bumps and bruises won't keep you or the Riviera down.

The Riviera's tough, sure, but what do the ladies think? Dalton says to Elizabeth Clay (Kelly Lynch), "I keep talking, you're gonna go thinking I'm a nice guy." Elizabeth responds, "I know you're not a nice guy." That doesn't stop Elizabeth from jumping Dalton's bones, though. Women are attracted to rugged bad boys with a sense of mystery about them, and the 1965 Buick Riviera is just the car to project that image.

So park that fancy Mercedes in Emmett's barn, and come on down to the showroom to pick up a car that more closely fits your personality—the 1965 Buick Riviera. As Dalton's amigo Wade Garrett (Sam Elliott) tells him, "Let's crank that thing up and head down the road."

1981 DeLorean DMC-12: *Back to the Future* (1985)

Do you need a car with some serious power? I'm talking 1.21 "jigowatts" of power! If so, then there's only one car for you, the 1981 DeLorean DMC-12. This car is so perfect, they only manufactured it for one year, and then they broke the mold. The DeLorean DMC-12 is available in striking silver, and features distinctive gull-wing doors that will be the envy of all your neighbors.

But color and features aren't what drew you to the DeLorean, am I right? Great Scott, let's talk about that power! This baby can go from zero to 88 in a flash. It's so fast that it's been known to cause "temporal displacement." As one owner, Dr. Emmett Brown (Christopher Lloyd) puts it, "When this baby hits eighty-eight miles per hour, you're gonna see some serious shit." The key to the DeLorean's power is the innovative flux capacitor, which is not available on any other foreign or domestic models.

The only drawback is that the DeLorean "requires something with a little more kick" than regular unleaded gasoline. Although it's electric, you need a nuclear reaction to kick-start the flux capacitor. Future models are being designed to run on banana peels and Miller High Life, but they aren't available to the public yet. So until plutonium is available at every corner drug store, you

can either steal some from Libyan nationalists, or try to harness a bolt of lightning. But for the discriminating car buyer, the 1.21 jigowatts of power the flux capacitor offers is well worth the extra effort.

2. How to Give Your Life a Bitchin' Soundtrack

Hey dudes and dudettes! It's your pal DJ XCess at WMOV FM, the station that plays '80s movie soundtracks, *all day long*! I'm here to take you Material Girls and Boys back to the era of legwarmers, Members Only jackets, and big hair. The only way I can get my time machine up to 88 miles per hour, though, is to play totally tubular hits from your favorite '80s flicks.

As we all know, '80s films are iconic because of their radical characters and styles. However, many of us forget that their music is really righteous and memorable, too. '80s pictures teach us that good tunes not only set the proper mood for a scene, but also create awesome memories for the audience too. A large part of that has to do with all the catchy melodies and choruses in '80s movie music. Whether it's an epic score by John Williams, an original number by Kenny Loggins, or just a well-placed rock tune by The Cars, you'll always remember the adventures of Indiana Jones, the first time Kevin Bacon cut footloose, and the instant Phoebe Cates became your perfect teenage fantasy. If some of these examples aren't enough to convince you, don't worry, there are plenty more in store for you today.

Listen up, because my program will show you the importance that music plays in setting a mood. We'll explore exactly why '80s movie tunes create such a lasting impression, so you can understand how to give *your* life a bitchin' soundtrack. That way when you're feeling happy, sad, or just feel like rocking out in your underwear, you'll know exactly what you should throw on your boombox.

Sit back, relax, and take a chill pill. There's plenty of great music coming your way. There's a problem with the DeLorean's starter, so it may take a minute. Psych! Time circuits are on, the flux capacitor is fluxing, and away we go!

First Block: Classical Isn't a Bad Word

Classical music can be totally boring sometimes, but not all of it makes me want to gag myself with a spoon. In fact, some of it can be pretty damn cool, especially when it's part of a movie's score. I don't think anyone creates classical music that's more rad than composer John Williams. Although he was already famous before the 1980s for his collaborations with directors George Lucas and Steven Spielberg, Williams made a big splash early in the decade with his totally excellent work on two other Lucas and Spielberg films: *Star Wars: Episode V – The Empire Strikes Back* and *Raiders of the Lost Ark*.

"The Imperial March (Darth Vader's Theme)" from
The Empire Strikes Back

As soon as you hear this epic song, you know immediately that Darth Vader is an evil dude who doesn't take crap from anybody. His face may be grody to the max under that helmet, but he's not a guy you want to mess with. Even if he lacked the ability to choke you out with The Force, his theme is intimidating enough on its own to strike fear into his minions and any soldiers from the Rebel Alliance who might dare to cross him. If you're in a take-no-prisoners kind of mood, make sure to queue up "The Imperial March (Darth Vader's Theme)," so you can intimidate your cronies just like Vader.

"Desert Chase" from Raiders of the Lost Ark

Every track John Williams composed for the first Indiana Jones flick perfectly expresses that totally awesome sense of danger and excitement in Indy's adventures. None do it better than "Desert Chase", which can be heard during the movie's thrilling truck chase sequence. In that scene, Indy conquers a roving convoy to reclaim The Ark of the Covenant from the Nazis. When the trumpets blare with his theme, you can't help rooting for Indy as he risks life and limb to keep the archaeological treasure from falling into the wrong hands. Although he may get shot and nearly run over, you know when you listen to this tune that somehow, someway, Indy will come out on top. If you're facing your own

impossible task, listening to "Desert Chase" can help you transcend your obstacles to save the day.

John Williams wasn't the only one composing fantastic music for films during the '80s. Additional credit should go to Greek composer Vangelis for his bodacious work on the 1981 British sports tale *Chariots of Fire* and to Alan Silvestri for his tubular contribution to the *Back to the Future* series.

"Titles" from Chariots of Fire

Few songs are as inspirational or as iconic as the title theme composed by Vangelis. While the music isn't strictly classical, Vangelis uses a fantastic mixture of synthesizer and piano to craft a tune that is energetic despite sounding old-fashioned. The song is so influential that it has lived on in other movies and television as both tribute and parody. Its impact is enduring enough that the opening ceremonies for the 2012 Olympic Games in London featured a silly scene where British comedian Rowan Atkinson (a.k.a. Mr. Bean), daydreamed about running with characters from the film, while this tune played in the background. If you need that extra push when you're out for a jog, the title theme from *Chariots of Fire* will get you to 110 percent until you cross the finish line.

"Back to the Future" from Back to the Future

Alan Silvestri's theme for *Back to the Future* is amazing because it totally fuses the playful imagination of Doc Emmet Brown (Christopher Lloyd) and the youthful energy of his assistant Marty McFly (Michael J. Fox). Silvestri has created something that makes you feel stoked during the happy moments and anxious when things are looking dicey for our heroes. No matter how many times I see this flick, Silvestri's thrilling theme makes me nervous as the DeLorean speeds toward the lightning bolt at the clock tower. With each viewing, I still worry that Marty might not actually get there in time. The fact that Silvestri can build that kind of suspense with music is righteous. When you're not sure you can make a tight deadline, listen to "Back to the Future" and you'll be reminded of Doc's famous encouragement, "If you put your mind to it, you can accomplish anything."

Second Block: Need Custom Songs? Call Loggins or Lewis

Classical music is perfect for some big-budget action and fantasy flicks, but sometimes you just need wicked tunes with catchy lyrics. That's where professional songwriters come in handy; they can produce that clever hook to get viewers singing along. It also helps to have a famous artist recording those tunes for your movie. There is a reason that musician Kenny Loggins earned the title of King of the Movie Soundtrack during the 1980s. He performed multiple songs featured in '80s films like *Caddyshack*, *Top Gun*, and *Footloose*.

"I'm Alright" from Caddyshack

A dancing gopher puppet has never looked this fresh and probably never will again, thanks to this gem sung by Mr. Loggins. After we meet Mr. Gopher in the film's intro, we're introduced to teenager Danny Noonan (Michael O'Keefe), who cares more about summer fun than figuring out what he wants to do with his life. The song continues on his subsequent bike ride through the posh neighborhoods of his town on his way to work at Bushwood Country Club. The music sets up the adolescent boredom that fuels the outrageous behavior and mischief at the club. If you just want to goof off without being hassled by The Man, then "I'm Alright" is your anthem.

"Footloose" from Footloose

When a tragic accident after the prom claims the lives of several teenagers, dancing is outlawed in their town, but Ren McCormick (Kevin Bacon) and his girlfriend Ariel Moore (Lori Singer) firmly believe that the law is completely bogus. That's why they spend the majority of *Footloose* fighting town officials so that they can have a senior prom. When their efforts pay off and it's finally time to dance, Kenny Loggins gets your toes tapping with this snappy tune. As you watch all the kids in the film freestyle dancing, you can't help singing along with this catchy song. In fact, "Footloose" became so popular that it climbed to the number 1 spot on the U.S. Billboard Hot 100 for three weeks in

1984. When you feel like you need to dance (even in your underwear), you should "cut footloose" with this Loggins song.

"Danger Zone" from Top Gun

There's no better song for fighter pilots like Maverick (Tom Cruise) and Ice Man (Val Kilmer) to cruise around to than "Danger Zone" by Kenny Loggins. If a Tomcat had a cassette player in it, you can bet that this song would be blasting as Maverick taunts the Russians. The epic nature of this Loggins tune feeds that patriotic feeling you get by watching this very American flick. With that in mind, it's no wonder why "Danger Zone" is the favorite song of modern-day cartoon secret agent Sterling Archer (H. Jon Benjamin). While you may not have a fighter plane of your own, you can still floor it in your car while cranking "Danger Zone" to achieve a similar badass effect.

"Back in Time" from Back to the Future

There has been a lot of Kenny Loggins in this block, so I think it's time to cleanse the palate with some Huey Lewis and the News. Huey Lewis came up with this great custom track for the *Back to the Future* soundtrack. You can only hear it briefly during the film, but this Huey Lewis and the News song, which also appears in the end credits, is totally radical. The tune was written and performed by Huey Lewis specifically for the movie, so it has entertaining lyrics related to Doc and Marty's adventure. The best ones are "Don't bet your future/On one roll of the dice/You better remember/Lightning never strikes twice." These words allude to Marty's one chance to harness the lightning bolt so that he can get back to 1985. Although it doesn't have much competition, "Back in Time" is easily the best time travel song of all time. Make sure to have it ready in your tape deck when you need to get your own DeLorean up to 88 miles per hour.

Interlude: Duran Duran Takes on Bond and Peter Gabriel Plays from a Boombox

This section features a couple of random '80s movie songs which are bitchin' but don't fall into any particular category. They're just two iconic tunes that I think deserve mention.

"A View to a Kill" from A View to a Kill

No Mr. Bond, I expect you to *dance*! It may not be the most popular James Bond film of all time, but *A View to a Kill* features the best-received theme song in Bond's 50 year run. The tune—written and performed by Duran Duran—remains the only Bond theme song to reach number 1 on the U.S. Billboard Hot 100. Duran Duran was hot in the mid-80s, which may have something to do with why it became a hit, although it probably helps that the chorus has wicked catchy lyrics like "Dance into the fire/That fatal kiss is all we need/Dance into the fire/To fatal sounds of broken dreams." If (like James Bond) you're feeling dangerous and a bit self-destructive, then you should turn on "A View to a Kill" to get those feelings out of your system.

"In Your Eyes" from Say Anything

This bitchin' movie moment almost didn't happen. In the famous scene where Lloyd Dobler (John Cusack) romantically holds a boombox over his head, the song coming out on set was by Fishbone. Director Cameron Crowe originally wanted to replace it with Billy Idol's "To Be A Lover," but thankfully he went with Peter Gabriel's "In Your Eyes" instead. Gabriel's sweet tune struck a chord with viewers, immortalizing it in popular culture and cementing its status as a make-up song. Like Vangelis' "Titles" from *Chariots of Fire*, this scene has been parodied many times in film and television—a testament to its huge impact. Next time you're in the doghouse with your significant other, dust off the boombox and pop in your Peter Gabriel tape. You'll be glad you did.

Third Block: Just the Right Mix of Existing Songs

You've heard a couple of memorable songs here and there from various '80s films and I'm sure you're wondering "Where's the beef?" You want to know which flicks have the best overall soundtracks. Many '80s movies can say that they've got one or two bitchin' tracks, but few can say that their soundtrack is entirely comprised of rockin' tunes. What I've discovered is that the absolute top '80s film soundtracks are made up of preexisting popular songs working together to establish the perfect ambiance. Rather than barf you out with tons of boring talk, I'm going to provide brief introductions, and then let the soundtracks speak for themselves.

First up, I'm going to play the soundtrack for *Fast Times at Ridgemont High*. This Cameron Crowe film perfectly captures what it's like for an American high schooler in the 1980s with all of its glorious sex, drugs, and rock music. Definitely put this soundtrack on when you're feeling nostalgic for the carefree days of your youth, even if those days didn't happen in the '80s.

Sadly, there are five songs that appear in the movie that are not on the official soundtrack. The fact that they're missing is totally bogus, considering they include righteous tunes like "Moving in Stereo" by The Cars, and "We Got the Beat" by The Go Go's. "We Got the Beat" plays during the movie's hilarious title sequence at the local mall, and "Moving in Stereo" during the notorious scene where Phoebe Cates takes off her top—a moment etched into the mind of every young straight man who sees the film. The remaining tracks that made it to the official soundtrack are still incredibly bitchin' and totally worth a listen.

- "Somebody's Baby" ----------------------- Jackson Browne
- "Waffle Stomp" ---------------------------- Joe Walsh
- "Love Rules" ------------------------------ Don Henley
- "Uptown Boys" ---------------------------- Louise Goffin
- "So Much in Love" ----------------------- Timothy B. Schmit
- "Raised on the Radio" --------------------- The Ravyns
- "The Look in Your Eyes" ---------------- Gerard McMahon

- "Speeding" ---------------------------------- The Go-Go's
- "Don't Be Lonely" -------------------------- Quarterflash
- "Never Surrender" -------------------------- Don Felder
- "Fast Times" --------------------------------- Billy Squier
- "Fast Times at Ridgemont High" --------- Sammy Hagar
- "I Don't Know" ----------------------------- Jimmy Buffett
- "Love Is the Reason" ----------------------- Graham Nash
- "I'll Leave It up to You" ------------------- Poco
- "Highway Runner" ------------------------- Donna Summer
- "Sleeping Angel" --------------------------- Stevie Nicks
- "She's My Baby" ---------------------------- Palmer/Jost
- "Goodbye, Goodbye" ---------------------- Oingo Boingo

Gotta love that Oingo Boingo. They did the wacky theme song for *Weird Science* and a gnarly track for Rodney Dangerfield's *Back to School* called "Dead Man's Party", which they performed in the movie. Today, the band's front man—Danny Elfman—is better known as a composer for and frequent partner of director Tim Burton.

Next up is the soundtrack for the 1984 film *Repo Man*, which features Emilio Estevez as a punk rocker who takes up work as—you guessed it—a repo man. Despite the movie's zany sci-fi plot involving a car with two aliens in its trunk, its music is insanely bitchin'. The soundtrack is filled with awesomely aggressive punk tunes from the likes of Iggy Pop, Black Flag, The Plugz, and The Circle Jerks. When you see this movie, you'll have a blast with its tubular characters, fast-paced story, and headbanging songs. If you're feeling a bit rebellious, you may want to do your own headbanging to this soundtrack, but just try not to pull anything in your neck doing it.

- "Repo Man" --------------------------------- Iggy Pop
- "TV Party" ----------------------------------- Black Flag
- "Institutionalized" ------------------------- Suicidal Tendencies
- "Coup d'État" ------------------------------- Circle Jerks
- "El Clavo y la Cruz" ----------------------- The Plugz
- "Pablo Picasso" ----------------------------- Burning Sensations
- "Let's Have a War" ------------------------ Fear

- "When the Shit Hits the Fan" ----------- Circle Jerks
- "Hombre Secreto" ----------------------- The Plugz
- "Bad Man" -------------------------------- Juicy Bananas
- "Reel Ten" -------------------------------- The Plugz

Sorry folks, but I'm getting a signal from my producer that it's time to wrap it up. That's all the time I have for today. Thanks for coming back in time with me to the '80s, and for listening. Hopefully you have a newfound appreciation for the importance of bitchin' tunes in creating incredible memories. Remember: a great movie soundtrack will make you laugh, cry, or bang your head (in a good way). These songs bottle feelings up, creating experiences that will stick with you for the rest of your life.

Now that you know why the specific tracks we've listened to are so important, you can create your own bitchin' soundtrack with music for every mood. My work is done here for today, but be sure to tune in again tomorrow for another great mix of '80s movie soundtracks to suit every situation on WMOV FM!

3. How to Survive an '80s Horror Movie Part I: The Spawning

I'm Jason Voorhees. You may remember me from my trademark hockey mask and my starring role in the *Friday the 13th* movie series. I've had a really good run. I turned a rough childhood, mommy issues, and an antipathy toward camp counselors into an enjoyable, lucrative career. Life as a psychopathic serial killer has its downsides, though. I've spent much of my adult life living like a hermit in the woods around Crystal Lake. I've been drowned, hit with a machete, stabbed with a knife, hung from a rope in a barn, gotten an axe to the head, electrocuted, and had my face impaled. Serial killing is definitely a game for the young! I'm ready to hang up the hockey mask and machete for good. I've retired and purchased a condo down in Florida.

Now that I'm out of the game, I can comfortably share all my secrets. To be perfectly honest, I couldn't have accomplished all I have without your help, especially the teenagers out there. You guys have made my job a lot easier over the years. If my victims hadn't been so stupid and clueless, my body count would have been much lower.

Like any true professional, I keep a close eye on my competition. You never know where or when you can pick up a good idea or a new technique from a fellow slasher. In fact, I host a monthly poker game with Michael Myers (*Halloween*), Freddy Krueger (*A Nightmare on Elm Street*), and Leatherface (*The Texas Chainsaw Massacre*). Boy, is it tough to pick up on "tells" when three out of four players at the table are wearing masks, and the fourth has horribly disfiguring burns!

Based on my own experiences and those of my '80s slasher film compatriots, I've put together my pointers on how to survive an '80s horror movie. Consider it my way of giving a little back. You never know when you might find yourself stalked by a psychopathic killer. Unless you're Jamie Lee Curtis, who has an uncanny knack for surviving horror movies—*Halloween*, *The Fog*, *Prom Night*, *Terror Train*, *Halloween II*, *Halloween H2O*—then you're going to need some help making it out alive. So pay heed: it might just save your life!

Proper Supervision

Any parent or teacher can tell you, if you leave teenagers unsupervised, there is potential for bad things to happen. Even though adults know this, they continue to do it. They choose their own needs and wants over their families and the safety of children. It makes life easier for crazed killers like me.

In *The Slumber Party Massacre* (1982), Trish's (Michelle Michaels) parents leave on a trip early in the movie. What does their teenage daughter Trish do? Why, she throws a slumber party, of course, inviting her friends from the high school basketball team. Mass murderer Russ Thorn (Michael Villela) is on the loose, and stalks victims both at the remarkably unsupervised school and at the slumber party. The parents of uninvited teammate Valerie (Robin Stille) are also away. The only adults in the neighborhood of the slumber party are creepy neighbor Mr. Constant (Rigg Kennedy), who gets whacked halfway through the movie, and of course the killer, armed with a power drill. The results are pretty predictable.

Graduation Day (1981) should be a happy time for the seniors at Midvale High. The only problem is that the members of the track team suddenly start disappearing right before graduation. The killer has a pretty easy time picking off his victims in and around the school—in the locker room, in the woods behind the school, at a school-sponsored pre-graduation party. The school security guard is remarkably ineffectual, Principal Guglione (Michael Pataki) just wants to be left alone so he can seduce his secretary, and teachers like the bitter Coach Michaels (Christopher George) and the sleazy Mr. Roberts (Richard Balin) are too focused on themselves to notice their class rolls are quickly declining. Even the missing kids' parents are inept—they call Principal Guglione for help instead of notifying the police. It takes Anne (Patch Mackenzie), the older sister of a classmate who died, to track down and dispose of the killer.

In *Halloween 4: The Return of Michael Myers* (1988), Richard Carruthers (Jeff Olson) is bucking for a promotion at work, and he and his wife attend a Halloween party at his boss' house, leaving teenage daughter Rachel (Ellie Cornell) and adopted daughter Jamie Lloyd (Danielle Harris) at home, despite

Jamie's recent nightmares and insomnia. Michael Myers escapes and comes looking for his niece Jamie. Rachel is left alone to protect Jamie as Michael takes out half the town of Haddonfield. The parents don't show up until the very end, and find two tweaked-out daughters who have been terrorized the entire night. I hope Mr. Carruthers at least got the promotion.

A Nightmare on Elm Street (1984) may be the best (or worst) example of poor parental supervision. Not only do the parents not look after their teenagers very well, but they're the direct *cause* of the killer's anger. Freddy Krueger was "a filthy child murderer" who was trapped in a boiler room and burned to death by a group of vigilante parents, including Marge Thompson (Ronee Blakley). Now Freddy's back, haunting the dreams of Marge's daughter Nancy (Heather Langenkamp) and her teenage friends. Marge has become a raging alcoholic, and provides no help to her terrified daughter. The parents of Nancy's best friend Tina (Amanda Wyss) are away for the night when Tina is murdered. Nancy's boyfriend Glen's (Johnny Depp) mother stands by helplessly as Glen is murdered. Nancy is eventually forced to confront Freddy on her own as her mother lies passed out on the couch.

My message to parents, administrators, teachers, and other adults is to provide proper supervision to teenagers. Be present in their lives, and be aware of what's going on. Insist on rules, curfews, and proper supervision. Though they may hate you for it now, it just might be the only way to keep them safe—from themselves and from those who mean them harm.

Be Wary on Holidays

Holidays are a time for sharing your happiness and good fortune with friends and loved ones. But to those who are unhappy, depressed, or suicidal, holidays can be an agonizing reminder of all that is wrong in their lives. So it should be no surprise that the 1980s were chock-full of holiday-themed slasher films. There was, of course, the movie that started it all—*Halloween*—and its '80s sequels (and my movies, the *Friday the 13th* franchise). But it seems like every holiday worth its salt got its very own horror movie in the 1980s. There was *Happy Birthday to Me* (1981), *My*

Bloody Valentine (1981), *April Fool's Day* (1986), *Silent Night, Deadly Night* (1984: Christmas), and *Terror Train* (1980: New Year's Eve). Even non-holiday events were commemorated with slasher movies: *Graduation Day* (1981), *Prom Night* (1980), *Hell Night* (1981: sorority/fraternity pledging), and *He Knows You're Alone* (1980: wedding day).

So while you're enjoying the holiday warmth and good cheer of friends and family, keep in mind that the holidays aren't all mistletoe and Easter egg hunts for everyone. There are quite a few of us out there whose home lives were royally screwed up, and our circle of friends pretty limited. We may not feel as "festive" as the rest of you, and some of us may actually resent your happiness so much that we're willing to do you harm. By all means, enjoy your birthday cake and your graduation parties...but keep a wary eye peeled when you're drinking your eggnog or trick-or-treating. One of us may be lurking around the corner!

Stay Out of the Woods and Other Secluded Areas

Sometimes the hustle and bustle of daily life can be too much—cell phones, morning commutes, e-mails, driving the kids to their soccer game, waiting in lines, staring at a computer. Sometimes you just need to get away. For your own safety, though, please stay out of the woods and other secluded areas. They're perfect cover for myself and other serial killers. You're out of your element there, and us killers gain a distinct advantage. Think twice before you book a quiet vacation in a cabin in the woods, a leisurely rafting trip down the river, or a hitchhiking expedition across the British moors. Why not consider a nice Caribbean cruise, an all-inclusive resort, a Broadway show, or some other vacation in which there are other people around?

A number of '80s horror films involve killings in the woods, such as *Pumpkinhead* (1988) and *Sleepaway Camp* (1983). *Graduation Day* (1981) features several killings around the school, including a topless girl running in slow motion and a football player in full gear and shoulder pads inexplicably jogging through the woods. My mother and I committed most of our murders in the woods around Crystal Lake, and still the idiots kept showing up—

you can't have a series of twelve movies without a constant fresh supply of moronic teenagers!

The Evil Dead (1981) is the original cabin-in-the-woods thriller. Ash (Bruce Campbell) and four of his college buddies decide to take a vacation in a cabin in the rural North Carolina woods. They accidentally unleash ancient demons, and because of the cabin's seclusion, Ash is stuck dealing with the problems all on his own. The forest around the cabin itself becomes possessed, and roots actually rape one girl.

The woods aren't the only secluded area you might want to avoid. David (David Naughton) and Jack (Griffin Dunne) are backpacking across Europe in *An American Werewolf in London* (1981). No problem—there are a lot of great sites to visit in Europe. But the British moors? Great expanses of infertile, boggy land? Why do you need to see that? Sure enough, David and Jack meet up with a vicious werewolf. Secluded hedge mazes figure prominently in both *The Shining* (1980) and *Hell Night* (1981). In fact, the whole story of *The Shining* takes place in a secluded area, as Jack Torrance (Jack Nicholson) and his family spend the winter as caretakers of the remote Overlook Hotel.

Trust Your Instincts & Use Common Sense

Humans have instincts and rational thought for a reason. Instincts develop unconsciously as reactions to help us deal with certain circumstances. Rationality enables us to make reasoned judgments and decisions. Yet humans don't always trust their instincts or use their best judgment, and that helps keep us serial killers in business. Below are a few examples of how characters in '80s horror movies got into trouble by not paying attention to their instincts and common sense.

- *Pet Sematary* (1989): Louis Creed (Dale Midkiff) knows it's wrong to bury his dead son in the magical pet cemetery in the woods behind their Maine home, but his grief drives him to do it anyway. Little Gage comes back to life, but boy has he changed!

- *Christine* (1983): Dennis (John Stockwell) doesn't like the used car his buddy Arnie (Keith Gordon) has his eye on, nor the shady character (Roberts Blossom) who's selling it. Dennis' instincts are confirmed when the car, Christine, turns out to be possessed by the evil spirit of its former owner. Another example of not using common sense from *Christine* is when bad guy Buddy Reperton (William Ostrander) is chased by the possessed car, and runs away **right down the middle of the road!**
- *Child's Play* (1988): We all want to please our children, but Karen Barclay (Catherine Hicks) goes overboard to get her son the toy he wants. Karen buys a bargain Chucky doll from a homeless street peddler in an alley. You get what you pay for, and Karen's efforts to save a few bucks put the family in mortal danger when Chucky turns out to be possessed.
- *My Bloody Valentine* (1981): When a crazed killer warns you not to hold another Valentine's Day dance after a fatal mine accident, perhaps you should consider postponing the festivities until St. Patrick's Day or Cinco de Mayo. The residents of Valentine Bluffs, Nova Scotia don't listen though, and tempt fate even further by taking the party right down into the mine itself.

So please, trust your instincts—they're smarter than you are—and use common sense. Do you *really* need to go out alone in the dark to check out that noise you think you heard? No, you don't. It's probably just the wind. And if it *is* a psychopathic killer, you don't stand much of a chance by yourself anyway. Stay tuned for my sequel, gang, because '80s slashers like me *always* come back for more!

4. Tips on Dancing
Hosted by Deney Terrio and Dance Fever

Hello, America! Welcome to a very special episode of the number one dance show on television, *Dance Fever*! I'm your host Deney Terrio. I'd like to thank Triple S Connection for our funky theme song. I'd also like to welcome our three celebrity judges for this week: musician and soap star Rick Springfield, *I Dream of Jeannie* star Barbara Eden, and TV's *Incredible Hulk* Lou Ferrigno. None of them know the first damn thing about dancing, but who cares? Let's have some fun.

Some of you out there have written in to the show for tips on how to dance. Good advice comes in handy. Just ask John Travolta. I taught him everything he knows about disco dancing when I worked as the dance instructor for *Saturday Night Fever* (1977). Tonight, *Dance Fever* has assembled some stars of the cinema to share their tips on dancing with America.

So let's get started. First up on stage is Willard Hewitt (Chris Penn) from *Footloose* (1984), dancing to "Let's Hear It For The Boy" by Deniece Williams.

> **Willard**: **Anybody can do it**. You don't need any special skills or even coordination to dance. Just look at me. I've got two left feet—in cowboy boots no less. But my girl Rusty (Sarah Jessica Parker) just loves to dance, so I got Ren (Kevin Bacon) to teach me a few things. The important thing though, is just to get out on the dance floor. If I can do it, anybody can.

Thank you, Willard. Usually we don't allow cowboy boots on the dance floor, as it can ruin the finish, but I guess we can make an exception tonight. Next is the gang from *The Breakfast Club* (1985): Andrew (Emilio Estevez), Brian (Anthony Michael Hall), Claire (Molly Ringwald), John (Judd Nelson), and Allison (Ally Sheedy). These five detention students will be dancing to "We Are Not Alone" by Karla Devito. They've elected Brian Johnson (Anthony Michael Hall) as their spokesperson.

BJ: Uh, yeah, hi. Um, we see dance as a way to express yourself and your individuality. We're all very different people: a jock, a brain, a princess, a criminal, and a basket case. Just look at us dance. Andrew struts around in an athletic way. I do a head-bobbing, geeky dance. Claire looks like she's in the spotlight, dancing up on the staircase landing. John's banging his head and thrashing around on top of the statue defiantly. Allison is spinning and flailing around, then collapsing in a heap. We're all different, and when we dance, we can express our own personalities and what makes us who we are.

Thanks, Brian. Can we please get John down off that statue? Don't mess with the bull, Bender, or you'll get the horns. Joining us on stage now is Al Czervik (Rodney Dangerfield) from *Caddyshack* (1980), dancing to "Any Way You Want It" by Journey.

AC: Oh, what did somebody step on a duck or something? Hey honey, you wanna make fourteen dollars...the hard way? My tip is dance whenever and wherever the mood strikes you. It doesn't matter if you're on the golf course, at dinner, or in the john. Any way you want it, baby, that's the way you need it.

Quite an outfit, Al. And I thought the fashions of the disco days were bad. Josh Baskin (Tom Hanks) is our next guest, and he has some *Big* (1988) advice for all of you, as he dances to traditional piano tunes "Heart and Soul" and "Chopsticks."

JB: Hey, wow, look at all the people. Gosh, this is great. My advice is to **unleash your inner child**. This toy store I work at has this cool giant piano on the floor that you can play with your feet. I had piano lessons as a kid, and so did Mr. MacMillan (Robert Loggia), so we hopped right on. Man, was it awesome! You gotta try it. And don't forget,

everything's more fun when you cut loose and act like a kid.

The spotlight dance is next, as we're joined by Johnny Castle (Patrick Swayze) and Frances "Baby" Houseman (Jennifer Grey) from *Dirty Dancing* (1987), as they do the *pachanga* to "(I've Had) The Time of My Life" by Bill Medley and Jennifer Warnes.

> **JC**: Dancing is all about trusting your partner, and **showing the world how special they are**. Nobody puts Baby in the corner, and you shouldn't let your partner feel that way either. Lift them up and show the world how special they are.

Oops, somebody tell Johnny a wallet just fell out of his pocket. I guess he can pick it up later. O.K., jump in the line and shake señora, because we have Delia (Catherine O'Hara) and Charles Deetz (Jeffrey Jones) and their dinner guests from *Beetlejuice* (1988), dancing to "Day-O (The Banana Boat Song)" by Harry Belafonte.

> **DD**: **Let the music take control**. Feel the beat, and dance wherever and however the music takes you. You can't go wrong when you let the music "possess" you. *Day-O!*

We go from day-O to day-glo, as in the bright outfits of Ozone (Adolfo Quinones), Turbo (Michael Chambers), and Special K (Lucinda Dickey) from *Breakin'* (1984) and *Breakin' 2: Electric Boogaloo* (1984). They'll be poppin', lockin', and breakin' to "*Breakin'...There's No Stopping Us*" by Ollie and Jerry.

> **Ozone**: **Dance with pride**. The breakdancing we do comes from the streets. We're proud of who we are and where we're from. If you don't get it, that's your problem, not ours. We do what feels good. We don't do it in classrooms either. We do it on the

streets, 'cause that's where we're from, and that's who we are. By the way, we're raising money to help save the community center downtown, so please help.

Thanks, Ozone. Now we move from a trio of teenagers to a group of thirty-something friends from *The Big Chill* (1983), as they dance around the kitchen table to The Temptations' "Ain't Too Proud to Beg." Here's Sam (Tom Berenger), Sarah (Glenn Close), Michael (Jeff Goldblum), Nick (William Hurt), Harold (Kevin Kline), Meg (Mary Kay Place), and Karen (JoBeth Williams). Harold Cooper (Kevin Kline) will speak for the group.

> **HC**: **Dancing is a great way to spend time with friends**. All you need is some good music—I prefer oldies rock and roll from the 1950s and 1960s—and some good friends. As we demonstrate, you can dance anywhere (like the kitchen) and anytime (like clearing the table after dinner). As long as you're with your friends, you're sure to have fun.

Next up on the *Dance Fever* stage is Clark Griswold (Chevy Chase) from *European Vacation* (1985). Clark is joined by a bunch of Germans in *lederhosen* as they perform a traditional German slap dance.

> **CG**: You see, kids, it's important to experience cultures other than our own. **When in Rome, do as the Romans do**. Or in this case, when in Germany, do as the Germans do…no matter how painful it is. Remember, kids, we're visitors here and—

I'm sorry, it appears that a brawl has broken out on stage between Clark and the Germans. Let's say *auf wiedersehen* as security escorts them off the stage. Our next guests are sure to act with more decorum. The caddies of Bushwood Country Club from *Caddyshack* (1980) will perform a synchronized swimming exhibition to "The Waltz of the Flowers" from Tchaikovsky's

Nutcracker. Representing the caddies is Danny Noonan (Michael O'Keefe).

> **DN**: **We all need some classical beauty in our lives**, no matter how rough around the edges we are. Even though us caddies are a rude, rowdy, and largely unwashed bunch, and even though we're only allowed in the Bushwood pool for fifteen minutes one day out of the year, we can bring some classical beauty into everyone's lives. And that's what dancing can do for you, too.

Well, the Bushwood caddies have pretty much ruined any dress code on *Dance Fever*, so let's go ahead and welcome Joel Goodsen (Tom Cruise) from *Risky Business* (1983), who will dance in his tighty-whiteys to Bob Seger's "Old Time Rock and Roll."

> **JG**: Sometimes you just gotta say "what the fuck" and make your move. **Let your guard (and maybe your pants) down** and cut loose. Dance like you think nobody is watching. Trust me, it's a lot of fun.

Now invading our stage are the students from the New York City High School for the Performing Arts, who will dance to "Hot Lunch" by Irene Cara. Speaking for the group from *Fame* (1980) is Coco Hernanadez (Irene Cara).

> **CH**: **Dancing can bring people together**. Look at all of us in the lunchroom. Everyone is doing their own thing, in their own world. But get a nice beat going, start moving, and suddenly everyone is dancing together and having a good time. So get out on the dance floor, or up on the lunchroom table, and show us your moves.

Wow, what a mess. Give us a minute while the janitor brings out the big broom to clean up all this lunchroom mess. O.K., good. Now we have Ronald Miller (Patrick Dempsey) from *Can't Buy Me Love* (1987), who will be dancing the African Anteater Ritual.

> **RM: Look to unexpected sources for inspiration.** I wanted to learn some moves for the big dance, so I turned on the TV to catch *American Bandstand*. Little did I know I was actually watching the *PBS Cultural Hour*, and learning the African Anteater Ritual. But what do you know—now it's the hottest dance at school!

Hard to believe, Ronald, but hey, if that's what the kids are into. Our next guest is Ren McCormack (Kevin Bacon) from *Footloose* (1984), dancing to "Never" by Moving Pictures.

> **RM:** Sometimes you need to blow off steam. **Dancing can be a great way to relieve stress.** Drive down to your local warehouse, pop in a cassette tape, and dance that stress away. It will help you forget, at least for a while, about all the problems that are getting you down.

Duckie Dale (Jon Cryer) from *Pretty in Pink* (1986) just slid onto stage in his white loafers to the opening notes of "Try A Little Tenderness" by Otis Redding. Otis, my man!

> **DD:** This is Otis. I love Otis! When I dance to Otis, I feel the **passion**. I might not have the best dance moves, but I dance passionately, and that goes a long way. By the way, do you think Andie (Molly Ringwald) liked my dancing?

I doubt it, Duckie. You're no Andrew McCarthy. Next up are Jake (John Belushi) and Elwood (Dan Aykroyd) Blues of *The Blues Brothers* (1980), dancing to "Respect" by Aretha Franklin and "Twist It (Shake a Tailfeather)" by Ray Charles.

EB: Look, ah, I ain't one for speeches, but me and Jake grew up in an orphanage, and Curtis (Cab Calloway) taught us to **respect tradition**. Modern music and dance wouldn't be nothin' without all the legends that came before it. We grew up listenin' to Elmore James and all the great ol' blues acts. So when we got our chance, we made sure to R-E-S-P-E-C-T the greats. Just listen to Ray sing about the Bird, the Watusi, the Mashed Potato, and the Bony Maroney. Those are some great old dances. So see the light and respect tradition.

From the twist to a rather twisted individual, Pee-wee Herman (Paul Reubens) from *Pee-wee's Big Adventure* (1985), dancing to "Tequila" by The Champs.

PW: Ha, ha, hey everybody. **When you don't know what else to do, dance**! I went into this biker bar to use the telephone, and somehow those biker dudes got really mad at me. They wanted to beat me up bad, but I got them to grant me a last wish. So I danced to "Tequila," and they loved it! By the time I left to go find my bicycle, we were best buds.

I could use a couple shots of tequila myself right now. Are we almost done? Yes, I'm told these are our last guests, the cast of *Footloose* (1984), led by Ren McCormack and dancing to "Footloose" by Kenny Loggins.

RM: **Dancing is a way to celebrate life**. Everybody can appreciate that, even reactionary old preachers like Shaw Moore (John Lithgow). I know his daughter Ariel (Lori Singer) sure gets it, if you know what I mean. *Let's dance*!

Those kids dance pretty well for having grown up in a town where dancing is banned. Well, that's all the time we have, America. I hope you picked up some useful pointers on dancing from our '80s movie guests. Let's go to our celebrity judges to find

out the winner. You know what, forget about it. Who really cares what they think, anyway? They're just here to promote their own project. I'm Deney Terrio, and thanks for watching. Until next week, here's hoping *you* catch dance fever!

5. Are Country Clubs Bastions of Tradition or Elitist Institutions?
Judge Elihu Smails vs. Al Czervik

Country clubs have been a part of American society for much of the 20th century. They are private clubs, often with restricted memberships, that offer recreation, dining, and other services to their members. Some see country clubs as bastions of tradition and class, oases of fine living and respectability. Others view country clubs as elitist institutions, pampering wealthy white families while denying admittance or membership to minorities, people of lesser means, and sometimes women.

We decided to take this debate directly to the source. Point/Counterpoint recently traveled to Bushwood Country Club, a private club in suburban Nebraska [*Caddyshack* (1980)]. There we interviewed leading proponents of each side of the debate. Judge Elihu Smails (Ted Knight) is a co-founder of Bushwood, and believes his club to be a bastion of class and tradition. Al Czervik (Rodney Dangerfield) owns a large construction company, and was recently a guest at Bushwood. Czervik sees Bushwood as an outdated, elitist institution.

Country Clubs are Bastions of Tradition: Judge Elihu Smails

My generation has been labeled "the Greatest Generation." Far be it from me to contradict history. Men like myself and Ty Webb's (Chevy Chase) father define this greatest generation. We prepped together, and when the time came, we went to war together. When we returned from serving our country in the war, we helped build the economic, political, and financial institutions that made the United States the greatest nation in the world. We worked hard, we sacrificed, and we built comfortable lives for our families.

Shouldn't we then deserve some time to enjoy the fruits of our labor? Ty Webb's father and I, we built this club, he and I. The two of us, and other like-minded men, built Bushwood into the finest club in the area. Bushwood counts many of the area's civic

leaders among its members. Why, just yesterday I played golf with Bishop Fred Pickering (Henry Wilcoxon) and gifted surgeon Dr. Beeper (Dan Resin). Dr. Beeper, by the way, is the club champion three years running, and I'm no slouch myself.

As I stated earlier, we work hard and our communities are far better off for our efforts. We deserve the opportunity to enjoy some leisure activities and the company of people with whom we share values. *That* is what Bushwood offers. It may seem snobbish or outdated to some, but enjoying the finer things in life—a quality golf shoe buffed with a fine shammy, a round of golf on Bushwood's excellent course, or a cocktail with friends aboard my yacht *The Flying Wasp*—these are things we have *earned* in life.

Not everyone understands or respects what we have built at Bushwood. We recently had a man (or should I call him a baboon?) that came to Bushwood as a guest of the Scotts. The man was no gentleman, I can assure you, and he quickly wore out his welcome at Bushwood. Before I even met the oaf, he insulted the hat I was wearing, saying if you bought a hat like that, you should get a free bowl of soup. Can you imagine the nerve? In my own club? I was preparing to tee off, and this man once again flagrantly violated etiquette by betting me that I would slice the ball into the woods. Well sir, I replied to him that gambling is illegal at Bushwood, and that I *never* slice. You would think that my stern warning should have sufficed, but this Neanderthal Czervik persisted in his loutish behavior during his entire stay at Bushwood, trampling all over our standards of decorum and common decency.

Whenever someone criticizes Bushwood for being a private, members-only institution, I immediately think of this man Czervik and those like him. If we were to allow just anyone into Bushwood, it would cheapen and demean the institution we took such great care to mold to the highest standard. After all, the world needs ditch diggers, too. There is a lot of, well, badness in the world. I see it in court every day. I've sentenced young boys to the gas chamber. I didn't want to do it, but I felt I *owed* it to them.

If we don't understand and abide by the rules of decent society, the way of life we have so carefully crafted is threatened. That's why I insist my grandson Spaulding (John F. Barman Jr.) and my niece Lacey Underall (Cindy Morgan) spend so much time

at Bushwood. I know how hard it is for young people today, and I want to help them learn how to be members of a decent society. Well, just ask Spaulding. He and I are regular pals. How about a Fresca? Hmm?

Country Clubs are Elitist Institutions: Al Czervik

Bushwood? Why, that whole place sucks! The only reason I even went to that dump is I thought maybe I'd buy it, turn it into condos or a shopping mall or something useful. Country clubs and cemeteries are the biggest wastes of prime real estate going. In this economy, if you don't own land, you own a popcorn fart. Oh, did somebody step on a duck? Just ask my friend Wang (Dr. Dow), he'll tell you. We just bought property behind the Great Wall…on the good side.

I tell you, Bushwood is nothing but a crummy snobatorium. It's the old buddy system all over. They don't want anybody who's different in any way. Like I told my Chinese friend Wang, the place is restricted, so don't tell 'em you're Jewish, O.K.?

You should see this place. It's like going back in time. Nothing ever changes. The dance floor on a Saturday night looks like the dance of the living dead. I told one old broad she must have been something before electricity. That music they were dancing to would put you to sleep, let me tell you. I gave the bandleader some dough and told him "Hey Ringo, play something hot, huh, and get these guys some more lessons." And the food at this place was low-grade dog food. I had better food at the ballgame. My steak still had marks from where the jockey was hitting it. And they're passing these crappy traditions down to the next generation. This guy Smails had his grandson there; now I know why tigers eat their young.

Smails! Now there's a piece of work. What a stuffed shirt that guy is. I mean, who made him the pope of that dump. I tell you, these old money types are all the same. No fun, no sense of humor, afraid of change. They want to keep everything just the way it was in the Eisenhower era. They got no respect for a guy like me, works hard building something with his bare hands. Smails tried telling me he'd call the police on me. I told him to call

the *chief* of police, because I built his condo. Smails and his crew want to sit on their old money, and not invite anyone new to join their crummy little snobatorium. Hell, I saw Smails sailing at the lake; my dinghy's bigger than his whole boat. I could buy that precious club of his three times over, but that don't mean nothing to them. If you didn't go to some Ivy League school, and you don't talk, dress, and act just like them, you're beneath them. I wasn't born with a silver spoon in my mouth, I tell you that. I worked for my money. Why, when I was a kid, I'd lug fifty pounds of ice up five, six flights of stairs to make a buck. Bet you'll never see that Spaulding kid doing that.

 Who needs 'em? I would never want to be a member of Bushwood anyway. Let 'em keep their private club, their sacred traditions, and their old ways. Knockin' a little white ball around for four hours and then dancing to Lawrence Welk tunes with a bunch of old farts ain't my idea of fun. So crank up the rock and roll, and let's dance! We're all gonna get laid!

6. Tips on Teaching
Mr. Hand, Ben Stein, and Teaching in '80s Movies

The 1980s was a difficult decade for teachers, both in reality and in cinema. During the 1980 presidential election, Ronald Reagan derided the newly formed Department of Education as "President Carter's new bureaucratic boondoggle," and threatened to dismantle it if elected. While Reagan was unable to abolish the Department of Education, he did cut the federal education budget in half during his eight years as president. In 1983, Reagan's National Commission on Excellence published a report titled *A Nation at Risk* that was very critical of the state of public education in America. Reagan and his Secretary of Education William Bennett repeatedly vilified teachers' unions as a major reason for the decline of public education. Home schooling and private schools became more popular options in the 1980s. To top it off, America's first teacher-astronaut, Christa McAuliffe, was killed when the space shuttle *Challenger* exploded shortly after takeoff in 1986.

Teachers are treated roughly in '80s movies as well. There are very few three-dimensional educators in the decade's movies. Teachers tend to be portrayed as hopelessly clueless, staggeringly incompetent, mind-numbingly boring, or just downright mean. Perhaps this should be expected in the decade of the teen movie. Nothing defines the teenage years more than a healthy contempt for parents, teachers, and other authority figures. John Hughes, the undisputed master of the teen genre, certainly understood this. His movies are filled with teachers who fit these negative stereotypes. Ask anyone to reference an educator from an '80s movie, and most likely you'll hear one from a John Hughes movie. Who could forget Ben Stein, in *Ferris Bueller's Day Off* (1986), repeatedly reading "Bueller" and getting no response? Or soliciting responses from his students with "Anyone? Anyone?" Then there are two principals from John Hughes movies: the buffoonish Ed Rooney (Jeffrey Jones) from *Ferris Bueller's Day Off*, maniacally driven to catch Ferris skipping school, and Richard Vernon (Paul Gleason)

from *The Breakfast Club* (1985), trying to intimidate the Saturday detention students into toeing the line.

There are five movies from the 1980s that challenge these stereotypes by portraying more complex, flesh-and-blood educators. None of them are perfect, but then who is? The teachers (both good and bad) in these five movies offer us a great deal of advice on teaching—what has been labeled the noblest profession.

Dead Poets Society (1989) takes us to the prestigious Welton Academy, a private boys school whose four pillars are "tradition, honor, discipline, excellence." Entry into an Ivy League college is the goal of the students, their rigorous teachers, and their determined parents. Enter John Keating (Robin Williams), the new English teacher, who challenges the boys to think for themselves and "seize the day."

The students in *Summer School* (1987) are about as far away from the ambitious preps of the Welton Academy as one can imagine. They're a motley crew of California teens whose minds are on everything *but* the remedial English class they're forced to take over the summer. Their teacher, Freddy Shoop (Mark Harmon), isn't much better. He is a gym teacher, forced into teaching the summer course by the assistant principal who threatens to derail Shoop's efforts to secure tenure. Shoop's attitude changes though, as he gets to know the students and attempts to woo another teacher.

Stand and Deliver (1988) is based on the story of real-life Los Angeles mathematics teacher Jaime Escalante (Edward James Olmos), who attempts to reach his poor, predominantly Latino students. Escalante pushes them to achieve beyond their own—or the school's—expectations.

Fast Times at Ridgemont High (1982) features Mr. Hand (Ray Walston), a no-nonsense history teacher. Mr. Hand rules his class with an iron hand, despite the disruptive presence of surfer dude Jeff Spicoli (Sean Penn).

Teachers (1984) centers on jaded teacher Alex Jurel (Nick Nolte). Alex works in an inner-city school that is being sued by a former student who graduated without being able to read or write. A current wayward student and the return of one of his old students reinvigorates Alex's love of teaching and pushes him to challenge the school's administration.

Pizza Delivery and Byron on the Beach: Humor as an Effective Classroom Tool

A good sense of humor can be a very effective teaching tool. Teachers are authority figures, and there is a natural tension between teacher and pupil. Humor is one way to ease that tension, and can foster a more comfortable learning environment for students.

Robin Williams began his career as a stand-up comedian, so it seems natural that his character in *Dead Poets Society*, English teacher John Keating, uses humor in the classroom. The boys he teaches at the stuffy Welton Academy are not accustomed to humor from adults—neither from their over-serious parents nor from the teachers at the school, who rely on discipline, rigor, and tradition. Keating tries to loosen his students up, de-institutionalize them, and teach them to think for themselves. One way to do that is to get them to find the humor in themselves, their situation, and the school. During his first class, Keating uses self-deprecating humor to set the boys at ease. He tells them that when he was their age, he was the intellectual equivalent of a 98-pound weakling. "I would go to the beach, and people would kick copies of Byron in my face." After getting to know the boys better, Keating gently pokes fun at their tendency to conform, and uses absurdity to pull them out of the shells that their parents and their school have been carefully constructing.

In *Stand and Deliver*, Jaime Escalante uses humor to defuse a potentially volatile situation in the classroom. When a student (Lou Diamond Phillips) gives Escalante the finger, he turns it around on the hostile student by showing him what he can do with his fingers, a trick to learn how to multiply by nine. The student rolls his eyes, but it's clear who's in charge of this classroom. Later, a gang member is posturing, trying to hijack the class. Escalante uses the gang references as a source of humor to recapture control of the class. "I am *El Ciclon*, a one-man gang from Bolivia. Don't give me no gas. I'll jump on your face, tattoo your chromosomes." The class laughs, and control once again returns to the teacher. Humor also becomes a way for Escalante to help motivate his students. At one point in the movie, he jokes to his students, "the Japanese pay me to do this. They're tired of

making everything. They want you to pull your own weight." Substitute Chinese for Japanese, and this statement would be just as valid today.

Mr. Hand from *Fast Times at Ridgemont High* is definitely *not* a happy-go-lucky teacher who employs humor as a regular weapon in his classroom. He is not, however, humorless. Mr. Hand has his moments of subtle humor. In one of the movie's more memorable scenes, the slacker Spicoli orders a double cheese and sausage pizza to be delivered to Mr. Hand's classroom. Mr. Hand reminds Spicoli of his classroom no-food policy, to which Spicoli responds, "I've been thinking about this, Mr. Hand. If I'm here, and you're here, doesn't that make it *our* time? Certainly there's nothing wrong with a little feast on our time." Mr. Hand turns the disruptive situation around by confiscating the pizza and handing out slices to other members of the class. Then he stands in front of a disappointed Spicoli, gleefully munching on the last slice of Spicoli's pizza. You can almost hear Mr. Hand thinking to himself: "take that, you little bastard".

Spicoli shows up late for Mr. Hand's class on another occasion. Mr. Hand asks the reason for the truancy, to which Spicoli replies, "I don't know." Mr. Hand writes the phrase on the board, sarcastically commenting, "I like that…Mr. Hand, will I pass this class? Gee, Mr. Spicoli, I don't know." The sarcasm is lost on Spicoli, who smiles and says "all right" when Mr. Hand tells him he's going to leave the phrase on the board for everyone to see, giving him full credit. Mr. Hand's own unique sense of humor is carried to its perverse conclusion when Mr. Hand shows up at Spicoli's house on the night of the graduation dance to "square the account" for all the time Spicoli has wasted in his class. Spicoli asks him if he has a guy like him in class every year. Mr. Hand gets in one last dig: "You'll find out next year, Jeff."

Despite their demanding and infuriating jobs, humor also helps keep teachers sane outside the classroom. In the movie *Teachers*, the school superintendent (Lee Grant) at one point berates assistant principal Roger Rubell (Judd Hirsch). "Your school psychologist has flipped out in the middle of your goddamned office. And I get here and I find out there's been a stabbing. And if that's not enough, one of your kids tries to eat one of your goddamned teachers. Mr. Rubell, what the hell do you call

that?" Rubell simply replies, "Monday." Later in the movie, Rubell and Alex Jurel (Nick Nolte) are out drinking, complaining about the situation at the school.

> **Rubell**: "Hey, we do good. Lots of those kids learn. We are not the bad guys. We do good…with what we've got."
> **Jurel**: "What we've got sucks."
> **Rubell**: (laughing) "I know…if it wasn't for us, anarchy! Or worse, a baby boom. What do you think those little monsters would be doing if they weren't in school? Fucking!"
> **Jurel**: "You mean I'm a contraceptive?"
> **Rubell**: "Yes, and one of the best."
> **Jurel**: (laughing now, too) "I'm a fucking rubber."

An E for Effort

Most students, parents, and even some educators are obsessed with grades. Students' grades have become the be-all & end-all in many schools, and the perfect grade point average has become an obsession. While there is nothing wrong with wanting to achieve at a high level, grades can stand in the way of a student's education. Students are unique individuals, and measuring everyone by the same yardstick can be misleading, and in some cases even harmful. Scoring well on a test doesn't necessarily mean a student understands the material, or that they how to apply that knowledge in the real world.

Growing numbers of educators have advocated moving away from a traditional test-based grading system in favor of a truer assessment of a student's efforts to advance his or her learning. While that might not be practical in our increasingly budget-challenged public schools, some measure of effort should be included in student assessments.

Many of John Keating's lessons in *Dead Poets Society* are non-traditional and focus on participation. His lessons include standing atop desks, reciting poetry while kicking a soccer ball, and walking in the courtyard. Keating is more concerned with his

students' efforts to think for themselves and find their own voice than he is with rote learning and test-taking.

In *Teachers*, Alex Jurel discovers that one student, Eddie (Ralph Macchio) can't read, despite having passed a remedial reading class. Jurel schedules Eddie to retake the course, despite the objections of Eddie's parents and the school administration. To Jurel, the grade Eddie received is irrelevant if he is functionally illiterate.

The students in *Summer School* are attending the remedial English class because they failed the reading skills exam during the school year. At the end of the summer course, most of the students still fail the exam, but show a 125% increase in their scores. Their parents come in to laud Shoop for helping their children embrace learning for the first time, which prompts the principal to grant Shoop tenure.

Mr. Hand's trip to Spicoli's house to "square our account" in *Fast Times at Ridgemont High* is all about making a point. Mr. Hand can cook the books to make Spicoli pass or fail, but he wants to make sure that Spicoli understands the material. The camera pans around the surfing pictures and nude women plastered all over Spicoli's wall as he states, "So what Jefferson was saying was 'Hey, you know, we left this England place 'cause it was bogus, so if we don't get some cool rules ourselves, pronto, we'll just be bogus too, yay?" It's not exactly an answer worthy of an A on an exam, but Mr. Hand is more interested in effort and understanding from Spicoli than proper academic form. Mr. Hand smiles and says, "Well, I think I've made my point with you" before shaking his head at Spicoli's centerfold wall decorations and leaving.

Crossing the Delaware: Keeping It Interesting

Ben Stein, an economist and speechwriter, became an unexpected star after his small role as an economics teacher in *Ferris Bueller's Day Off*. While calling roll, Stein repeatedly states, "Bueller…Bueller" to an empty seat, unaware that Ferris (Matthew Broderick) is skipping school. Then he memorably drones on and on in a nasal monotone about voodoo economics and the Hawley-Smoot Tariff while students glaze over, drool, and fall asleep.

While Ben Stein might be the most memorable, he was by no means the only boring cinematic educator from the 1980s. In the same movie, an English teacher similarly bores Ferris' classmates with his halting teaching style. "In…what…way…" He's only three words in, and he's already lost us. In *Dead Poets Society*, the first teachers we see in action are a boring chemistry teacher loading on work on the first day of school, and a Latin teacher having the students repeat verb derivations back to him. Even the teachers look bored with this; these private school teachers have fallen into a rut of tradition and routine. Perhaps the epitome of the boring teacher can be found in *Teachers*' Mr. Stiles. Stiles is known to everyone as "Ditto" because all he does is run off copies of worksheets for his students to complete silently while he reads his newspaper and dozes at his desk. Ditto brags to Alex Jurel that he has "received three consecutive teaching awards for the most orderly class." Alex tells him, "Your class is boring. Your students don't learn a thing. If it weren't for tenure, you'd be selling vacuum cleaners." Ditto's class is so regimented and uninteresting that no one notices for several periods when he dies at his desk of a heart attack during class.

Robin Bishop (Kirstie Alley) does double duty in *Summer School* as Shoop's love interest and his teaching muse. She tells Shoop that "the best teachers are the teachers who entertain while they teach." The Hawaiian-shirted Shoop has the entertainment angle down; it's the teaching he needs to work on.

Whether you like his brand of humor or not, Robin Williams is certainly interesting. His John Keating character in *Dead Poets Society* employs a variety of techniques to spur student interest. At one point, Keating has his students stand atop their desks to remind them to consider things from a different perspective. Keating has his students read poetic verses while kicking a soccer ball and listening to classical music. Most memorably, Keating instructs the students to rip the entire introduction out of their textbooks. The offending piece, J. Evans Pritchard's essay "Understanding Poetry," instructs readers how to quantitatively measure the quality of an essay. "We're not laying pipe, we're reading poetry," Keating chastises as he tells his students to rip away. After that exercise, he certainly has gained his students' interest.

In *Teachers*, the most interesting educator at JFK High is a substitute who is not a teacher at all. Herbert Gower (Richard Mulligan) is an outpatient from a mental institution who mistakenly answers a telephone call for a substitute teacher in a neighboring apartment. Gower brings a different perspective to his role as American history teacher, eschewing the textbook in favor of a more hands-on, participatory approach. Gower dresses in character as General Custer to pepper students with questions about the general's strategy. Later we see Gower dressed as George Washington, surrounded by students in desks pretending to row. "What river are we crossing?" he asks the students. One student replies "the Potomac," and is quickly corrected by the other students, who shout out "the Delaware!" Granted, it's not a very advanced question, but the students are interested, engaged, and learning.

All We Need is *Ganas*: Setting Expectations in the Classroom

In *Stand and Deliver*, Jaime Escalante (Edward James Olmos) attends a math department meeting. The principal tells the department members that he is worried the inner city East Los Angeles school (James A. Garfield High) might lose its accreditation because of low test scores. The chair of the math department complains that they don't have much to work with. "You can't teach logarithms to illiterates. There's not a teacher in this room who's not doing everything he possibly can." Escalante surprises everyone by interjecting, "I'm not. I could teach more. Students will rise to the level of expectations." Escalante's point is that the education of the lower-level students has become a self-fulfilling prophecy. No one expects much of them, so they don't get much. Escalante believes that "all we need is *ganas* (desire)." If students have the desire, they can achieve the high expectations that the teacher sets for them.

Escalante tells his students that "math is the great equalizer," and that learning math is the ticket to a good job and a brighter future. He wants his students to take calculus, and to complete the prerequisites with him during the summer. Escalante holds them to a high standard. "When you get a job, the person

giving you that job won't want to hear your problems, and neither do I." He's not being unsympathetic; he's being realistic. And soon, his students develop higher standards for themselves.

Establishing expectations early in a course is fundamental to effective class management. Mr. Hand from *Fast Times at Ridgemont High* is a veteran teacher, and wastes no time in setting the tone for his U.S. history course. The first day, the bell rings, Mr. Hand locks the door, underlines his name on the chalkboard, and launches into his introductory spiel. "Aloha. My name is Mr. Hand. I have but one question. Can you attend my class? It is for your own good, and if you can't make it, I can make you (removing a student's hat). We have a 20-question quiz every Friday. Your grade is the average of all your quizzes, plus the midterm and the final, which counts for one-third (taking a cigarette out of a student's mouth, breaking it, and smelling it). Also, there will be no eating (taking away a student's candy bar). E-A-T-I-N-G. No eating in this class. You'll get used to doing your own business on your own time. That's one demand I make. Just like you wouldn't want me to come to your house some evening and discuss U.S. history on *your* time, understand?"

In one fell swoop, Mr. Hand has set forth a set of criteria for the course: attendance policy, grading policy, and behavioral expectations. He has also established the concept that since the time between the bells is *his* time, *his* rules will apply.

Life after the Fire Drill: Caring about Students' Lives

Students relate better to teachers who they know care about them and their lives. If students know their teacher cares, they are far more likely to invest themselves in the class. On the flip side, students can easily see right through educators whose primary interest is *not* the development of the student—Ditto and the *Dead Poets Society* teachers who just want obedient pupils to regurgitate memorized information, the obsessed Principal Rooney who can't stand to see Ferris Bueller getting away with any day-off shenanigans, or the bullying Principal Vernon who makes it abundantly clear he has no respect for *The Breakfast Club*'s detention students or their hopes, dreams, or futures.

Freddy Shoop has no desire to teach *Summer School*, but grows to care for the kids who want to be there even less than he does. In order to get them to work, Shoop agrees to help each of them out with something that's important to them. It's through these "favors"—helping one student learn to drive, another train for football practice, accompanying an unwed mother in the course to Lamaze class—that Shoop develops a close bond with his students. They begin to trust him, and are more willing to exert the necessary effort in the classroom as a result.

Mr. Hand shows up at Spicoli's house near the end of *Fast Times at Ridgemont High* to make a point—but there's more to it than that. A less caring teacher certainly wouldn't have gone out of his or her way to reach a student in this manner. Most teachers would have written off Spicoli as a lost cause early in the semester, but despite Spicoli's antics and disruptions, Mr. Hand is still hopeful that he can reach this surfer dude who has "been stoned since the third grade."

In *Dead Poets Society*, John Keating is more concerned with developing his students' individualities and voices than he is about teaching the standard curriculum. The whole point of the titular secret society—the Dead Poets—is to "suck the marrow out of life." Keating brings Todd (Ethan Hawke) out of his shell by helping him overcome his fears about opening up and expressing himself. Keating encourages Neil (Robert Sean Leonard) to confront his father and act in the play. "You are not an indentured servant. Prove to him through your conviction." Keating also disputes the school's headmaster about the purpose of education. "I thought the idea of education was to learn to think for yourself." The headmaster replies, "At these boys' age, not on your life." We see what Keating, and the boys, are up against. We also see why they are so receptive to Keating, a teacher who cares more about who they are than what they can be molded into.

When we first meet Alex Jurel of *Teachers*, he's a washed-up shell of what was once an idealistic, inspiring teacher. But the years, the apathy, and the bureaucratic nonsense have drained him of his own inspiration. A lawsuit against the school and an encounter with a troubled student named Eddie (Ralph Macchio) reignite his passion for teaching. Jurel barrels through red tape to get Eddie the reading help he desperately needs. In showing that he

cares about Eddie and his future, Jurel inspires Eddie to show up for class and put forth an effort. The movie's final scenes play out during a fire drill at the school. Jurel confronts the administrators about their attempts to fire him. Rubell snarkily quips that half of the students won't even be back after the fire drill. Jurel replies, "Yes, but half of them will." In this statement lies the essence of the movie: that teachers and the educational system should do their best to educate and care for every student who is willing to learn.

Radiators and Free Sunglasses: Relating Education to the Real World

"This stuff don't make no sense unless you show us how it works in the real world," one student complains to Jaime Escalante in *Stand and Deliver*. Escalante responds by taking his students on a field trip to a computer corporation where math is being applied in the real world every day. Escalante's pitch to his students as to why they should work hard to learn math is based on its real world utility. He tells his predominantly Mexican-American students that their ancestors, the Maya, were the first to use the zero, a concept unknown to the Greeks or Romans. "You *burros* have math in your blood." When one student tells Escalante he has been offered a job as a mechanic, and thinks he has to sacrifice school because he can't turn down the money, Escalante pointedly asks him, "Wouldn't you rather be designing these things [cars] than repairing them? All you see is the turn, not the road ahead." Escalante's point is made; math is the ticket to a better, more rewarding life. A female student has a telling exchange with her mother, who is not supportive of her studies. "Boys don't like it if you're too smart," she tells her daughter. The girl replies, "I'm doing this so I don't have to depend on some guy for the rest of my life." For her, math is empowering; it means independence in the real world.

Mr. Vargas is the biology teacher in *Fast Times at Ridgemont High*. Every year he takes his students to the local hospital to show them the "circle of life" in the real world. This includes a trip to the hospital's nursery and—the highlight of the field trip—a visit to the morgue. Vargas reaches into a cadaver and pulls out organs to show the kids up close. The field trip is so

popular that even the learning-averse Spicoli tags along, despite not even being in the class.

Sometimes, a teacher's toolkit should include an actual toolkit. In *Teachers*, Jurel spends one class period teaching his social studies students radiator repair on their classroom's faulty radiator. It is a move borne out of necessity (and poor school resources), but it's an opportunity for Jurel to teach his students that "learning is limitless." Jurel also deviates from the curriculum when his students ask him about the lawsuit against the school. Jurel takes advantage of the teachable moment by challenging his students to tell him what they think is wrong with the school, using whatever means they like. Eddie does a photo exposé, which includes shots of a student being busted for drugs and Ditto sleeping behind his paper during class. The assignment sparks Eddie's interest because it is relevant and affects *his* world.

Keating's first lesson in *Dead Poets Society* involves a short trip to the school's trophy case, which contains photographs of students from the school's long history. Keating has the class take a long look at the boys in the photos. "These boys are now fertilizing daffodils," Keating tells them. Nothing grounds us in the real world as thoroughly as the knowledge of our own mortality. Keating goes on to challenge the boys to "seize the day" (*carpe diem*), to "gather ye rosebuds while ye may." Keating tells them that their (or their parents') real world goals (medicine, law, engineering, etc.) are necessary to sustain life, but that beauty, love, and the like are worth staying alive *for*.

In *Summer School*, Shoop motivates his students to practice their writing by relating it to the real world. He has the students compose a letter to someone they believe has ripped them off. One student, Chainsaw (don't call him Francis), writes a complaint letter to a company whose sunglasses broke on him. In return, the company sends a box of complimentary sunglasses for the entire class—real world results from educational application.

Contributing a Verse to the Powerful Play: Inspiring Students

A good teacher can inspire students to believe in themselves and their ability to achieve their goals, whatever those goals may be. To inspire young minds is the greatest gift that any teacher can offer humanity.

Results are not always dramatic. Only a handful of Freddy Shoop's *Summer School* students pass the reading skills test they re-take at the end of the summer. Sure, their scores are higher than before, but what's *really* important is that Shoop has inspired them to study hard and to take their education seriously for the first time in their lives. Chainsaw and the others may not go on to become U.S. senators or to cure cancer, but opportunities are certainly greater for motivated individuals than for apathetic ones.

In *Stand and Deliver*, Jaime Escalante inspires his underprivileged students to defy society's expectations by achieving on the AP calculus exam. They are disadvantaged, but Escalante sells them on the notion that "math is the great equalizer." Escalante motivates them in the beginning, but they become self-motivated once they are inspired. Their results on the AP calculus exam are so impressive and unexpected, that the testing service suspects that they cheated, and forces them to re-take the test. The students do so, confirming their impressive earlier results. Many of Escalante's students go on to attend and graduate college, a goal they would never even have considered without Escalante's inspiration.

John Keating's students at the Welton Academy are far from disadvantaged, but privilege carries with it a different set of obstacles. Neil's father epitomizes the rigid expectations and parental pressures faced by the boys in *Dead Poets Society*. The challenge for them is not so much one of achievement, but of becoming their own person. "No matter what anybody tells you, words and ideas *can* change the world," Keating tells his students, anticipating the attitudes of their parents, who would have them concentrate on "more serious" subjects like science and math. "We read and write poetry because we are members of the human race, and the human race is filled with passion." Keating wants the boys to find their own passion and embrace it. He inspires them to

action with words from Walt Whitman: "The powerful play goes on, and you may contribute a verse." Keating's class, as well as the Dead Poets Society the boys form, inspire them to chip away at the walls that box them in. Knox pursues the girl of his dreams with reckless abandon. Charlie insists on being called "Nuwanda," and openly questions the school's boys-only admission policy. Neil defies his overbearing father by acting in a stage production of *A Midsummer Night's Dream*. Shy, fearful Todd stands atop his desk at the end and says "Captain, my Captain" to pay honor to Keating, who has been fired as the scapegoat after Neil's tragic suicide.

Inspiration can come in many forms. No two students are exactly the same. Some need a reason to care, some need an adult to believe in them, some need a gentle nudge in the right direction. Effective teachers determine what a student needs to succeed and try to provide the proper inspiration.

Teaching is a challenging profession. Some days you feel like Ben Stein, droning "Bueller…Bueller" to glazed-over, drooling teenagers. Some days you feel like Mr. Hand, returning awful papers, and you want to repeat his line, "What are you people… on dope?" But every once in a while, the connections spark and you can see a young mind igniting. You'll probably never have a group of students stand atop their desks to stirring music and pay tribute to you by saying "Captain, my Captain", but those little victories are what make teaching worthwhile.

There are far more Ben Steins and Dittos in 1980s movies than there are Jaime Escalantes and John Keatings. However, the few positive examples of educators in '80s movies offer some advice on effective teaching. A good sense of humor can put students at ease and help create a positive learning environment. Teachers should focus on rewarding effort rather than judging performance strictly on grades. An interesting approach to the material will help keep students engaged in the classroom. Believe in your students and set challenging expectations for them. If you express interest in students' lives and show them you care, they are more likely to put forth effort in your class. Relevance to their lives and real-world examples stimulate greater interest among students. Lastly, be inspiring! Help your students contribute a verse to the powerful play.

7. How to Survive an '80s Horror Movie Part II: Unhappy Campers

Welcome back, folks! It's Jason Voorhees again. This is part two of my advice on how to survive an '80s horror movie. This section provides advice on why camp counselor might not be the best career choice, why you should look both ways (and not just when you cross the street), and the dangers of false leads and red herrings.

Don't Take a Summer Job as a Camp Counselor

Finding decent employment when you're young and inexperienced can be difficult. But no matter how tempting a summer job as a camp counselor sounds, don't do it! Sure, you might get a fun camp like Camp North Star (*Meatballs*, 1979) where all the counselors get along, and Bill Murray is there to cheer you up. But you might also end up at Camp Arawak (*Sleepaway Camp*), Camp Stonewater (*The Burning*), or Camp Crystal Lake (*Friday the 13th*), where a serial killer anxiously awaits your arrival. So why take the chance? Get a newspaper route, or take a job landscaping, or flip burgers at McDonald's. Those jobs might not be sexy, but they're safe.

In *Friday the 13th, Part 2* (1981), head counselor Paul (John Furey) tells the other counselors that "being a counselor isn't the gravy summer job everybody thinks it is." Paul's got that right! Not only do you have to spend the summer battling the elements and babysitting a bunch of bratty children, you have to worry about being stalked by a rampaging serial killer.

Former summer camp caretaker Cropsy (Lou David) is horribly burned and disfigured by a prank gone awry (*The Burning*). Years later, he's back to stalk a new group of campers. With his trusty gardening shears, Cropsy hunts and dispatches most of a group of camp counselors on a rafting trip.

My mother Pamela Voorhees (Betsy Palmer)—may she rest in peace—was *very* protective of me (*Friday the 13th*). When I (allegedly) drowned in Crystal Lake, Mom blamed the camp

counselors, who were too busy fornicating and carrying on to properly watch me. Twenty years later, Mom found out the camp was re-opening under new ownership and took out her anger on the new group of camp counselors. Mom killed six counselors and the new owner/operator.

In short, you don't want a summer job as a camp counselor. It's too risky. Take a safer job in a less remote area. You'll probably live longer.

When the Coast Looks Clear, Look Again

Nothing is more terrifying than believing the danger has passed and you're out of trouble than finding out you're wrong—dead wrong. So stay alert! Don't let your defenses down. You may not be out of the woods yet. When the coast looks clear, look again.

In *Friday the 13th*, beleaguered Alice (Adrienne King) is tormented by a killer at Camp Crystal Lake. She has seen her friends picked off one by one. You can understand Alice's relief when a jeep pulls up and the matronly Pamela Voorhees gets out. Alice doesn't know yet—but she soon will—that Mrs. Voorhees (my mom) is actually the killer!

If your front door doesn't have a peephole, you really should invest in one. It's good to know *exactly* what's on the other side of the door. When the doorbell rings in *Slumber Party Massacre* (1982), the girls think it's the pizza they ordered. Jeff asks through the door, "What's the damage?" The "pizza guy" answers, "Six, so far." They open the door and the pizza delivery guy drops dead with the killer right behind him. He's in the house—all for the want of a peephole.

In *Motel Hell* (1980), accident victims on a rural road are relieved when kindly Farmer Vincent (Rory Calhoun) shows up to help them out. It turns out though that ol' Vince is the one who set the traps that caused their accident in the first place. And on top of that, he and his creepy sister Ida (Nancy Parsons) are using these "accidents" to harvest human ingredients for their tasty smoked meats.

Four pledges are forced to spend the night in a haunted mansion in *Hell Night* (1981) and are stalked by a killer. At one

point, Seth (Vincent Van Patten) believes he has shot and killed the killer. As he's telling the other what he's done, the killer grabs Seth and finishes him off—a grisly lesson not to count your chickens before they hatch.

Someone is stalking members of the Midvale High track team in *Graduation Day* (1981). The team's pole vaulter decides to relieve some stress by practicing his pole vault. Unfortunately for him, he assumes the coast is clear and neglects to notice the spikes that the killer has placed in the vaulting pit. Ouch!

As bodies start piling up in *The Burning* (1981), some of the teenagers decide to raft back to Camp Stonewater for help. They are relieved when they see some of their buddies lounging in a canoe. It turns out the kids are not lounging but dead, and the killer pops up to dispatch all four of them as well.

In *Prom Night* (1980), Wendy (Anne-Marie Martin) is chased by the killer through her school. She hides in a storage closet and peeps out the small window to make sure the coast is clear. A dead body hidden in the closet freaks Wendy out and she runs out of the closet—directly into the killer's axe.

Drivers are taught to look left, right, and then left again before entering an intersection. You should heed the same advice if you find yourself in an '80s horror movie. Don't assume the coast is clear after checking it once. Check again.

Don't be Distracted by Red Herrings

A red herring is a clue or a lead that is intentionally misleading or which distracts from the reality of the situation. Red herrings are common plot devices in crime stories, mysteries, and horror movies. Readers and viewers are presented with characters who would appear to be guilty, only to distract from the real culprit. Keep your eyes on the prize; don't be distracted by red herrings. It could be a dangerous mistake.

Creepy next-door neighbor Mr. Constant (Rigg Kennedy) is a red herring in *The Slumber Party Massacre* (1982), lurking about while the girls have their party. In one scene, he surprises a girl outside. He's holding a cleaver, which he's using to kill snails that he claims are wreaking havoc on his garden. Alas, he's not the killer, as we find out when he becomes the third victim.

Crazy Ralph (Walt Gorney) creeps everyone out with his apocalyptic warnings about Camp Crystal Lake in *Friday the 13th* (1980). "It's got a death curse!" he emphatically warns Annie (Robbi Morgan). Crazy Ralph even shows up at camp, hiding in the pantry and scaring Alice (Adrienne King): "You're doomed if you stay here!" Crazy Ralph emerges from the first movie unscathed, but I clean up loose ends in the second movie, making Alice and Crazy Ralph my first two victims.

Though Principal Hammond (Leslie Nielsen) assures the girls that school custodian Mr. Sykes (Robert Silverman) has had a thorough background check, he still creeps everyone out in *Prom Night* (1980). Sykes is lurking around the school "fixing" things and watching the girls. Though he may not be suited to employment at a high school, Sykes is not the killer, as we discover at the rather bloody prom.

The Prowler (1981) does its best to distract viewers from the real killer in vintage World War II Army fatigues stalking people on the night of the graduation dance. We're offered Old Man Chatham (Lawrence Tierney), who watches co-eds through his mansion window and blocked graduation dances for years after his daughter and a young boy were killed after one. We also have creepy convenience store employee Otto (Bill Hugh Collins), who keeps showing up in the vicinity of dead bodies. Neither is the prowler, though.

Graduation Day (1981) is filled with unlikable characters any of which you suspect could be the killer. Foremost among them is imperious and abusive Coach Michaels (Christopher George). At one point, he tells gymnast Sally (Denise Cheshire) to "get her little ass up on those bars and get to work." Coach Michaels is bitter about being fired as track coach after a female athlete died on the track, perhaps from being overworked. Another red herring is the dead girl's older sister Anne (Patch Mackenzie), home from the Navy for what would have been her sister's graduation day. Anne threatens Coach Michaels and hangs around the school an awful lot. But again, neither is the killer.

Magicians, like clowns and mimes, are a pretty eerie bunch. What better occupation for a red herring? And what better magician to serve as a red herring than real-life conjurer David Copperfield? Copperfield plays Ken the Magician, the

entertainment for the New Year's Eve party aboard the *Terror Train* (1980). Ken performs his magic, hits on Alana (Jamie Lee Curtis), and lurks around the train between shows. We discover he's not the killer when Alana finds him in one of his magician's boxes with swords through his body.

Weird neighbors, town crazies, a-hole coaches, magicians—we really *want* to believe these guys are the killers, but they're not. If it seems to be too good to be true, it's probably a lie. Such is the case with these red herrings. Stay focused. If you're distracted by a red herring, you just might fall victim to the real killer.

Keep an eye peeled for the third installment—coming soon!

8. How to Deal with Life after College

"You can't always get what you want.
But if you try, sometimes you get what you need."
- The Rolling Stones

For many, college is a magical time full of big dreams, amazing opportunities, and seemingly limitless possibilities—and sex, drugs, and rock & roll. One's only real job at college is to pass the courses that one is taking. There are few serious worries and plenty of perks.

Life after college, however, is far more challenging. One has to find (and keep) a real job. One has to start paying for more—and more expensive—items. Romantic relationships become trickier and involve more commitment. And this difficult period of transition comes at a time when your closest college friends are drifting off in different directions. Is it any wonder, then, that people struggle so mightily with the transition from college to the "real" world?

Two movies from the 1980s explore the struggles of life after college in great depth. Both films focus on groups of seven close college friends. *St. Elmo's Fire* (1985) centers on seven recent Georgetown University graduates who still live, work, and play in the area around the college. *The Big Chill* (1983) chronicles a weekend in the lives of seven 30-something University of Michigan alumni who reunite at the funeral of one of their close college friends. These two movies have a great deal to say about life after college, how to (and how *not* to) deal with it, and what the future may hold.

St. Elmo's Fire stars a number of members of the so-called Brat Pack, a group of young Hollywood actors from the 1980s. Kirby Keger (Emilio Estevez) runs into a crush from college, Dale Biberman (Andie MacDowell) and spends the rest of the movie chasing after his ideal woman. Billy Hicks (Rob Lowe), the screw-up of the group, struggles to keep a job and find direction in his life. He laments that "in everyday life, there's just no way to be out of hand" like he had been in college. Jules (Demi Moore) pursues all the excesses the '80s have to offer, but isn't quite as fabulous as she'd like everyone to think. Kevin Dolenz (Andrew McCarthy) is

a cynical writer who is hiding a burning passion for his best friend's girlfriend, Leslie. Leslie Hunter (Ally Sheedy) deals with pressure from her boyfriend Alec to get married while trying to figure out who she is. Alec Newbary (Judd Nelson) is a social climber with eyes on a political career and on making Leslie his wife. Wendy Beamish (Mare Winningham) is the daughter of a wealthy businessman who wants her to marry and join the family business, but she has plans of her own.

The Big Chill begins with seven friends getting ready, intercut with shots of the mortician preparing the body of their friend Alex for his funeral. Alex (Kevin Costner) had a few flashback scenes in the original script, but his parts ended up on the cutting room floor. Sam Weber (Tom Berenger) is a big Hollywood actor, starring as the title character on the successful private eye show *J.T. Lancer*. However, his personal life is a mess. Sarah Cooper (Glenn Close) is a doctor with a loving husband and two kids. She's having a lot of trouble dealing with Alex's death, and we find out that she and Alex had an affair a few years ago. Harold Cooper (Kevin Kline) is Sarah's husband and runs a successful company that's on the verge of being bought out by a huge conglomerate—with a nice payday for Harold. Karen Bowens (JoBeth Williams) is having second thoughts about the life she has chosen as a stay-at-home mother. Michael Gold (Jeff Goldblum) writes for a tabloid-esque magazine, although he is considering opening a club for which he is soliciting investors. Meg Jones (Mary Kay Place) toils as a corporate lawyer, yet she longs to have a child. Nick Carlton (William Hurt) is a cynic who has dropped out of the rat race and become a drug dealer. Chloe (Meg Tilly) is the girlfriend left behind by Alex's suicide.

Bread and Revolutionaries: Entering the Work Force

O.K., college is over. Now what? Well, for starters, it's time to get a job—hopefully one that is personally rewarding and pays well. Alas, it's not quite that easy. A degree from a good college is no longer a guarantee of a successful, fulfilling professional career. Despite having graduated from two of our

nation's finest institutions of higher learning, our 14 protagonists are struggling with life in the working world.

In *St. Elmo's Fire*, Kirby (Emilio Estevez) is waiting tables at the gang's old hangout, and can't decide whether to go to law school or not. Kirby even considers going to medical school to impress the woman of his dreams, Dr. Dale Biberman (Andie MacDowell). Wendy (Mare Winningham) is employed as a social worker, but is struggling with the poor attitudes of her clientele and parental demands to quit her job and enter the family business. Jules (Demi Moore) discovers her office job doesn't quite pay for her extravagant lifestyle. She has a dramatic breakdown when she loses her job and most of her assets are repossessed. The group's screw-up, Billy (Rob Lowe), tells Jules, "What's the big deal here? You lost a job? I've lost 20 since graduation!"

The Big Chill characters are further away from college, and have further compromised their professional dreams. Michael (Jeff Goldblum) is a writer at a magazine that has "only one editorial rule. You can't write anything longer than anyone can read in the average crap." Michael is considering leaving the job to open up a club, for which he is soliciting investors. Meg (Mary Kay Place) started her career as an idealistic public defender, but grew sick of defending "scum." She complains, "I didn't think they'd be so *guilty*." So Meg sold out, joining a higher-paying real estate law firm, that "only rapes the land." Sam (Tom Berenger) has become a huge Hollywood TV actor, but scorns the shallow nature of the private eye show on which he stars. "It's just garbage," he tells Karen (JoBeth Williams). At one point, he says to Harold (Kevin Kline), almost regretfully, "Who'd have thought we'd both make so much bread? Two revolutionaries." Karen has forsaken her dreams of writing short stories to be a stay-at-home mother, leaving her with "a space" she can't seem to fill. Nick (William Hurt), like Billy in *St. Elmo's Fire*, is the screw-up of the group. He left his job as a radio psychologist and has drifted around, selling drugs to make ends meet.

The most professionally satisfied characters from the two movies are the ones who are doing what *they* want, rather than what society wants—or what they *think* society wants. At Georgetown, Alec (Judd Nelson) from *St. Elmo's Fire* was the president of the school's Young Democrats. Now, despite

switching political allegiances, Alec is doing precisely what he wants to do: working in Washington politics. Wendy decides to keep her job as a social worker, against her family's wishes, because it's what *she* wants. In *The Big Chill*, the only two characters who *don't* complain about their jobs are the Coopers: Harold (Kevin Kline) and Sarah (Glenn Close). Harold owns a small company (it's never mentioned, but we can assume it's the running shoe company that drops off sneakers for everyone) that is soon to be bought out by a large corporation, which will net Harold a tidy profit. Harold is the movie's most well adjusted character, firmly and happily rooted to home, job, and community. His wife Sarah is a doctor. She quietly and efficiently mends Sam's wounds when he unwisely attempts to jump into a car in the manner of his TV private eye character, J.T. Lancer. The takeaway is to do what you love, not what you think you *should* be doing. As the old adage goes, "do what you love, and you'll never work a day in your life."

Dinosaurs and Ancient Lurking Passions: Love after College

Early in *St. Elmo's Fire*, Kevin (Andrew McCarthy) the cynic and Kirby (Emilio Estevez) the romantic have a discussion about love.

> **Kevin**: Love's an illusion.
> **Kirby**: It's the only illusion that counts.
> **Kevin**: Says who?
> **Kirby**: Anyone who's ever been in love.
> **Kevin**: Love sucks.

Illusion or not, sucky or not, questions of love are in the forefront for the 20-somethings of *St. Elmo's Fire*, and are still a major concern for the 30-somethings of *The Big Chill*.

In *St. Elmo's Fire*, Alec tries to convince Leslie (Ally Sheedy) to marry him. However, Alec seems to be more interested in the *idea* of marriage, since he can't bring himself to stop cheating on Leslie with "nameless, faceless many." He tells Kevin that marriage will keep him faithful.

Kevin: The notion of two people spending their entire lives together was invented by people who were lucky to make it to 20 without being eaten by dinosaurs. Marriage is obsolete.
Alec: Dinosaurs are obsolete. Marriage is still around.

Billy, the group's wild boy, is trying to handle his roles as husband and father, neither of which he is equipped for. Jules carries on an ill-advised affair with her married boss while trying to set up Kevin with her male neighbor because she is convinced he is gay. Leslie's difficulty coping with Alec's infidelity leads her into an affair with Kevin, Alec's good friend. Even though Wendy is not involved in any tawdry affairs, she must deal with her family's expectations that she marry Howie, a nice but uninspiring young man.

The Big Chill's characters reunite for the funeral of their friend Alex. We find out that a few years earlier, Sarah had a brief affair with Alex. Alex's girlfriend Chloe (Meg Tilly) must deal not only with her boyfriend's unexpected suicide, but also with Michael's fumbling attempts to hit on her. Sam is divorced and fears that he couldn't hack marriage and fatherhood out of "boredom." Karen feels trapped in a loveless marriage to a man she married because he offered her "stability." Meg is a career woman whose dating life is going nowhere. "They're either married or gay. And if they're not gay, they've either just broken up with the most wonderful woman in the world or they've just dated a total bitch who looks just like me." The ovulating Meg has decided all she really wants is a child, and she's determined to be impregnated by one of the men during the weekend. Harold eventually "fills" that role, at Sarah's request. And then there's Nick, who is physically unable to perform since an unspecified injury in Vietnam.

Unrequited love (or lust) is another big issue in both movies. Kirby spends the better part of *St. Elmo's Fire* doggedly pursuing Dale Biberman (Andie MacDowell), his dream girl, who does not reciprocate his feelings. He follows her to a ski cabin, where his car gets stuck and he is awkwardly forced to spend the night in the cabin with Dale and her boyfriend. Wendy finally fulfills her long-held feelings by sleeping with Billy, right before

he leaves for New York City to play his saxophone. Kevin finally reveals his love for Leslie when she finds a box of pictures of her he has collected. They begin an affair, but Leslie breaks up with him because she needs time and space to figure herself out. In *The Big Chill*, Karen and Sam each believe the other is the one that got away. However, after finally sleeping together, they wake up to realize they're probably better off keeping things the way they are rather than disrupting their lives. Sarah and Alex "finally consummated this ancient lurking passion, and all it had done was put up a wall in our friendship."

In short, sex and friendship don't necessarily mix. Unrequited love is often best left unrequited. Consummating these feelings didn't benefit any of the characters or lead to a discovery of true love. For a brief passionate fling, the characters jeopardized friendships, relationship, and even their marriages. Love can be complicated, but as Kirby says, it's the only illusion that matters.

Young Republicans and Fashion: A Loss of Idealism

Over dinner one night, *The Big Chill* friends lament their lost idealism. Sarah says sadly, "I'd hate to think that it was all just *fashion*." Was their late '60s idealism just "fashion?" Did they sell out, or simply grow up?

Sam looks back on his days as a campus radical, delivering inspiring speeches at rallies. Now his TV show reaches an audience of millions, but what's the message? Karen feels she has sold herself short, and now feels stifled by her husband, her kids, and the life she's chosen. "I feel like I've never been alone in my own house," she complains. Nick started out as a radio psychologist because he wanted to help people, but grew jaded and is now cynical about everything and everyone, hiding behind drugs and a snarky sense of humor. He may not have *sold* out, but he's certainly *dropped* out. Meg gave up on her dream career as a public defender to make the big bucks, and she's so fed up with men and dating that she's looking for any option (except Michael) for a sperm donor. Michael's goals—to teach inner-city kids and to be a legitimate journalist—faded rather quickly. Harold seems to be the most comfortable trading in his college idealism for the

reality of the world. He's proud of his life, and the lucrative upcoming buyout of his company. Harold's idealism is now confined to allowing only 1960s-era rock and roll to be played in his house.

The *St. Elmo's Fire* crew are recent college graduates, and therefore should still have a firm grasp on their ideals and dreams. However, after only a few short months, we can already see some chinks in their idealistic armor. As with Meg's realizations that the clients she was defending were scum, Wendy is confronted by the reality of social work. She tries to counsel a young welfare mother regarding her options, only to be rebuffed by the woman's impatient "just give me my check." Nothing challenges idealism like the pessimistic reality of someone who has given up on her dreams. Then there's the poster boy for sellouts: Alec. Alec was the president of Georgetown's Young Democrats, but quickly abandons his convictions and starts working for a better-paying Republican. When his friends ask him about it, Alec replies that he's "moving up." None of his friends appear surprised or call him out on abandoning his beliefs.

Social or political ideals seem less important to the 1980s graduates of *St. Elmo's Fire* than to the late 1960s/early 1970s graduates of *The Big Chill*. This is largely a sign of the times. *The Big Chill* friends attended college at the height of campus radicalism, in the liberal college town of Ann Arbor, Michigan. They had plenty to protest about—civil rights, gender equality, Vietnam, Nixon. The *St. Elmo's Fire* crew attended college in the early 1980s, a period of economic recovery and relative peace and stability, at Georgetown—traditionally a much more conservative university. Thus it's not surprising that the loss of idealism is a far more prevalent theme in *The Big Chill*.

Forever Suddenly Got a Lot Shorter: Friends Drifting Apart

It is perhaps inevitable that one loses touch with friends after college. Jobs, family, and significant others often leave college friends geographically dispersed. Everyone starts to focus on their new lives, and keeping in touch with college friends

becomes less of a priority. After all, there was no Facebook in the 1980s.

It's difficult even for the *St. Elmo's Fire* gang, who are recently out of college and all still live in the same area. They have changing priorities now, and life is no longer like it was in their college days. Leslie laments, "I just wish everything could be like it used to be, all of us friends." In one scene, Kirby and Kevin walk by their old college hangout to see Alec sitting at their old table with a new group of yuppie friends. "I always thought we'd be friends forever," Kirby says sadly. "Yeah, well, forever suddenly got a lot shorter," Kevin replies.

The college friends of *The Big Chill* have had even longer to drift apart, and the effects are very evident. After all, they are attending the funeral of someone they all considered a very good friend. They spend the bulk of the movie trying to comprehend how they lost touch so much with their good friend Alex, and why things went so wrong for him that he committed suicide. Sarah begins crying at dinner, and says, "I feel I was at my best when I was with you people." Sam agrees with Sarah, and gives us further reason for the group's loss of idealism, when he says, "When I lost touch with this group, I lost touch of who I should be." Nick, the cynic of the group, disagrees. "A long time ago, we knew each other for a short period. You don't know anything about me. It was easy back then, and no one had a cushier berth than we did. It's not surprising our friendship could survive *that*. It's only out here in the world that it gets tough."

Nick has a point. College is a cloistered time, when people are thrown together and share vital experiences at a critical time in their development. When friends no longer share the same zip codes, hangouts, and experiences, they often find they no longer have the same interests and priorities. This is not necessarily a bad thing; after all, would you really want to take your kids for a play date with the kids of the crazy guy you did beer bongs with in your college dorm?

Joy to the World: There's Still Hope

Life after college presents numerous challenges—finding employment, navigating love and marriage, redefining dreams and goals, holding onto old friends while gaining new ones. It's no wonder that this period is so fraught with angst, and is such good fodder for cinematic drama. And it's the difficulty of this phase of life that is precisely *why* it's so important to hold onto true friends. Who better to console you when you're sitting in just a T-shirt in your cold, empty apartment? Or when you're mourning the tragic loss of a close friend?

Both movies end on a high note, with both groups together; they're both jaded but optimistic about the future. The *St. Elmo's Fire* crew meet at the station to see Billy off to New York City. They stop in front of their old hangout, where a younger group occupies their old table. Instead of going in, they plan to meet for brunch later at a more "adult" place. During the funeral for their friend Alex, Harold discusses the friendship of *The Big Chill* group: "Neither time nor distance breaks the bonds we feel." This enduring friendship is evident in a small part of the final scene. Nick, in lieu of a spoken apology to Sam for blowing up at him earlier, comes up behind him at the kitchen table, puts his hands on Sam's shoulders, and shakes his head. No words are spoken, but there is a great deal of shared experience in their knowing looks. *The Big Chill* closes to Three Dog Night's rendition of "Joy to the World," a positive song if ever there was one, as the friends joke with each other around the table.

There's a great scene early on in *The Big Chill* that illustrates hope. At the funeral for Alex, Karen gets up to play one of Alex's favorite songs on the organ. From the opening notes of the Rolling Stones' "You Can't Always Get What You Want," the camera pans around the church to catch the knowing smiles of Alex's friends. The smiles speak volumes about their friendship and shared experiences. It may seem like an inappropriate song to play at a funeral, but the friends get it, because it's a song that meant something to them all at an important juncture in their lives. Those smiles are also a shared understanding that Alex, like the rest of them, didn't always get what he wanted. But, they hope, if they try, they may just get what they need.

9. Tips on Home Improvement
With Bob Vila on *This Old House*

Hello everyone, and welcome to another episode of *This Old House*. I'm your host, Bob Vila. For those of you unfamiliar with our show, or who happened to stumble onto your local PBS channel by accident, let me explain how it works. *This Old House* is a home improvement show. Every week we follow a remodeling project as a homeowner attempts to restore a run-down architectural classic to its former glory. Let's say hello to this week's homeowner, Walter Fielding, Jr. [Tom Hanks, *The Money Pit* (1986)]. Walter, an entertainment lawyer, and his fiancée Anna (Shelley Long), a musician, bought this million-dollar country estate for the bargain price of $200,000. Shortly after moving in though, Walter and Anna discovered their dream home had a few nightmares in store for them. Walter, would you like to share your story with our viewers, and pass along your hard-earned tips on home renovation?

> **Walter Fielding**: Sure Bob. Thanks for having me on the show.
> **Bob Vila**: Well, you and your fiancée have a lovely home.
> **WF**: We do *now*, Bob. But I don't mind telling you it was a long, hard, painful, expensive process.
> **BV**: It typically is, Walter. You and Anna must have been very excited when a home worth in excess of one million dollars came on the market for a fraction of that price.
> **WF**: We were excited, Bob. We were probably *too* excited. We saw the potential and the reduced price tag, and we decided to take the leap.
> **BV**: You really have to take the emotions out of the equation when making these big-ticket purchases.
> **WF**: Yeah, thanks Bob. Where were you when we bought the house? The old adage is true- **if it seems too good to be true, it probably is. You need to do your research and your due diligence** before you commit to buying a house.

BV: Very true, Walter.

WF: In fact, it's a good idea to **have the home professionally inspected and assessed** before you buy. That would have informed us of a lot of the structural problems in the house that we only discovered *after* we moved in.

BV: What kind of problems, Walter?

WF: You name it, Bob, and we had to deal with it- crumbling plaster, electrical issues, a leaky roof, a faulty staircase, plumbing problems. And those are only the problems we found in the first *week*.

BV: Wow, that sounds like quite a renovation challenge, Walter. I understand you initially planned to do the renovations yourself, but soon discovered you were in over your head.

WF: *Way* over my head!

BV: So you started looking for a professional contractor to come in and do the job. Tell us about that process, Walter.

WF: Well Bob, once the bathtub fell through the bathroom and shattered on the downstairs floor, I knew I needed help. But the so-called "legitimate" contractors gave me estimates that were four times what I was willing to pay for the job. We had laid out all our savings to buy the house, and I was looking to cut corners. So I hired the Shirk Brothers (Joe Mantegna and Carmine Caridi), who were willing to do the job for less.

BV: And what lesson did you learn from your experience with the Shirks?

WF: (rolling his eyes) You get what you pay for. They took my money, ripped the place apart, and then I didn't see them for a while. My advice is to **hire reputable contractors**. If you go with a cut-rate operation, you're likely to get a cut-rate job.

BV: Yes, I'm afraid there are too many shady people working in the construction business, so you need to be very careful about who you hire. Always check their references, and if possible, talk with other

homeowners who have worked with the contractors you are considering.

WF: Absolutely. Whenever I asked Curly (Philip Bosco), the Shirks' foreman, how long something would take, his automatic response was "two weeks." But **everything takes longer and costs more money** than the original estimate. Four *months* after Curly told me two weeks, our house was still a mess and barely inhabitable.

BV: That's a common complaint among homeowners. On almost every job I've ever worked on, you have unforeseen problems that arise during the remodel—shoddy construction, mold, electrical issues. Often it simply can't be avoided.

WF: And it all means more time and more money. It can also **take a toll on a relationship**. Living in a home that's being remodeled, and constantly worrying about your financial situation, can be extremely stressful. Anna and I were at each other's throats, and very nearly broke up for good. At one point, we were screaming at one another in front of all the workers. I can tell you I wasn't proud of our behavior, Bob.

BV: You're right, Walter. Home renovation *can* be very stressful. But you can't argue with the results. You and Anna are now married, and living happily ever after in your dream home.

WF: Well Bob, as Curly told us, "**The foundation is good. If that's O.K., everything else can be fixed.**"

BV: That's the perfect note to end on. I'd like to thank homeowners Walter and Anna Fielding for inviting *This Old House* into their lovely home, and sharing their renovation story with us. Thanks also to the Shirk Brothers Construction Company for all their great work on this beautiful home.

Please join us next week when we refurbish the suburban Chicago home of the Ryan family, whose home was heavily damaged by a wild party thrown by their son Jake (*Sixteen Candles*). For *This Old House*, I'm Bob Vila. Thanks for joining us.

10. How to Deal with Bullies (Cobra Kai)

How often has this happened to you? You're hanging out on the beach, playing soccer with your friends, hitting on Elisabeth Shue, and then all of a sudden you're confronted by a gang of blonde karate students on motorcycles, who proceed to beat you up and leave you humiliated, face down in the sand. Well, you no longer have to be that 98-pound weakling who has sand kicked in his face.

The Karate Kid (1984) introduced us to Johnny Lawrence (William Zabka) and the other blonde assassins of the Cobra Kai karate dojo. The dojo is operated by intense Vietnam veteran John Kreese (Martin Kove); he's the sensai who drives his blonde warriors toward karate perfection.

> **Kreese**: Fear does not exist in this dojo, does it?
> **Cobra Kai**: No, sensai!
> **Kreese**: Pain does not exist in this dojo, does it?
> **Cobra Kai**: No, sensai!
> **Kreese**: Defeat does not exist in this dojo, does it?
> **Cobra Kai**: No, sensai!

The Cobra Kai appear invincible. Johnny is the two-time winner of the All-Valley Karate Championships. Maybe it wasn't such a good idea to hit on Ali (Elisabeth Shue) and show up on the Cobra Kai radar. But there's good news for all of us bicycle-riding nerds: the Cobra Kai can be defeated, and here's how.

Follow the Wisdom of Miyagi

Daniel Larusso (Ralph Macchio) is forced to move from New Jersey to California when his mother takes a job on the West Coast. After some bullying from the Cobra Kai boys, Daniel befriends the janitor/super of his apartment building, Mr. Miyagi (Pat Morita), who just happens to be a karate expert.

Mr. Miyagi steps in when Johnny and the Cobra Kai boys (dressed appropriately as evil skeletons) are in the process of beating up Daniel after the Halloween dance. Miyagi swoops in

and makes quick work of the five Cobra Kai attackers, prompting an amazed Daniel to ask Miyagi to teach him karate.

Miyagi's first rule is that karate should be used for defense only. This is reinforced in *Karate Kid II* (1986), where we learn that Miyagi rule number two is: first, learn rule number one. Miyagi so thoroughly believes that karate is for defense only that he refuses to train Daniel when he wants to defend his All-Valley Karate championship in *Karate Kid III* (1989). "If karate used defend honor, defend life, mean something. If karate used defend plastic metal trophy, karate no mean nothing." The majority of Miyagi's training involves defensive strategies. "Best way to avoid punch, not be there." At the karate tournament that provides the culmination of the first movie, Miyagi advises Daniel to focus on defense, and the points will come.

Mr. Miyagi constantly preaches focus to Daniel, and indeed all his lessons are very purpose-driven. Daniel's first four sessions with Miyagi involve him washing and waxing Miyagi's cars ("wax on, wax off"), sanding Miyagi's long wooden walkway, painting the fence around Miyagi's property, and painting Miyagi's house. Daniel confronts Miyagi in the belief that he is being used simply as free labor; Miyagi reveals how all the tasks mirror defensive moves in karate. Miyagi's purposeful training is also seen in *Karate Kid II*. Upon viewing someone breaking a log with a karate chop, Daniel asks Miyagi if he could do that. Miyagi replies, "Don't know. Never been attacked by tree." The message—if it doesn't specifically help your training, what use is it? Miyagi's lessons focus on simplicity. When Daniel asks Miyagi for advice right before the tournament, Miyagi replies simply, "don't get hit."

Mr. Miyagi continually refocuses Daniel throughout the *Karate Kid* trilogy. We see his importance in the third installment. Daniel begins training with the shady Terry Silver, who turns out to be an old Army buddy of Daniel's nemesis John Kreese. Daniel quickly loses his way when he leaves Miyagi's tutelage, and ends up breaking a guy's nose at a dance club. A good teacher is the key to overcoming the Cobra Kai.

Use Your Head

When Daniel expresses fears about the strength and skill of the Cobra Kai, Miyagi replies, "not matter who stronger, matter who smarter." This could well be the theme of the *Karate Kid* movies. After all, Ralph Macchio's Daniel will never be mistaken for Chuck Norris or Arnold Schwarzenegger. He *has* to use his head.

Before beginning Daniel's training, Miyagi takes Daniel into the lion's den, so to speak. They go to the Cobra Kai karate dojo, where Miyagi extracts a promise from Kreese that his Cobra Kai boys will leave Daniel alone if he agrees to enter the All-Valley Karate Tournament. This wise move gives Daniel the breathing room he needs to train. Instead of living in constant fear of bullying, he can focus on developing his karate skills. Instead of fighting *every* day, he only has to fight *one* day.

Miyagi is dealing with an unskilled pupil and a limited time frame in which to train. He wisely focuses on teaching Daniel balance and defensive moves rather than the more time-consuming traditional methods of learning series of punches and kicks. When hampered by an injured leg in the finals of the tournament, Daniel returns to these fundamentals, and employs a crane technique that Miyagi taught him to improve his balance.

The Cobra Kai sensai John Kreese, on the other hand, does *not* use his head. He allows emotion to cloud his judgment. When Daniel faces one of the Cobra Kai in the tournament's semi-finals, Kreese instructs his pupil to go after Daniel's knee, to put him "out of commission." The pupil, Bobby, argues that he can beat Daniel straight up, but Kreese won't hear it. Bobby takes out Daniel's knee, and is immediately disqualified. The move backfires when Daniel goes on to defeat Johnny in the finals.

Take Advantage of Your Opponent's Aggressiveness

Kreese instructs his Cobra Kai warriors that they should show their opponents no mercy, because "mercy is for the weak." In all three *Karate Kid* movies from the 1980s, Daniel faces extremely aggressive opponents, but he is able to use their aggressiveness to his advantage.

In the first *Karate Kid*, Daniel faces Johnny in the tournament finals. On instructions from Kreese to "sweep the leg," Johnny goes after Daniel's injured leg rather than focusing on winning points, and thus the tournament. Overconfident after re-injuring Daniel's leg, Johnny goes for the kill shot, leaving himself vulnerable to the crane kick that wins Daniel the tournament.

In *Karate Kid II* (1986), Daniel faces off against Chozen, who blames Daniel for bringing shame upon him. Chozen interrupts the traditional bone dance in Miyagi's village in Okinawa to challenge Daniel to a fight. Chozen's emotions and aggressiveness lead to his downfall. Daniel uses a defensive drum technique he learns from Miyagi to ward off Chozen's attack and defeat him.

Karate Kid III (1989) introduces us (and Daniel) to Terry Silver, former Army buddy of John Kreese, successful businessman, and karate aficionado. Silver decides to punish Daniel and Miyagi for humiliating his old buddy Kreese, whose students left his Cobra Kai dojo following his behavior during and after the tournament. Silver befriends Daniel and when Miyagi refuses agrees to train him to defend his tournament title. But all the while, Silver is actively working to undermine Daniel's training, and brings in Mike Barnes ("karate's bad boy") to challenge Daniel in the tournament. Silver's three rules demonstrate his aggressive approach to karate.

> Rule #1: If a man can't stand, he can't fight.
> Rule #2: If a man can't breathe, he can't fight.
> Rule #3: If a man can't see, he can't fight.

At the tournament, Kreese and Silver are in Mike Barnes' corner as Barnes and Daniel appear in the finals. Silver, wearing an ascot (I mean, who wears an ascot to a karate tournament?), advises Barnes to keep the score close, so he can inflict the maximum possible damage to Daniel, then score the winning point in overtime. Barnes follows the advice to a tee, earning two points but losing them soon after for an illegal kick to the groin and punch to the face. In extra time, Daniel uses the momentum of the lunging Barnes to flip him and score the championship point.

Embarrass Them

The contrast between Mr. Miyagi and the Cobra Kai sensai John Kreese could not be more glaring. Essentially, the difference comes down to pride. Miyagi is a very humble man, respectful of karate and its teachings. Daniel asks Miyagi if he's ever been in a fight, and Miyagi tells him he has always tried to avoid fights. "Yeah, but you know karate," Daniel says. "Someone always know more," Miyagi replies. One can't imagine Kreese or Terry Silver ever admitting that. Another humorous exchange between teacher and pupil reveals Miyagi's humility. Daniel asks Miyagi what kind of belt he has, referring to the color-coded belts that denote level of training in karate. Miyagi replies, "Canvas. You like? J.C. Penney. $3.98." John Kreese, on the other hand, is an angry egomaniac with an axe to grind. And as it states in Proverbs, "pride goeth before destruction, and a haughty spirit before a fall."

This quotation sums up the situation for John Kreese. *Karate Kid II* begins where the first film left off—after the tournament. Outside the arena, Kreese berates Johnny and his other Cobra Kai students for losing. One tournament official comments, "that guy just doesn't know what karate's all about." When the confrontation in the parking lot between Kreese and Johnny gets physical, Miyagi intercedes. Kreese tries to punch Miyagi, who moves aside. Kreese's hand shatters the window of the car behind Miyagi. Miyagi pretends he's going to take Kreese out, but instead grabs Kreese's nose and makes a honking sound. Kreese is exposed as the unprincipled bully that he truly is. After the parking lot incident, he loses all the students in his Cobra Kai dojo; who wants to be called a loser after coming in second place?

Embarrassment also works well against Daniel's opponents in II and III. Daniel embarrasses Chozen by revealing that he has been cheating the villagers, then exposes him as a coward during the big storm that threatens the Okinawan village. In *Karate Kid III*, the resurgent Cobra Kai dojo is once again embarrassed. Daniel's bravery in overcoming Mike Barnes' brutal and unsportsmanlike tactics shows the crowd the true nature of Cobra Kai's character (those who weren't already scared away by Terry Silver's ascot!).

The *Karate Kid* movies offer us important lessons on dealing with bullies. First, learn from an expert, focus on applying those lessons, and return to the fundamentals of your training when things get difficult. Second, use your head. It is by far your greatest tool, and a well thought-out strategy can often overcome superior resources. Three, use your adversary's aggressiveness against him. Patience is a virtue in short supply. When your opponent is impatient and overreaches, be ready to seize the advantage. Four, be humble and stick to your principles. If your efforts are worthy, people will eventually realize you are in the right, and your foes will be exposed. In this case, the Cobra Kai are shown for the brutal blonde bullies that they truly are.

11. Tips on Positive Thinking: A Perfect '80s Movie Day

A positive outlook is essential to fully embracing the human experience. As that old sage Walt Whitman advised, "Keep your face always toward the sunshine- and shadows will fall behind you. " Or as those other great philosophers from Monty Python sang, "When you're chewin' on life's gristle, don't grumble, give a whistle, and this'll help things turn out for the best…Always look on the bright side of life!" You'll be surprised how much having a positive attitude will affect your life and your personal relations. Let me share with you how my positive outlook transformed an ordinary day into a perfect '80s movie day.

 I woke up gently to peaceful orchestral music being played by an ensemble in an alcove above my bed. Three beautiful flower bearers sprinkled rose petals on my path to the bathroom, where I received a warm, refreshing bath from more beautiful women (*Coming to America*). One woman emerged from the water to announce, "The royal penis is clean, your highness."

 I like to work out first thing in the morning, so I headed down to the beach for a run with Rocky Balboa and Apollo Creed (Sylvester Stallone and Carl Weathers, *Rocky III* and *IV*). I was quite a bit ahead, so at the end I threw my head back and ran in slow motion (*Chariots of Fire*) to Vangelis' stirring music. Now that I was warmed up, I joined Jessie (Jamie Lee Curtis, *Perfect*) for some aerobics and stretching. To cool down, I shot some hoops with Jimmy Chitwood (Maris Valainis) and the boys from Hickory (*Hoosiers*). We ran the ol' picket fence play, and I nailed the winning shot—nothing but net, baby!

 I was headed home for a shower, but when I passed by the ball field, Ray Kinsella (Kevin Costner, *Field of Dreams*) asked me to have a catch. I threw the baseball around with Ray for a while as a gentle breeze stirred the corn stalks, then shagged some fly balls in the outfield with Shoeless Joe Jackson (Ray Liotta, *Field of Dreams*), Willie Mays Hayes (Wesley Snipes, *Major League*), and Roy Hobbs (Robert Redford, *The Natural*). Not a bad outfield, if I do say so.

 I grabbed a quick shower with Ellen Griswold (Beverly D'Angelo, *Vacation*). Ellen asked me to wash her back…and her

front. I had a lot to do today, but I took time out while I was getting dressed to dance around the room in my underwear (*Risky Business*) to Bob Seger's "Old Time Rock and Roll."

In the kitchen, Uncle Buck (John Candy, *Uncle Buck*) had whipped up a big batch of pancakes for breakfast. The orange juice on the table reminded me that I needed to hurry over to the stock exchange for the opening bell. Winthorpe and Valentine (Dan Aykroyd and Eddie Murphy, *Trading Places*) and I had some great inside information on orange juice futures, and we made a killing.

Outside the stock exchange, Ren McCormack (Kevin Bacon, *Footloose*) challenged me to a game of chicken on tractors. I didn't back down like that wimp Chuck (Jim Youngs), and Ren's tractor went into the ditch. I helped him out and there were no hard feelings. I promised to meet Ren, Ariel (Lori Singer), and Willard (Chris Penn) for a dance later.

I took a shortcut through the woods, passing by the tree house. I gave the secret knock, and said hello to Gordie (Wil Wheaton), Chris (River Phoenix), Teddy (Corey Feldman), and Vern (Jerry O'Connell, *Stand By Me*). They invited me in for a smoke, and asked me if I wanted to go see a dead body, but I told them I was running late for a tee time with Ty Webb and Al Czervik (Chevy Chase and Rodney Dangerfield, *Caddyshack*), so I'd catch up with them later. I shot a great round, breaking the Bushwood club record. My caddy Danny Noonan (Michael O'Keefe) was a big help. Danny told me the caddies were going for a dip in the Bushwood pool later, and told me I should stop by.

I had a ton of errands to run the rest of the morning, so I grabbed a quick slice of pizza from Daisy (Julia Roberts, *Mystic Pizza*), and had Hoke (Morgan Freeman, *Driving Miss Daisy*) pick me up. I helped *E.T.* make a long-distance call, which he seemed really happy about. I stopped to see Terri (Joyce Hyser, *Just One of the Guys*), who needed some advice on how to walk like a man—don't ask why. I helped Daniel Larusso (Ralph Macchio, *The Karate Kid*) wax Mr. Miyagi's (Pat Morita) car. He was having trouble until I taught him the proper technique: wax on, wax off. I gave Chris and Mitch (Val Kilmer and Gabriel Jarret, *Real Genius*) some advice on their laser—can you believe they never even thought of synthesizing bromide in an argon matrix? Next up was helping Wanda (Jamie Lee Curtis, *A Fish Called Wanda*) practice

her Italian. That took longer than expected, if you know what I mean, so I was late meeting up with *The Goonies* to help them find One-Eyed Willie's treasure, and almost got caught in one of Willie's booby traps.

I took a quick break to sneak in and watch the girls' gym class shower with Pee Wee (Dan Monahan, *Porky's*), Billy (Mark Herrier), and Tommy (Wyatt Knight), and to ride my Big Wheel around the Overlook Hotel (*The Shining*) with Danny (Danny Lloyd). Luckily we didn't run into those two creepy twins—they freak me out.

Bud (Harry Dean Stanton, *Repo Man*) and Otto (Emilio Estevez) picked me up outside the hedge maze by the Overlook, and we went looking for a Chevy Malibu with some serious junk in the trunk. After we found that, a helicopter picked me up and I rappelled into the jungle with Dutch (Arnold Schwarzenegger, *Predator*) and his crew. I didn't like the vibe that crazy Indian Billy (Sonny Landham) was getting. I decided that "I ain't got time to bleed," so I took off. I slipped down a muddy hill, and slid right into Joan Wilder's (Kathleen Turner, *Romancing the Stone*) crotch. She didn't seem to mind though.

Hoke picked me up and drove me to the Piggly Wiggly (*Driving Miss Daisy*) so I could buy Scott (Michael J. Fox, *Teen Wolf*) a keg of beer, Hi and Edwina (Nicholas Cage and Holly Hunter, *Raising Arizona*) some Pampers, and Da' Mayor (Ossie Davis, *Do The Right Thing*) a Miller High Life. Hoke dropped me off at Marty McFly's (Michael J. Fox, *Back to the Future*) place, and we skateboarded over to the Twin Pines Mall.

I entered the mall through the MacMillan Toy Company (*Big*), where I danced on the big piano with Josh (Tom Hanks). Bill and Ted (Alex Winter and Keanu Reeves, *Bill and Ted's Excellent Adventure*) were hanging out at the mall with Socrates, Napoleon, Sigmund Freud, Beethoven, Billy the Kid, Joan of Arc, Genghis Khan, and Abraham Lincoln, and really had their hands full. Spicoli (Sean Penn, *Fast Times at Ridgemont High*) and his stoner buds were sitting shirtless in the food court. I walked by the travel agency, which was advertising trips to Walley World (*Vacation*) with a talking moose out front. I punched Marty Moose right in the nose, then bummed a piece of bubble gum off Nada (Rowdy Roddy Piper, *They Live*). I bought Earth, Wind, and Fire

tickets from Damone (Robert Romanus, *Fast Times at Ridgemont High*) outside the arcade, then went in to play some video games with David Lightman (Matthew Broderick, *WarGames*), and Wyatt and Gary (Ilan Mitchell-Smith and Anthony Michael Hall, *Weird Science*).

 I headed out to the mall parking lot, where Doc Brown (Christopher Lloyd, *Back to the Future*) tossed me the keys to the DeLorean, warning me to keep it below 88 miles per hour, or I'd see "some serious shit." Mercedes (Heather Graham, *License to Drive*) was dancing on the hood, so I politely asked her to get down. As I helped Mercedes down, we heard a bicycle bell and waved to Pee-Wee Herman (Paul Reubens, *Pee-Wee's Big Adventure*) as he rode by.

 At the first stop light, Lane Meyer (John Cusack, *Better Off Dead*) and two Japanese brothers pulled up on either side of me. We drag-raced. I beat them off the start, and blew them away when I clicked on the flux capacitor. That little stunt got me pulled over for speeding by Frank Drebin and Nordberg (Leslie Nielsen and O.J. Simpson, *The Naked Gun*), but just then Mahoney and Jones (Steve Guttenberg and Michael Winslow, *Police Academy*) ran up and told us there was an angry mob headed our way. Jones grabbed a bullhorn and imitated machine-gun fire, confusing the mob and allowing us to get away.

 By now, I was hungry, so I met Sally (Meg Ryan, *When Harry Met Sally*) for lunch at the deli. Our sandwiches were so good that Sally had an orgasm right there at the table! At least I think she did. The woman next to us said, "I'll have what she's having." As we finished our lunch, Coco (Irene Cara, *Fame*) and the kids from the performing arts school sang, danced, and entertained us.

 Next door at Señor Pizza, Randy (Patrick Dempsey, *Loverboy*) looked worn-out, and asked me if I could deliver a pizza with extra anchovies for him. On the way, I stopped by Tubby's Drive-In (*Hollywood Knights*) to show off the DeLorean to Newbomb Turk (Robert Wuhl) and the guys in the car club. You wouldn't believe the tip I got when I delivered that pizza with extra anchovies to a lonely woman in the valley! As I lay there afterwards, I heard "In Your Eyes" streaming through the open window. I looked outside to see Lloyd Dobler (John Cusack, *Say*

Anything) holding up a boombox, and it reminded me I still had a lot to do today.

On the way back to town, I felt like some adventure, so I jumped from the moving DeLorean onto the back of a truck caravan. I helped Indiana Jones (Harrison Ford, *Raiders of the Lost Ark*) beat up some Nazis and recover the Ark of the Covenant.

As I'm sure you know, beating up Nazis is dusty, dirty work, so I headed over to the pool. I waved to Madison the mermaid (Daryl Hannah, *Splash*) lounging in the shallow end. Ben (Wilford Brimley, *Cocoon*) yelled "Cannonball!" and we jumped in for a rejuvenating swim. I worked with Thornton Mellon (Rodney Dangerfield, *Back to School*) on his Triple Lindy dive. I was just kicking back on a deck chair to catch some rays when I saw Linda (Phoebe Cates, *Fast Times at Ridgemont High*) diving into the pool. I took her over a towel when she climbed out. Sprinklers went off, somebody turned on The Cars' "Living in Stereo," Linda peeled off her red bikini, and started making out with me! No lie. It was pretty hot and heavy until this hot blonde (Christie Brinkley, *Vacation*) interrupted to ask me if I wanted to go skinny-dipping with her. Linda got mad, and stormed off in a jealous rage. "This is crazy, this is crazy," I said as I whipped off my trunks and dove in. We were all having a great time until Madison screamed and pointed to "doodie" floating in the pool (*Caddyshack*). Turns out it was just a Baby Ruth bar that Ben had accidentally dropped in the pool, so Carl Spackler (Bill Murray, *Caddyshack*) ate it and we all had a good laugh. That guy is crazy.

To dry off, I had Han and Chewie (Harrison Ford and Peter Mayhew, *The Empire Strikes Back* and *Return of the Jedi*) pick me up in the Millennium Falcon and kick that puppy into hyper-drive. Back on *terra firma*, I stopped by the community center for some popping and locking with Ozone, Turbo, and Special K (Adolfo Quinones, Michael Chambers, and Lucinda Dickey, *Breakin'* and *Breakin' 2: Electric Boogaloo*). Next I took some target practice in Ralphie's (Peter Billingsley, *A Christmas Story*) back yard with Ralphie, Billy the Kid (Emilio Estevez, *Young Guns*), John J. Rambo (Sylvester Stallone, *First Blood*) and Murtaugh and Riggs (Danny Glover and Mel Gibson, *Lethal Weapon*). After I won, I raised my Red Rider B-B gun to the sky, shouted "WOLVERINES!" (*Red Dawn*) and fired a few rounds in the air.

Just down the street from Ralphie's, I helped Elizabeth (Kim Basinger, *Nine ½ Weeks*) clean out her fridge. That's a story for another time. I dropped in at Sarah Connor's (Linda Hamilton, *The Terminator*) to warn her and her roommate that they might expect a not-so-friendly visit from a stranger.

I took the DeLorean to go pick up Andie Walsh (Molly Ringwald, *Pretty in Pink*) from the record store. Sorry Duckie (Jon Cryer), but she's with me. We went to the Cubs game with Ferris, Cameron, and Sloane (Matthew Broderick, Alan Ruck, and Mia Sara, *Ferris Bueller's Day Off*). The Cubs won, and I even caught a foul ball. After the game, Ferris and I sang "Twist and Shout" on a float in the parade.

At the country club, Fletch (Chevy Chase, *Fletch*) treated me to an afternoon snack on the Underhills—"a Bloody Mary, a steak sandwich, and a steak sandwich"—after I helped him with some ball bearing repairs on Alan Stanwyk's (Tim Matheson) private jet. I got a call from the *Ghostbusters* that a giant Stay-Puft marshmallow man was terrorizing downtown, so I strapped on my proton pack. We took him out without getting slimed, so I spent the rest of the afternoon fishing with Norman Thayer (Henry Fonda, *On Golden Pond*) on Bernie's (Terry Kiser, *Weekend at Bernie's*) boat. Bernie wasn't much help baiting the hooks, but Norman and I had a nice time anyway.

I took my catch down to the diner to get some grub, catch up with Eddie, Boogie, Modell, and the guys (Steve Guttenberg, Mickey Rourke, and Paul Reiser, *Diner*), and talk about the Colts' chances this fall. After dinner, I helped Sarah, Nick, Karen, and the gang (Glenn Close, William Hurt, and JoBeth Williams, *The Big Chill*) clear the table, and we ended up dancing to The Temptations "Ain't Too Proud to Beg" around the kitchen. Meg (Mary Kay Place) asked me to impregnate her, but I took a pass.

I took Ray (Dustin Hoffman, *Rainman*) to the casino for a little blackjack. I let him drive the DeLorean, which he really seemed to enjoy. We won big, and made it rain up in that casino, let me tell you.

Over at the Curtis place, I met up with Ponyboy, Sodapop, Dallas (C. Thomas Howell, Rob Lowe, and Matt Dillon, *The Outsiders*), and the other Greasers. We went over to the park, and kicked the living crap out of those snobby Socs in the rumble. I

needed to chill out after the rumble, so I went to the cave to hear some poetry from Neil, Todd (Robert Sean Leonard and Ethan Hawke, *Dead Poets Society*), and the Welton Academy boys. The nerds from the Tri-Lambda fraternity (*Revenge of the Nerds*) picked me up and we went on a panty raid at the Pi house.

Oh crap, I promised Billy (Zach Galligan, *Gremlins*) that I would feed his pet gremlins; I need to do that before midnight! John Winger (Bill Murray, *Stripes*) swung by in his cab. We went back to his apartment and listened to Tito Puente before we went out to a strip club to see Alex (Jennifer Beals, *Flashdance*) and the girls do their thing.

When I ran out of ones, I headed over to the honky-tonk bar. I said "hi" to the Diceman (Andrew Dice Clay, *Pretty in Pink*), who was bouncing at the door and ushered me right in. Rusty and Gar (Cher and Sam Elliott, *Mask*) were there with their biker buddies, so I did a shot with them. Brian (Tom Cruise, *Cocktail*) at the bar mixed me up a cocktail with some serious showmanship, then I had a beer with the Mackenzie brothers, eh (Dave Thomas and Rick Moranis, *Strange Brew*).

Leslie (Ally Sheedy, *St. Elmo's Fire*) beckoned me over to a table with my old college buddies. Billy Hicks (Rob Lowe) was wailing away on his sax on stage, and Jules (Demi Moore) was straddling the jukebox. Alec (Judd Nelson) bought another round as Billy finished his set, and the Blues Brothers set up their gear on stage. Jake and Elwood (John Belushi and Dan Aykroyd, *The Blues Brothers*) invited me up on stage to sing "Stand By Your Man"; Jake even let me crack the whip a couple times. Some big drunken idiot threw a beer bottle at the chicken wire around the stage, showering me and the band with beer. So I went out and punched him. When he tried to hit me, I ducked behind Dalton (Patrick Swayze, *Road House*), and watched the best damn cooler in the business make quick work of the guy by stomping his knee and escorting him outside. Reggie Hammond (Eddie Murphy, *48 Hrs.*) heard the ruckus and flashed a badge, telling us to settle down because there was "a new sheriff in town."

I decided to get out of there before it got too rough. Since I'd been drinking, I left the DeLorean in the parking garage and hitched a ride over to Jake Ryan's party with Long Duck Dong (Gedde Watanabe, *Sixteen Candles*). I carried a watermelon inside

(*Dirty Dancing*) since it's always nice to bring something to a party. Jake (Michael Schoeffling, *Sixteen Candles*) tried to get me to be Keymaster (*Say Anything*), but I told him no way—that job sucks. Farmer Ted (Anthony Michael Hall, *Sixteen Candles*), Baby (Jennifer Grey, *Dirty Dancing*), and Ronald Miller (Patrick Dempsey, *Can't Buy Me Love*) were leading everyone in the African Anteater Ritual dance, until "Tequila" came on and Pee-Wee Herman (Paul Reubens, *Pee-Wee's Big Adventure*) started dancing on the table. Booger (Curtis Armstrong, *Revenge of the Nerds*) broke out a "wonder joint" and passed it around. I bumped into John McClane (Bruce Willis, *Die Hard*), who was going to a party over at the Nakatomi Building and wanted me to join him. I told John "no thanks", grabbed a beer, and watched Ogre (Donald Gibb, *Revenge of the Nerds*) and the Alpha Beta boys do fireballs with grain alcohol and catch the drapes on fire. Luckily, a fireman (Sean Connery, *Time Bandits*) was nearby and put the blaze out quickly.

After a couple more drinks, I stumbled to the back of Jake's house, where Thornton (Rodney Dangerfield, *Back to School*) was in the hot tub with a girl named Bubbles and a couple other hot co-eds. One of them was an English literature major and helped me straighten out my Longfellow.

The rest of the night was a drunken blur. All I know is that I woke up cuddling in bed with Neal and Del (Steve Martin and John Candy, *Planes, Trains, and Automobiles*). Wait a minute, those aren't two pillows! I got out of there quick. Maverick (Tom Cruise, *Top Gun*) offered me a ride home in his jet and told me I could be his wingman anytime. I remembered how poorly that had gone for Goose (Anthony Edwards), so I climbed in with Iceman (Val Kilmer) instead. We took out a few Soviet bogies on the way home.

Iceman dropped me off back in the palace in Zamunda (*Coming to America*) just before dawn. Oh no, I forgot to feed the Gremlins! Ah, I'm sure they'll be fine. I crawled into bed and drifted off to the sounds of zebras, monkeys, and exotic birds through my open window. What a day! I wonder what tomorrow will bring.

You too can start experiencing days like my perfect '80s movie day. All you need is a smile and a positive outlook. Instead of dreading getting out of bed and facing the day, embrace it! Today could be your perfect day. Think of the possibilities and opportunities every single day could hold. Go out there and grab the bull by the horns!

12. How to Survive an '80s Horror Movie Part III: Dream Warriors

Jason Voorhees again, back with part three of my advice series on how to survive an '80s horror movie. This section will teach you to keep it in your pants, fear the night and the dream world, tame your curiosity, and that even celebrities are not immune to the horrors of the slasher genre.

Check Your Libido

Teenagers have raging, out-of-control hormones. They seem to be obsessed with having sex. But there's no quicker way to get killed in a horror movie than to have sex. It isolates you from others and it *certainly* distracts you. That's a recipe for disaster when a psychopathic killer is on the loose.

The couples having sex in '80s horror movies are typically among the first victims. In *He Knows You're Alone* (1980), the first of the friends killed is Joyce (Patsy Pease), who is sleeping with her married philosophy professor (James Rebhorn) to earn an A in the class. In *The Burning* (1981), Karen (Carolyn Houlihan) and Eddy (Ned Eisenberg) go skinny-dipping and engage in some foreplay, shortly before Karen becomes Cropsy's first victim. In *Slumber Party Massacre* (1982), Diane (Gina Smika Hunter), who sneaks out of the party to get it on, is the first of the girls killed, along with her boyfriend John (Jim Boyce). The opening murders of *The Prowler* (1981) occur when a couple making out hot and heavy in a gazebo get a pitchfork shoved through them. I used a similar double-impalement in *Friday the 13th, Part 2* (1981) when I drove a post-coital spear through both Sandra (Marta Kober) and Jeff (Bill Randolph).

Sexual behavior is grimly punished in almost every '80s slasher film. In *Prom Night* (1980), Kelly (Mary Beth Rubens) gets topless to mess around with Drew (Jeff Wincott) in the locker room during the dance, and has her throat slit after Drew leaves. Later in the movie, Jude (Joy Thompson) and Slick (Sheldon Rybowski) have sex in his van, and are both offed by the killer. Debbie (Tracie Savage) and Andy (Jeffrey Rogers) have sex in a

hammock in *Friday the 13th, Part III* (1982), right before I killed them both with a machete. In the vampire flick *Near Dark* (1987) Caleb (Adrian Pasdar) becomes a vampire after being seduced by Mae (Jenny Wright). The same is true in *Lost Boys* (1987), as Michael (Jason Patric) is lured into the vampire lifestyle because of his sexual attraction to Star (Jami Gertz). *Halloween II* (1981) features Karen (Pamela Susan Shoop) and Bud (Leo Rossi) having sex in a hot tub before both meet their early demise. I was particularly tough on couples engaged in sexual activity in *Friday the 13th, Part 4* (1984)—a mortician and a nurse killed at the hospital, Samantha (Judie Aronson) and Paul (Clyde Hayes), Sarah (Barbara Howard) and Doug (Peter Barton), and Tina (Camila More) and Jimmy (Crispin Glover). In *Graduation Day* (1981), Dolores (Linnea Quigley) and Tony (Bill Hufsey) go into the woods during a school dance to have sex, and neither makes it to the end of the dance. In *Motel Hell* (1980), kinky swingers who show up at the motel looking for some action end up fertilizing Farmer Vincent's garden. My favorite may be from the original *Friday the 13th* (1980). Jack (Kevin Bacon) and Marcie (Jeannine Taylor) have sex in one of the cabins. Afterwards, Jack gets an arrow right up through his neck, and Marcie has her head split open in a shower stall with an axe. Nice work, Mom!

Typically, one girl will make it out of an '80s horror movie alive. She's almost always the "good girl" who doesn't have sex during the movie. That was one of Jamie Lee Curtis' secrets to staying alive throughout her run as a scream queen. In *Halloween 4* (1988), Kelly (Kathleen Kinmont) lectures Rachel (Ellie Cornell) that she needs to put out if she wants to keep her man. Kelly is killed in the next few minutes, while Rachel makes it out alive. In *Hell Night* (1981), Marti (Linda Blair) rejects the sexual advances of Jeff (Peter Barton), telling Jeff "wrong bed" when he tries to crawl into the twin bed with her. Jeff later gets thrown out a window, while Marti survives the movie.

Who knows the reason why '80s slashers act out so violently against teens having sex? Perhaps we're extremely old-fashioned and moralistic. Or maybe we're jealous and angry because we're not attractive to the opposite sex. Regardless, sex equals death in horror movies. So please, keep your pants on.

Whatever You Do, Don't Go to Sleep

While I watch and admire the work of my colleagues, it's not often that I'm envious. But Freddy Krueger (Robert Englund) is really onto something in *A Nightmare on Elm Street* (1984) with this whole dream thing. After all, people can stay out of the woods, avoid summer camps, and use common sense. Everyone has to sleep though, and that's where Freddy is waiting!

Freddy kills people in their dreams, but he's not the only murderer waiting in the dark. It turns out the killings in *Happy Birthday to Me* (1981) occur when Virginia (Melissa Sue Anderson, a long way from her role on *Little House on the Prairie*) is chloroformed to "sleep" by her friend Ann (Tracey Bregman)—the real killer who tries to frame Virginia. The title *The Slumber Party Massacre* (1982) says it all, as the girls at an overnight slumber party are hunted by an escaped killer. The full moon brings murder and mayhem in *An American Werewolf in London* (1981), when a transformed David (David Naughton) stalks London and unleashes bloody hell on Piccadilly Circus. In *Near Dark* (1987), the band of vampires travel by day in a foil-covered Winnebago to protect them. Sunlight is what finally does them in at the end of the movie. In *Halloween 2* (1981), a distraught Laurie (Jamie Lee Curtis) begs the paramedics and the doctor not to put her under. "Don't let them put me to sleep," she tearfully sobs, because she knows Michael Myers will be waiting for her when she wakes up.

Sunlight and daytime are your friends. The night and the dark can be very scary and dangerous. As '80s rap group Whodini warned, the freaks come out at night. And you're most vulnerable and defenseless when you're asleep. Sleep tight and have pleasant dreams, but watch out for Freddy!

Curiosity Killed the Cat—and a Bunch of Teenagers

Curiosity can be a good thing. As Walt Disney said, it "keeps leading us down new paths." Walt's path led him to the world's greatest entertainment empire, vast wealth, and happiness. But what if I had been waiting on one of those paths Walt's

curiosity led him down? You could have kissed Mickey Mouse and all his fun little friends goodbye. My point is that it isn't *always* a good thing to be inquisitive. Sometimes you're better off *not* knowing the answer.

Horror movies from the 1980s are filled with dumb-asses who go someplace dark and scary to investigate noises they heard, or things they saw. There's Rick (Paul Kratka) from *Friday the 13th, Part III* (1982), who says, "I'm gonna go outside and take a look around." You do that, genius. I'll be right there waiting for you! In *Pumpkinhead* (1988), teenagers trapped in a cabin go out into the woods multiple times to check out noises, allowing the vengeance-conjured demon to pick them off one by one. In *Friday the 13th* (1980), the would-be camp counselors repeatedly go out alone to investigate—Ned (Mark Nelson) goes to check out noises in a "deserted" cabin, Marcie (Jeannine Taylor) checks out noises in a shower stall, Brenda (Laurie Bartram) investigates a voice she hears outside (in a nightgown, in the rain), and Bill (Harry Crosby) goes to check on that pesky generator. What do these curious teens have in common? They're all dead!

Hellraiser (1987) provides a perfect warning against being too curious. Young Kirsty (Ashley Laurence) solves a metallic puzzle box, accidentally opening a portal to the demonic world of the evil Cenobites. Kirsty literally opens Pandora's Box, and it's all she can do to keep Pinhead (Doug Bradley) and the other Cenobites from murdering her.

A group of college friends vacation in a remote forest cabin in *The Evil Dead* (1981). They find a bizarre old book in the basement, and their curiosity gets the better of them. They read the book aloud (there's even a cassette tape version), which turns out to be an ancient Sumerian book of the dead, and thereby unleash the demons trapped within. The friends become possessed one by one, and Ash (Bruce Campbell) is left alone to fight off his demon-possessed buddies.

So even though curiosity can be a positive character trait, it should also have its limits. All things in moderation. Don't let your curiosity overcome your better judgment.

Celebrities Don't Get a Pass

Celebrities often lead a pampered existence far from the worries and cares of us common folk. But they're not immune to the murder and mayhem of the slasher genre. A number of celebrities and award-winning actors appeared in '80s horror movies. Some made it out alive, but others didn't. Celebrities don't get a free pass.

David Copperfield is one of the most popular illusionists in history. His television specials have won 21 Emmy awards, he has a star on the Hollywood Walk of Fame, but Copperfield was one of the victims on the *Terror Train* (1980). On that same train was Ben Johnson, who won a Best Supporting Actor Oscar for *The Last Picture Show* (1971), but was relegated to conducting a train full of drunken college kids and one angry killer. *Motel Hell* (1980) features two celebrities in minor roles—famed gravelly-voiced disc jockey Wolfman Jack as a sleazy TV preacher, and *Cheers* alumnus and frequent Pixar voiceman John Ratzenberger as the drummer for the heavy metal band Ivan and the Terribles. Wolfman Jack survives, but Ratzenberger gets buried in Farmer Vincent's garden. *The Burning* (1981) also sports two future acting celebrities—Jason Alexander of *Seinfeld* fame and Oscar-winning (*The Piano*, 1993) actress Holly Hunter. Tom Hanks is a two-time Oscar winner (*Philadelphia*, 1993 and *Forrest Gump*, 1994) and Hollywood megastar, but his first movie role was in the horror flick *He Knows You're Alone* (1980). When Hanks' character delivers lines like "Too bad they don't have a roller coaster," you know he's headed for acting greatness. *Wheel of Fortune* letter-turner Vanna White is less famous for her role as Doris in *Graduation Day* (1981), probably because her main contribution to the movie's dialogue was, "You scared me so much I wet my pants." Hollywood leading ladies Demi Moore and Patricia Arquette took early roles in *Parasite* (1982) and *A Nightmare on Elm Street 3: Dream Warriors* (1987), respectively.

Horror films aren't only for young, up-and-coming actors though. Older, more established actors can also be found. Legendary actor Glenn Ford shows up as a shrink in *Happy Birthday to Me* (1981). Leslie Nielsen was a very experienced dramatic actor when he appeared as Jamie Lee Curtis' father and

school principal in *Prom Night* (1980). His role in *Airplane!* (1980) later that year transformed him into a highly popular comedic actor.

My favorite celebrity appearances in '80s horror movies are by Johnny Depp and Kevin Bacon. Both talented and prolific actors experience gruesome deaths. Depp's first film role is as Glen Lantz, a high schooler who gets pulled into his mattress and killed by Freddy Krueger in *A Nightmare on Elm Street* (1984), unleashing oceans of blood all over Glen's bedroom. Kevin Bacon stars as camp counselor-to-be Jack Burrel in *Friday the 13th* (1980). Jack may know when a storm is coming, but he doesn't notice my mom hiding under his bunk until he gets an arrow shoved up through his throat.

I have to admit, I'm jealous of mom, Freddy, and other slashers who have bagged a celebrity. The most famous person I ever killed was that guy (Crispin Glover) who played Marty McFly's dad. Maybe I should come out of retirement to slice up one of the Kardashians. Let's ponder that scenario while we await part four!

13. How to Deal with Ghosts

"Are you troubled by strange noises in the middle of the night? Do you experience feelings of dread in your basement or attic? Have you or any of your family ever seen a spook, specter, or ghost?" You may find these questions a bit unorthodox, but they're business as usual for Peter Venkman, Egon Spengler, and Ray Stantz in the 1984 comedy *Ghostbusters*. If you answered 'Yes' to all of the above, others may doubt your sanity—but not Venkman, Spengler, and Stantz, who state in their commercial "We're ready to believe you."

And thank god someone does, because '80s films have shown us that no matter where you live, you can't hide from paranormal peril. Whether you're decorating a new home in the country, pursuing the American Dream in suburbia, or just struggling to survive life in the Big Apple, ghosts, spooks, spirits, and specters will terrorize you in any way they can, especially if you're doing something they don't like.

The '80s films *Ghostbusters*, *Beetlejuice*, and *Poltergeist* show that unless you face those spiritual oppressors head on, dire consequences will ensue, the least of which might include dogs and cats sleeping together. Using the wisdom in these movies, you'll figure out how to send ghosts packing if you encounter them, or you'll learn how to create suitable cohabitation rules if they have to stay.

Throw Skepticism Out the Window

You may not believe in ghosts, but living in denial won't get you anywhere. You can claim that they aren't real, but that won't keep you safe from angry spirits who want to torment you. Once you realize ghosts exist, you'll need to ditch your skepticism and take charge of your situation to combat them.

Dr. Peter Venkman (Bill Murray) in *Ghostbusters* doesn't take anything seriously, despite his dual doctorates in psychology and parapsychology. He uses his position as a professor at a local university to slack off and hit on co-eds rather than pursue legitimate research. Venkman's colleagues Dr. Ray Stantz (Dan Aykroyd) and Dr. Egon Spengler (Harold Ramis), on the other

hand, take paranormal pursuits much more seriously. Venkman doesn't hesitate to tell his friends that he thinks they're wasting their time.

> **Venkman**: As a friend, I have to tell ya you've finally gone around the bend on this ghost business. You guys have been running your ass off, meetin' and greetin' every schizo in the five boroughs who says he has a paranormal experience. What have you seen?
> **Stantz**: Of course you forget, Peter. I was present at an undersea, unexplained mass sponge migration.
> **Venkman**: Ray, the sponges migrated about a foot and a half.

When the three men are called to the New York City Public Library to investigate a paranormal disturbance, Venkman decides to ditch his doubts after a librarian's ghost shushes him for making too much noise. Even though she sends him running scared out of the library, Venkman figures out a plan to profit from the situation: they will go into business catching ghosts. And thus, the Ghostbusters are born. If you discover that ghosts exist and you're still feeling brave about facing them, you could start a business to hunt and trap them for money—just like Peter, Ray, and Egon.

In *Beetlejuice*, young spouses Adam and Barbara Maitland (Alec Baldwin and Geena Davis) are enjoying a happy life together in small-town Connecticut. Everything is just dandy until a Sunday drive turns fatal with their car falling into a river. Adam and Barbara wake up and come to a disturbing realization: they are now ghosts! This wouldn't be such a big deal if they could just continue their days undisturbed in their lovely home, but to their dismay, the Deetz family purchases their house.

The Deetzes couldn't be more different from the Maitlands. Delia (Catherine O'Hara) is a kooky artist and Charles (Jeffrey Jones) is businessman recovering from a nervous breakdown. They have also have a daughter named Lydia (Winona Ryder), who's perpetually clad in black and snaps bizarre pictures with her camera. As an artist, Delia can't stand the quaint interior design of Adam and Barbara's home, so she starts some aggressive remodeling. Annoyed with their new roommates, Adam and

Barbara attempt to scare Charles and Delia away; they unfortunately discover—while reading their Handbook for the Recently Deceased—that "the living usually won't see the dead." Luckily for them, Lydia has no problem spotting them.

> **Adam**: You can see us without the sheets?
> **Lydia**: Of course I can see you.
> **Adam**: Well, how is it you see us and nobody else can?
> **Lydia**: Well, I've read through that Handbook for the Recently Deceased. It says: "live people ignore the strange and unusual". I, myself, am strange and unusual.

Because Lydia isn't afraid to embrace the paranormal, she gains an edge in dealing with the ghosts living in her house. Her ability to communicate with Barbara and Adam allows her to befriend them and helps establish peaceful coexistence. You should always try to talk with your spirits before taking a hostile stance. They might turn out to be nice entities willing to negotiate with you.

Steve and Diane Freeling (Craig T. Nelson and JoBeth Williams) are living the '80s yuppie dream at the start of *Poltergeist*. The couple has three children, a dog, and a lovely new home in a vibrant suburban area. Even though they're too cheap to have their own cable tuner (they have to share with the neighbors), Steve and Diane are happy with their new domicile, and have plans develop their property with a pool.

Things seem to be going smoothly for Steve and Diane until they notice an increasingly bizarre series of occurrences in their new home. The television starts inexplicably going to static, as voices from inside seem to be communicating with their daughter Carol Anne (Heather O'Rourke), and kitchen furniture starts moving around on its own. Even after all this, Steve and Diane are hesitant to believe they might be dealing with ghosts. In a hilariously awkward scene, as they are inexplicably attacked by mosquitoes, Steve and Diane try to ask one of their neighbors if they have noticed strange happenings as well. As expected, the man and his son look at them as if they are nuts. It takes their daughter being sucked into the spirit world for Steve and Diane to

fully accept that they are being haunted. That's when they actually decide to do something about their wayward spirits. Don't wait until spirits are physically hurting you or your family before you acknowledge their existence. Accept the evidence early and start working on a plan to handle them.

Throw your skepticism about ghosts out the window and doors will open for you—to chat with them or to eradicate them. After you acknowledge their presence, you can decide on what kind of approach you want to take in dealing with them, whether it's kind or tough.

Try Killing Them Again—with Kindness

Once you realize that doubt isn't going to get you anywhere, you could try to handle spectral assailants by turning the other cheek. That rationale finds lease in the old adage "You'll catch more flies with honey than with vinegar." No sense riling up spirits—especially if they're already irked by your presence. The Ghostbusters see them as paranormal pests in need of eradication, so they dispense with the pleasantries, but Lydia in *Beetlejuice* and the Freelings in *Poltergeist* attempt a kinder approach—which meets with mixed results.

Once she discovers her spooky roommates, Lydia tries to warn her parents about upsetting the Maitlands and encourages her mother and father to leave the poor ghosts alone. But that's not all she does to help them. When the evil "bio-exorcist" Betelgeuse (Michael Keaton) is unleashed upon their world to wreak havoc, Lydia goes to bat for Adam and Barbara again, offering to marry him if he saves the couple from a painful demise. All of her efforts pay off in the end, because the Deetzes form a lasting peace with the Maitlands so they can live together comfortably. Plus, any time Lydia does well in school, Adam and Barbara invent a fun game where they use their ghostly powers to levitate her and sing entertaining songs like "Jump in the Line (Shake Señora)." If you're willing to compromise, you have a good shot at getting along with your ghosts. There are *way* worse ways to spend your time than dancing with them. That's for sure.

The Freelings try to become chummy with their ghosts as well, in an effort to communicate with them. Diane and Carol

Anne arrange chairs in the kitchen so that the specters can move them around in entertaining ways. Diane is even brave enough to place Carol Anne on the floor in a spot, where they push her forward in a straight line. For a time, their friendly approach works—until the ghosts decide to kidnap Carol Anne and bring her into their world. That's when Steve and Diane figure out that they can't play nice anymore if they're going to get their daughter back. When killing your ghosts with kindness is no longer an option, you'll need a more aggressive approach to dealing with them.

Taking the high road with ghosts is always your best first move, because once and a while it will lead to success. Sometimes though, they'll force you to take more drastic measures.

Call in the Experts

After you've exhausted all of the obvious—and humane—options for combating your ghosts, you'll need to seek professional assistance. "When there's something strange, in your neighborhood, who you gonna call? When there's something weird, and it don't look good, who you gonna call? If you're seeing things, running through your head, who you gonna call?" The answer to these questions is, of course, the Ghostbusters. But when you're dealing with pesky spirits, Peter, Ray, and Egon aren't the only ones you can trust to get the job done. Other seasoned paranormal investigators and psychics can help in different ways. Even if they can't necessarily trap ghosts and store them in a containment grid, they have their own technology and tricks that are also quite effective.

In the Big Apple's five boroughs, you won't find anyone more qualified to assist you in dealing with pesky spooks than Peter Venkman, Ray Stantz, Egon Spengler, and their new hire Winston Zeddemore (Ernie Hudson). Ray and Egon especially possess extensive knowledge in metallurgy, engineering, and physics in addition to their penchant for the occult. Despite his belief that "print is dead," Egon recognizes that sometimes he needs paranormal research books, such as the all-encompassing Tobin's Spirit Guide. This particular text allows him to deduce that the ghost living in their customer Dana's (Sigourney Weaver) apartment building is a Babylonian demigod with plans to bring

about the apocalypse. With their understanding of Gozer the Gozarian's plot, the Ghostbusters easily figure out how to send her packing to the nearest convenient parallel dimension. After ghosts start bothering you, be sure to hit up your local bookstore or library to see if you can locate Tobin's Spirit Guide. That way you can quickly identify who or what you're dealing with. Once you know your enemy, you can more effectively fight it.

Since it's their first time as ghosts, Barbara and Adam Maitland are ill-equipped to handle the afterlife at the opening of *Beetlejuice*. Thankfully, they have a support system in place to help them adjust: a manual which contains detailed instructions on coping with their situation and a case worker named Juno (Sylvia Sidney) to guide them through haunting the Deetzes. Sadly, neither "expert" resource aids the Maitland's significantly in their quest to scare the Deetzes out of their home. Their best work comes when they get really creative, possessing the Deeztes and their dinner guests in order to perform a spirited rendition of "Day-O."

On the flip side of things, Charles and Delia Deetz find their own specialist to combat the Maitlands: Otho (Glen Shadix). Delia's heavyset friend is a pretentious interior designer with delusions of grandeur who sees the moneymaking potential that the Maitlands present for Charles and Delia.

> **Otho**: Oh, you family types, you got other things to worry about. Maxie Dean's coming up here tonight. You got to figure out a way to sell these ghosts. I can only do so much.
> **Charles**: What are you gonna do, Otho, viciously rearrange their environment?
> **Otho**: I know just as much about the supernatural as I do about interior design.

He may be exaggerating, but Otho figures out how to force Adam and Barbara to physically manifest by reading passages from the Handbook for the Recently Deceased. Otho quickly discovers that he is meddling with powers he doesn't understand, since Adam and Barbara start to decay before his eyes. Thankfully, Lydia steps in to save them, although she has to enlist the dastardly Betelgeuse to assist. Don't trust amateurs like Otho when dealing

with the supernatural. They'll only foul things up and create bigger problems than they solve.

Diane and Steve Freeling in *Poltergeist* hire a group of professional ghost hunters from a local university in order to help get their kidnapped daughter back. Leading the team is Dr. Lesh (Beatrice Straight), a sympathetic woman who seems to have more theoretical knowledge of fighting paranormal antagonists than actual field experience. Dr. Lesh and her two student assistants descend upon the Freeling home with all sorts of equipment for studying the phenomena. In the end though, Dr. Lesh defers to Tangina (Zelda Rubinstein), a psychic medium who is well-versed in fighting angry spirits. Tangina's intelligent instructions are exactly what Steve and Diane need to reclaim their daughter. Listen to mediums when you have access to them. They have the necessary experience to help you effectively combat aggressive entities.

Paranormal experts have a variety of tactics at their disposal that they use to deal with ghosts, which is why you should turn to them when you've worn out all of your obvious options. Just don't listen to people who are mere enthusiasts; they can create bigger issues for you with their ill-informed opinions. Sometimes solid research is all you need to fix your situation, but don't be afraid to call in a psychic if you're out of your depth.

Use All of the Technology at Your Disposal

Having great gadgets can be clutch when it comes to busting ghosts. Barbara and Adam Maitland in *Beetlejuice* don't need special electronic doodads to rid themselves of the villainous bio-exorcist Betelgeuse, though. After being transported to a strange paranormal realm, Barbara manages to commandeer a vicious Sand Worm, which she uses to take down Beetlegeuse in the real world. Technology is pretty essential in *Poltergeist* and *Ghostbusters* for both studying and eradicating ghostly pests however.

Dr. Lesh and her team employ a number of electronic devices while they work inside the Freeling home. Their efforts mostly involve observation and study of the spirits. Cameras are set up all over the house to record the phenomena and to document

proof of the events as they unfold. A whole control center is assembled in the living room to watch for the suspicious movement. This surveillance equipment proves vital to monitoring spiritual activities, until the psychic Tangina steps in to help get Carol Anne back by having Steve travel by rope into the spirit world. Even if your gadgets can't catch ghosts, they might assist you with keeping an eye on them, so don't hesitate to use these tools when they're available.

 No one has better gadgets for dealing with ghosts than the Ghostbusters. Sure, they have little handheld objects like PKE meters for registering paranormal activity, but they also possess powerful tools for capturing the ghosts and trapping them in a proprietary storage system. Each one of them has an unlicensed nuclear accelerator (a.k.a. a proton pack) strapped to their back, which emits a strong electromagnetic stream that can be used to wrangle ghosts. The entities are then maneuvered over a trap that emits an extremely bright light no one is supposed to look at for some reason, even though Egon does without a problem. They are instructed at the beginning of the film to never ever cross these streams, or world-ending consequences will ensue—however, when they are trying to defeat Gozer the Gozarian, they decide to gamble on it.

> **Spengler**: I have a radical idea. The door swings both ways. We could reverse the particle flow through the gate.
> **Venkman**: How?
> **Spengler**: (hesitates) We'll cross the streams.
> **Venkman**: 'Scuse me Egon? You said crossing the streams was bad!
> **Stantz**: Cross the streams...
> **Venkman**: You're gonna endanger us, you're gonna endanger our client - the nice lady, who paid us in advance, before she became a dog...
> **Spengler**: Not necessarily. There's definitely a *very slim* chance we'll survive.
> (pause while they consider this)
> **Venkman**: (slaps Ray) I love this plan! I'm excited to be a part of it! LET'S DO IT!

Thankfully, their quick thinking and risk-taking works out, and the Ghostbusters are able to defeat Gozer the Gozarian, thus saving all of New York City and the world. They also manage to rescue their client Dana Barrett, the nice lady who turned into a dog. When you're blessed with kick-ass equipment like proton packs and traps for snaring evil ghosts, make sure you put it to good use just like the Ghostbusters. Don't let the limitations of your gadgets keep you doing some creative problem-solving, though. Take some risks when the chips are down, and you might be rewarded for your quick-thinking.

'80s films present different tactics for combating paranormal peril, although there are distinct lessons that you can glean from them. First, throw skepticism out the window, because that won't get you anywhere. Second, while you can try playing nice with your spirit attackers, you probably won't stand a chance unless you call in the experts. Third, make sure to use all of the technology at your disposal to level the playing field with your adversaries. A rope is a creative solution for jumping into the spirit world, but nothing beats a proton pack. Basically unless you're dealing with friendly ghosts like in *Beetlejuice*, you probably just want to call the Ghostbusters if they're available. They'll believe you *and* get rid of your paranormal pests.

14. Tips on Being a Man
What the World Needs Now is Patrick Swayze

With all due respect to uber-songwriter Burt Bacharach (love, sweet love) and 1990s alt-rock band Cracker (a new Frank Sinatra, with words of wisdom like la la la la la la la la-la), we believe the world needs...Patrick Swayze. Everything seemed much clearer and more focused when Patrick Swayze was around, whether he was facing down the Soviets, keeping order in a rowdy bar, or getting us hot under the collar with his dirty dancing. Life seems more complicated in the 21st century. It's hard to be a man in the modern world, and we could really benefit from his positive example.

Patrick Swayze was one of the leading movie stars of the 1980s and 1990s. Unfortunately, Swayze left us too early, passing away from pancreatic cancer in 2009 at the age of 57. Fortunately, he left us a memorable film legacy. A look at Swayze's 1980s movie roles gives us some insight into both what made him great and the important lessons he taught us on how to be a man.

- *The Outsiders* (1983): Swayze is Darrell Curtis, the older sibling of two teenage brothers. Since their parents died in an auto accident, Darrell is all they have to protect them from the mean streets of Tulsa and the turf war between Greasers and Socs.
- *Uncommon Valor* (1983): Swayze is Kevin Scott, the new addition to a team of Vietnam veterans who return to Laos in an attempt to free prisoners of war still being held captive.
- *Red Dawn* (1984): Swayze portrays Jed Eckert, ex—high school quarterback who must now lead a team of teenagers through the Colorado wilderness after America has been invaded by the Soviets.
- *Youngblood* (1986): Swayze is Derek Sutton, the team captain of junior hockey team the Hamilton Mustangs. Derek takes raw but talented Dean Youngblood (Rob Lowe) under his wing.

- *Dirty Dancing* (1987): Swayze's most famous role is dance instructor Johnny Castle, who literally and figuratively sweeps Baby (Jennifer Grey) off her feet at a 1960s Catskills resort.
- *Road House* (1989): Swayze stars as Dalton, the bad-ass "cooler" who is brought in to restore order at the rowdy Double Deuce roadhouse.
- *Next of Kin* (1989): Swayze is Truman Gates, a Kentucky-mountain-man-turned-Chicago-cop. When one brother is murdered by the Chicago mob, Truman must find the killer before his other brother Briar (Liam Neeson) exacts his own mountain justice.

Patrick Swayze Doesn't Let Anybody Put Baby in the Corner

All of Patrick Swayze's 1980s movie characters share a common character trait: loyalty. His characters are unflinchingly dedicated to family and friends.

Dalton (*Road House*) stands by his friend and mentor, Wade Garrett (Sam Elliott). He defends Wade when others say he's too old. He allows Wade to penetrate his defenses and to say things to him that he would never tolerate from anyone else. At the end of the movie, Dalton is all set to ride off into the sunset with his amigo, but bad guy Brad Wesley (Ben Gazzara) sticks a knife in Wade's chest, unleashing the unbridled fury of Dalton's revenge.

Kevin Scott (*Uncommon Valor*) is the outsider of the group of ex-soldiers, a neophyte with no combat experience. The loyalty and camaraderie of the rest of the group is understandable—the tight bond that develops between soldiers who served together in a war zone. Nevertheless, Kevin is fiercely steadfast to this group of men, and their mission to rescue P.O.W.s, Kevin risks his own life to execute the mission and to protect the other soldiers.

Jed Eckert (*Red Dawn*) drops his younger brother Matt (Charlie Sheen) off for another typical day at Calumet High School. But when Soviet troops start parachuting onto the football field and shooting teachers with AK-47s, Jed drives his pickup track back into the battle zone to save Matt and his friends.

Throughout the movie, Jed demonstrates rock-solid loyalty to friends, family, and the American way of life.

Truman Gates (*Next of Kin*) may have moved to Chicago to become a big-city cop, but he remains dedicated to his kin and their hillbilly, rural Kentucky way of life. Even though Truman wants to solve his brother Gerald's (Bill Paxton) murder in a legal fashion, he respects his other brother Briar's (Liam Neeson) oath to exact mountain vengeance on Gerald's killers. He remains loyal to Briar to the last, trying to protect him from the unyielding Chicago mob.

Derek Sutton (*Youngblood*) is the captain and unquestioned leader of the Hamilton Mustangs. Derek is faithful to his teammates and his team, particularly to the troubled but talented Dean Youngblood (Rob Lowe). Even after Dean quits on his team in the middle of a playoff series, Derek remains loyal and lobbies the coach to let Dean return.

Darrell Curtis (*The Outsiders*) is fiercely loyal to his family. Despite the hardships, Dean does his best to keep all the Curtis boys together after their parents are killed. He also remains committed to their group of Greaser friends, even though he now works a steady job in the "legitimate" world of the Socs. His fellow Greasers know and appreciate this. As Two-Bit (Emilio Estevez) tells Ponyboy (C. Thomas Howell), "You know, the only thing that keeps Darry from being a Soc is us."

Johnny Castle (*Dirty Dancing*) is one of the most loyal characters in all of '80s cinema. Johnny stands by his dance partner Penny (Cynthia Rhodes) after she is impregnated by scumbag college boy Robbie (Max Cantor), and takes responsibility for her when Dr. Houseman asks. Johnny becomes romantically involved with Baby (Jennifer Grey), though "the help" is only supposed to interact with resort guests on a professional basis. Johnny refuses to disclose their secret relationship, even after he is falsely accused of stealing a wallet when he was really doing the horizontal mambo with Baby. Johnny's final act of loyalty is to show up to dance with Baby at the resort's summer farewell show. "Nobody puts Baby in the corner," Johnny tells Baby's parents before he pulls her onstage for the uplifting finale.

Patrick Swayze is a man you want in your corner. He is loyal to a fault, and will fight for you regardless of the personal consequences.

Patrick Swayze Doesn't Change His Hair for a Role, He Adapts the Role to His Hair

Patrick Swayze had a magnificent mane of hair in the 1980s. Were there a Movie Hair Hall of Fame, Patrick Swayze's hair would surely be elected on the first ballot. To this day, his hair still has its own Facebook page.

Swayze's hair varied little from one '80s movie to the next. He had wavy, feathered brown hair with an unruly curl playfully tickling his forehead. Swayze's hair fit the definition of a mullet—business in front (shorter) and party in the back (longer)—while still managing to defy labels or categories.

Patrick Swayze's hair simply could not be contained. In *The Outsiders*, he's forced to grease it back in deference to his social class, but it refuses to be confined, particularly in the dramatic rumble sequence. In *Next of Kin*, Swayze wears a hat for much of the movie, and keeps his hair tied back in a ponytail. But when he turns in his badge and goes renegade in the end, he lets his freak flag fly. The hair that has been carefully controlled for the whole movie has now been released to exact its own wild vengeance on the Chicago mob.

The roguish charm of Patrick Swayze's hair is the perfect companion for his characters. Like Swayze himself, it is charismatic and winning, but hints at a naughty side lurking just beneath the exterior.

Patrick Swayze is His Brother's Keeper

Patrick Swayze's movie characters are leaders. They protect family, friends, and the innocent from the forces of tyranny. Is Patrick Swayze his brother's keeper? Yes, he is.

In *Uncommon Valor*, Kevin develops a close relationship with the ex-soldiers on a mission to rescue prisoners of war. They become like brothers to him, and he's willing to lay down his life to protect them and fulfill the mission. Kevin leaves his secure

ambush post to provide cover for Charts (Tim Thomerson) after Charts' helicopter goes down.

Johnny is the unofficial leader of *Dirty Dancing*'s working-class dancers. He watches out for them, refusing to put up with the condescending abuse of the preppy Ivy League waiters. Johnny is particularly protective of dance partner Penny (Cynthia Rhodes), organizing the other dancers to cover for her when she needs an abortion, so she won't lose her job.

Derek Sutton (*Youngblood*) looks out for talented rookie Dean Youngblood (Rob Lowe). Sure, he shaves Dean's balls in a locker room male bonding session, but he also protects Dean from the coach's wrath. After a dispute over playing time with Coach Chadwick (Ed Lauter), Dean throws away the puck he saved from his first professional goal. Derek secretly rescues the puck and returns it to Dean as a cherished memento. An injured Derek later intervenes to convince Chadwick to allow Dean to return to the team.

Dalton (*Road House*) comes to the small town of Jasper, Missouri to clean up the Double Deuce bar. Dalton soon learns that businessman Brad Wesley (Ben Gazzara) controls the town through coercion and physical intimidation. Wesley bleeds the town by taking 10% from all businesses for the "Jasper Improvement Society". Though it's not in his job description, Dalton takes on Brad Wesley. "I've seen his kind many times. He keeps taking and taking until somebody takes him." Dalton's just the man for the job.

Darrell Curtis looks out for his younger brothers Sodapop (Rob Lowe) and Ponyboy (C.Thomas Howell) in *The Outsiders* after their parents are killed. Darrell struggles to keep the family together. Even though Ponyboy bristles at Darrell's authority, he knows Darrell is trying to protect him just as his parents would have. Darrell is a father figure for the other Greasers, serving as their leader and spokesman at the big rumble.

Truman Gates is a Chicago cop, but his primary concern in *Next of Kin* is the safety of his own brothers. His brother Gerald (Bill Paxton) is murdered in cold blood by the Chicago mob. Truman is distraught that he couldn't protect his brother in his own city. "Damn what you coulda' done, it's what's gotta be done," his brother (Liam Neeson) tells Truman before heading to Chicago to

mete out his own vigilante justice. Truman knows Briar bit off more than he could chew in the Chicago mob, and with all the tools in his arsenal tries to protect his stubborn brother.

In *Red Dawn*, Jed Eckert is the acknowledged leader and protector of the motley group of teenagers hiding out from the Soviets in the Colorado mountains. No scene better illustrates how Patrick Swayze is his brother's keeper than when fatally injured Jed carries his dying brother Matt (Charlie Sheen) through the snow to the town park.

Patrick Swayze Has a Chip on His Shoulder

The running joke in *Road House* is that everybody thinks superbouncer Dalton should be bigger. Like David fighting Goliath, Dalton has something to prove—to himself and to everyone else. Patrick Swayze's other '80s movie characters also seem to have a chip on their shoulder.

Dalton (*Road House*) is out to prove that preparedness and guile can best brawn, and that he can outrun his brutal past. Jed Eckert (*Red Dawn*) wants to prove the survival tactics instilled in him by his father Tom (Harry Dean Stanton)—"*Avenge me!*"—and that American freedom and spirit are superior to Soviet tyranny. Darrell Curtis (*The Outsiders*) seeks to show that he can keep his family together in the face of long odds. *Youngblood*'s Derek Sutton is set on getting noticed by professional hockey scouts so he can earn a pro contract.

Kevin Scott (*Uncommon Valor*) has a huge chip on his shoulder. He isn't accepted by the former soldiers on the P.O.W. rescue mission because he is young and never served in Vietnam. The crucial moment for Kevin is when he fights Sailor (Randall "Tex" Cobb). Though he loses badly, Kevin keeps coming, a la *Cool Hand Luke*. The other soldiers learn Kevin's father is missing in action, and gain new respect for him and his commitment to the mission.

Johnny Castle (*Dirty Dancing*) also carries around a sizable chip on his shoulder in regard to the injustices of the American class system. Working class dancer Johnny dreams of being good enough for Baby (Jennifer Grey) in the eyes of Baby's father (Jerry Orbach). He resents the smugness and condescension of the

wealthy class. Winning Baby is one way to prove that he's good enough.

Patrick Swayze is Not Afraid to Take on a Big Fight

No opponent is too big, too powerful, or too numerous for Patrick Swayze. In the 1980s, he never backed down from a fight, no matter how hopeless the situation.

In *Youngblood*, the villain is Racki (George Finn), a goon on skates who still bears a grudge over being cut by Coach Chadwick. Mustangs captain Derek takes on Racki, checking him into the boards. A pissed-off Racki cheap-shots Derek, sending him to the hospital to have a metal plate inserted in his head, quite possibly ending his hockey career.

Darrell (*The Outsiders*) takes on the biggest Soc of the bunch at the big rumble. His example helps lead the Greasers to victory, and the Socs head home in their Mustangs with their tails between their legs.

In *Uncommon Valor*, Kevin and the others take on a mission everyone thinks is impossible. They sneak into Laos, and with no external support, this small team of soldiers infiltrates a P.O.W. camp and releases four American soldiers being held captive. They do all this while taking heavy fire from the Vietnamese army.

Dalton (*Road House*) takes on the powerful Brad Wesley (Ben Gazarra) and his goons in addition to performing his nightly duties as a bouncer at the rowdy Double Deuce. Wesley is well-connected and feared by everyone in town. Dalton defeats all of Wesley's hired goons, including martial arts expert Jimmy (Marshall Teague), whose throat he rips out with his bare hands! Dalton's selfless battle inspires the townspeople to rise up and take out Brad Wesley themselves in the movie's final scene.

Truman Gates (*Next of Kin*) takes on the entire Chicago mob after they kill his two brothers. Truman is a cop, but turns in his badge and picks up a bow and arrow to exact some Kentucky mountain vengeance on the mob. "You ain't seen bad yet, but it's coming," he warns head mobster John Isabella (Andreas Katsulas).

The final action sequence takes place in a cemetery at night, as Truman decides to "do a little huntin'" on a gaggle of mobsters.

Red Dawn takes the David vs. Goliath aspect of Swayze's characters to a whole new level. Soviet and Cuban armies parachute into middle America to cut off the eastern and western halves of the United States. Jed Eckert and a tiny band of high schoolers escape into the surrounding Colorado mountains. From these mountains, Jed leads the rebel Wolverines in small hit-and-run attacks on the Soviets, slowly drawing more and more heat. Though Jed and most of the others are eventually killed by the Soviets, they become martyrs that inspire the nation to fight back and repel the Communist invasion.

Patrick Swayze is Practical

Despite his characters' tendencies to take on big battles, Patrick Swayze's characters are also very practical. Practicality is a useful tool in dealing with the difficulties of daily life.

Johnny (*Dirty Dancing*) puts up with the condescension of his upper-class bosses because he needs the job. He tolerates a great deal from Neil, the son of the man who runs the resort, because he understands the reality of the situation. Both he and Neil know he can be replaced. As much as he enjoys dancing, it's still a business proposition for Johnny. As he tells Baby, the reason he got into dancing in the first place was because dance instructors made good money.

Darrell (*The Outsiders*) is thoroughly grounded in reality. Darrell would probably love to cruise around in a Mustang or try to pick up attractive girls at the drive-in, as the other characters in the movie do. He can't though—he's working to clothe, feed, and keep a roof over the heads of his two younger brothers, who have relied on him since their parents' death.

Dalton's choice of conveyance in *Road House* is pure practicality. Though he owns a very nice BMW, Dalton purchases a beat-up Buick Riviera at a used car dealership once he gets to town. We soon find out why, as disgruntled patrons of the Double Deuce slash his tires, break his radio antennae, and put a stop sign through his windshield. "Your fan club?" Elizabeth asks. "They

are devoted," Dalton says, knowing it means another trip to Red's Hardware.

There's nothing like a Soviet invasion to bring out your practical side. Jed (*Red Dawn*) appeals to the most practical human instinct of all—survival—when trying to calm the others. "My family would want me to stay alive." Jed's practical nature is shown later in the movie when a couple of their fellow Wolverines are killed.

> **Jed**: "It was bound to happen sooner or later."
> **Matt**: "You're gettin' pretty lean on feelings, aren't you?"
> **Jed**: "Can't afford 'em."

Pain Don't Hurt Patrick Swayze

When we first meet Dalton in *Road House*, his arm is sliced by a knife; after ridding the bar of the offending patron, Dalton calmly stitches up his wound in the bathroom sink. We should know at that point that Dalton is no stranger to pain.

It doesn't get much better for Dalton once he accepts a job at the rowdy Double Deuce. One of Brad Wesley's goons slashes Dalton's side, sending him to the hospital. An experienced emergency room visitor, Dalton brings along a complete medical history. Dr. Elizabeth Clay (Kelly Lynch) tells him he can "add nine staples to your dossier of 31 broken bones, two bullet wounds, nine puncture wounds, and four stainless steel screws."

> **Dr. Clay**: I'll give you a local.
> **Dalton**: No, thank you.
> **Dr. Clay**: Do you enjoy pain?
> **Dalton**: Pain don't hurt.

Derek Sutton (*Youngblood*) also endures a world of pain when Racki cheap-shots him, pulling out Derek's legs with his stick. Derek hits his head on the ice, and must have a steel plate inserted in his head. Derek doesn't complain though, and shows up to cheer on his team and to convince the coach to give Dean another shot.

How are you going to beat a guy who is oblivious to pain? That's one more reason why you shouldn't mess with Patrick Swayze.

Patrick Swayze: Lover, Fighter, Philosopher

It's not difficult to see why we love Patrick Swayze. For the ladies, he's handsome, loyal, he can dance, and he has that protective quality that makes a woman feel safe. For the guys, he kicks ass, is willing to take on the Soviets, hangs around with cool dudes like Sam Elliott, and does it all with panache. In short, Patrick Swayze is a 1980s Renaissance man—a lover, fighter, and philosopher.

Though Patrick Swayze clearly knows how to treat a lady, he doesn't sleep around in his '80s movie roles. There are no love interests in *The Outsiders*, *Uncommon Valor*, or *Red Dawn*. And while it's implied that he once enjoyed "tea time with Miss McGill" (Fionnula Flanagan), we don't see him fornicating in *Youngblood* either. In *Next of Kin*, he's married to Helen Hunt and doesn't even glance at another woman. *Road House*'s Dalton is a ramblin' man. Dr. Elizabeth Clay (Kelly Lynch) knows he's a bad boy, and that he'll soon be moving on, but she wants him anyway. She and Dalton share a steamy love scene against a fireplace and out on the roof of his barn loft. Dalton is loyal to Elizabeth, spurning some very aggressive offers from buxom blonde Denise (Julie Michaels).

Dirty Dancing is the movie that really cements Swayze's legacy with the ladies. Dance instructor Johnny has wealthy, neglected cougars stuffing their room keys in his pockets, but he only has eyes for Baby. Female viewers swoon when Johnny tells Baby's parents, "Nobody puts Baby in the corner," because that statement perfectly summarizes how special many women dream of being treated. What woman doesn't want to be lifted up by Patrick Swayze, and to sing "I've had the time of my life!" to the masses?

Though he's quite the lover, Patrick Swayze is a fighter, too. If you're his friend, he'll do anything for you. But if you cross Patrick Swayze, look out! Whether he's fighting Socs, Soviets, or sleazeballs, Patrick Swayze knows how to kick some butt. So look

out, rowdy bar patrons, because the "best damn cooler in the business" is on duty.

Not a fan of sex and violence? Well, Patrick Swayze has something to offer you too. Patrick Swayze is a philosopher! No, seriously. Dalton from *Road House* has a degree in philosophy from N.Y.U., where he studied "man's search for faith, that sort of shit." And aren't we all—deep down—searching for faith or some "sort of shit" like that?

Lover, fighter, philosopher, '80s Renaissance man. Patrick Swayze had special qualities that won us all over. He saved small-town America from corrupt thugs, he swept us off our feet and made us feel special, and he even helped America fight off a Soviet invasion. And he did it all with a truly extraordinary head of hair. We sure could use more men like Patrick Swayze around today to show us the way. Patrick Swayze, we salute you.

15. Nature or Nurture: Exeter or Racehorses?

What is more important to human makeup and development: environment or genetics? This scientific debate has raged for centuries. The answer has major social implications, including how we raise our children, how we approach education and health care, and how we conduct our criminal justice system. Some believe that the environment in which we are raised and live is more important—our family, education, friends, circumstances. Others believe that genetics play a much more important role in who we are, our character traits, and how we live.

A great deal of scientific research has been conducted on this topic, with few definitive conclusions. Good news though. As with most important human questions, '80s movies have an answer for us. The answer lays in the movie *Trading Places* (1983). Originally designed as a Gene Wilder/Richard Pryor vehicle, the movie stars Dan Aykroyd and Eddie Murphy as Louis Winthorpe III and Billy Ray Valentine. Winthorpe (Aykroyd) is the very picture of a yuppie: a wealthy, pampered business executive with the world at his fingertips, from his beautiful fiancée Penelope Witherspoon (Kristin Holby) to his servant Coleman (Denholm Elliott) to his friends at the exclusive Heritage Club ("Looking good, Louis." "Feeling good, Todd.") Valentine (Murphy), on the other hand, is a down-on-his-luck scam artist, pretending to be a blind, crippled Vietnam veteran, panhandling for money. Their fates collide because of the whim of two men: wealthy commodities brokers Randolph (Ralph Bellamy) and Mortimer (Don Ameche) Duke.

Randolph and Mortimer Duke are fabulously wealthy and powerful men. The brothers get into a disagreement about nature versus nurture after Randolph reads an article on the subject in *Science Journal* magazine. When their star employee Winthorpe enters the room, its sets off a lively debate between the brothers.

> **Randolph**: Exeter, Harvard, he's (Winthorpe) the product of a good environment.

Mortimer: It has nothing to do with environment. With his genes, you could put Winthorpe anywhere and he'd come out on top. Breeding, Randolph, same as in racehorses. It's in the blood.

Billy Ray Valentine enters the picture after a misunderstanding with Winthorpe, for which he is arrested and thrown in jail.

Randolph: That man (Valentine) is the product of a poor environment. There's absolutely nothing wrong with him. I can prove it.
Mortimer: Of course there's something wrong with him. He's a Negro. Probably been stealing since he could crawl.
Randolph: Given the right surroundings and encouragement, I'll bet that young man could run our company as well as your young Winthorpe.
Mortimer: Are we talking about a wager, Randolph? I suppose you think Withorpe, say if he were to lose his job, would resort to holding up people on the streets?
Randolph: No, I don't think losing his job would be enough for Winthorpe. I think we'd have to heap a little more misfortune on those narrow shoulders. If he lost his job, and his home, and his fiancée, and his friends, if he were somehow disgraced, arrested by the police and thrown in jail even…yes, I'm sure he'd take to crime like a fish to water.

The Dukes arrange for marked money and drugs to be planted on Winthorpe, and for a prostitute Ophelia (Jamie Lee Curtis) to make out with him and beg him for drugs in front of his fiancée. He's thrown in jail, loses his home and job, has his assets frozen, and sees his fiancée and friends quickly desert him. In desperation, he turns to Ophelia for a place to stay. Winthorpe shows up drunk and wielding a gun at the Dukes' corporate Christmas party, making good on Randolph's prediction.

At the same time, the Dukes install Valentine in Winthorpe's old home, and give him Winthorpe's job. When the Dukes condescendingly explain what a commodity broker does, Valentine replies, "Sounds to me like you're a couple of bookies." Randolph smiles to Mortimer. "I told you he'd understand." Valentine takes to the job quickly, using his street smarts and knowledge of human behavior to achieve success at Duke and Duke.

The Dukes' social experiment is answered decisively in favor of Randolph—and nurture. The experiences of Winthorpe and Valentine demonstrate conclusively that nurture trumps nature—that environment outweighs genetics. "We took a perfectly useless psychopath like Valentine, and turned him into a successful executive. During the same time, we turned an honest, hard-working man into a violently deranged would-be killer." Randolph gleefully accepts his prize—a crisp $1 bill—from Mortimer.

So there you have it. Mystery solved, debate over, thanks to '80s movies. Environment exerts a far greater influence on human behavior than genetics. So forget racehorses, and try to get your kid into Exeter.

16. How to Succeed in Business

The United States is the largest economy in the world. Our gross domestic product (GDP) is greater than that of the second- and third-largest nations (China and Japan) *combined*. The U.S. spends over 50% more than any other nation in the world. Life in the American corporate world is highly competitive and has become even more so since the recent economic recession. The question of how to get an economic edge has never been more pressing than it is today. *Rich Dad, Poor Dad*, *The Seven Habits of Highly Effective People*, *Smart Women Finish Rich*, and many other economic self-help guides pander to a population obsessed with its economic health.

Trying to get a leg up in the business world is by no means a new phenomenon. The 1980s were a decade abnormally preoccupied (even by American standards) with the corporate world, the accumulation of wealth, and material well-being. That preoccupation was reflected in 1980s movies, many of which offer important life lessons on how to succeed in business.

Know the Market

In order to succeed in any business, you have to know the market. You don't want to be selling capris when skinny jeans are all the rage, or monstrous gas-guzzling SUVs when consumers are interested in fuel efficiency. A number of '80s movies demonstrate how knowledge of the market can help people successfully compete.

After complaining to a carnival wish machine (Zoltar), pre-teen Josh Baskin suddenly grows *Big* (1988), and becomes a full-grown man (Tom Hanks). Naturally, he gets a job with a toy company, and demonstrates a much better understanding of the child demographic than the other adults at the company do. Josh's first-hand knowledge of what kind of toys children really want helps him succeed at his job and impress his boss (Robert Loggia).

Winthorpe (Dan Aykroyd) uses his knowledge of and experience with the stock market to best his former bosses and make a fortune in *Trading Places* (1983). On the way into the

stock exchange at the end of the movie, he tells inexperienced Billy Ray Valentine (Eddie Murphy): "Think big. Think positive. Never show any sign of weakness. Always go for the throat. Buy low, sell high. Fear? That's the other guy's problem. Nothing you've ever experienced can prepare you for the unbridled carnage you're about to witness."

Eddie Felson's (Paul Newman) area of expertise in *The Color of Money* (1986) is pool hustling. Though not a traditional occupation, it is certainly a business, and a potentially lucrative one. Eddie tries to tutor young pool shark Vince (Tom Cruise) in the art of the hustle, and especially in how not to scare away potential marks. "Sometimes if you lose, you win…The real money's (at a pool tournament) in the practice room." Vince has difficulty hiding his light under a bushel. Eddie advises him against taking a fancy cue (the Balabushka) into a pool hall: "Play with the house cue. Go in there with that, and nobody'll come near you with a nickel."

Joel Goodsen (Tom Cruise) takes advantage of his parents' vacation in *Risky Business* (1983) to turn their suburban Chicago home into a den of "human fulfillment." Joel uses his personal experience as an undersexed young man to sell other undersexed young men on the idea of patronizing his makeshift brothel. Joel points out the economic shrewdness of his cathouse to one guy (Stan), running through the cost of Stan's unsuccessful dates.

> **Joel**: Alright Stan, you're in for roughly 60-odd dollars. And what happened?
> **Stan**: (ruefully) She slept with Jacobsen.

Joel plays up the experience angle with another young man at a gas station. "You know what he [a guy who visited a prostitute] said afterwards? He said the lady had knowledge. And he was glad to get that knowledge. You know why? Because college girls can smell ignorance…like dogshit." Joel's sales pitches work, he fills his house, and grosses over $8,000 in one night—enough to fix his father's Porsche, which Joel accidentally rolled into Lake Michigan.

Knowledge of the market is essential. Josh, Winthorpe, Eddie, and Joel succeed because they can accurately read the market and know how to be successful in it.

It's the Little People that Make a Business Work

A very wise man once told his son before his first day of high school: "Son, you need to mind the principal and do whatever your teachers ask of you, but the people you really need to befriend are the so-called 'little people'—the secretaries, the custodians, the lunch ladies, the hall monitors. They're the ones who *truly* run the school. Be good to them, and you won't regret it." It was excellent advice that served the young man well, both in high school and in the working world.

The wise man's advice is true of almost every business. CEOs and board members may be very powerful and well-compensated, but businesses survive and thrive because of all the so-called "little people" who perform the essential daily grind.

In *The Secret of My Success* (1987), Brantley Foster (Michael J. Fox) works in the mailroom of the Pemrose Corporation, but dreams of being an economic player. Brantley uses his mailroom experience to take advantage of the company's bureaucratic structure in posing as an executive (Carlton Whitfield) and influencing company decisions. Brantley finds that he can get away with just about anything, as long as people get a memo. A sharp line is drawn within the corporation between the workers (who do all the real work) and the "suits" (who make the decisions). Neither group consorts with the other, which is a big part of the problem for the Pemrose Corporation. Brantley succeeds because he combines these two styles: the blue-collar hard work and the white-collar decision-making.

Gung Ho (1986) is the story of an American automobile plant that is purchased by a Japanese company. Hunt Stevenson (Michael Keaton) is hired as the liaison with the new Japanese owners. The Japanese apply their own business practices to the American plant. The plant doesn't succeed until the rigid Japanese owners compromise with the American line workers. Hunt finally

convinces both sides to work together, and the plant sets a manufacturing output record.

No '80s movie demonstrates the importance of the "little people" more than *Nine To Five* (1980). Violet (Lily Tomlin), Doralee (Dolly Parton), and Judy (Jane Fonda) are working women who end up kidnapping their sexist jerk of a boss, Franklin Hart (Dabney Coleman). The three women run the company themselves, forging Hart's signature and instituting a number of pro-worker innovations. The unit's efficiency improves by 20% and a clueless Hart is promoted up and out of the unit, leaving the true talent in charge.

Most people at one time or another think they work harder and could run their company better than the bosses. If '80s movies are to be believed, the workers really could run businesses better than the "suits." While this may be somewhat of an exaggeration, it is undeniable that businesses are more efficient and successful when the people who do the work are actively invested in the company's decision-making.

Fill a Need in the Marketplace

In the 1940s, Swiss electrical engineer George de Mestral was hunting with his dog in the Alps, and became annoyed with the burrs that kept sticking to all his clothes and his dog's fur. The burrs provided de Mestral with the idea that became Velcro, which he patented in 1955.

J.K. Rowling was a single mother, getting by with the help of Social Security, when she came up with the idea for the *Harry Potter* book series. Published in 1997 with an initial print run of only 1000 copies, Rowling's *Harry Potter* series went on to sell over 400 million copies and make Rowling a billionaire.

The success of both Velcro and *Harry Potter* depended on a confluence of factors, including conception, timing, distribution, and promotion. However, no factor is more important than demand. If people had been perfectly happy tying shoelaces, or if no one had been interested in reading about a school of wizardry, then de Mestral would have remained an unknown engineer and Rowling might still be living in a poor flat in London. It was public demand that made the difference for these two products.

Filling a niche in the marketplace can turn a good idea into a huge success. Two '80s movies provide excellent examples of how providing a needed service or product can be highly profitable.

Monty Capuletti (Rodney Dangerfield) is a typical working stiff in *Easy Money* (1983). Monty and his buddy Nicky (Joe Pesci) are frustrated with the froofy selection of shirts in the menswear section of Monahan's Department Store. "Do you have any men's shirts for men?" When questioned further by store executives, Monty tells them, "Men don't have style, men wear clothes. Women have style." Based on Monty's suggestions, Monahan's introduces "The Regular Guy Look," with comfortable shirts, pants with a lot of room, and shoes that go on and off easily. "The Regular Guy Look" is a surprise success and resonates with the public.

Risky Business' Joel Goodsen (Tom Cruise) makes the acquaintance of call girl Lana (Rebecca de Mornay), who visits him in his parents' wealthy suburban Chicago home while Joel's parents are on vacation. Lana tells Joel, "We ever got our friends together, we'd make a fortune." Naturally, Joel balks at the idea of turning his parents' home into a brothel. Lana eventually convinces him: "You're providing your friends an invaluable service. And God knows they need the service." Lana's hooker friends and Joel's wealthy, horny friends are the perfect mix, and Joel grosses $8,000 in one night.

Great ideas and great products are not enough if there is no demand. True economic success comes when the right product or service meets demand. If you can successfully fill an unmet need in the market, perhaps you too can create the next Velcro or *Harry Potter*.

Information is the Most Valuable Commodity

Wall Street (1987) tycoon Gordon Gekko (Michael Douglas) tells protégé Bud Fox (Charlie Sheen) that "the most valuable commodity I know of is information." He goes on to inform Fox that while the general public is "out there throwing darts at a board," he only bets on "sure things." And why are they sure things? Because Gekko has access to information that the

general public does not. Gekko advises Fox to "read Sun Tzu's *Art of War*. Every battle is won *before* it's even fought."

Making smart, effective decisions in business environments is critical to success. The decision-making process is informed by the facts you have available to you. It follows that you make better decisions if you have more—and better—information at your fingertips.

Brantley Foster (Michael J. Fox)—a.k.a. Carlton Whitfield—of *The Secret of My Success* (1987) moves up in the corporate world thanks to his command of information. CEO Howard Prescott (Richard Jordan) openly wonders how Brantley/Carlton obtains all his information. "Well, it's available in most quarterly stock reports," Brantley replies, with the implication that the information is there for those dedicated enough to look for it and smart enough to find it.

Winthorpe (Dan Aykroyd) and Valentine (Eddie Murphy) are able to turn the tables on the manipulating Wall Street tycoons Randolph (Ralph Bellamy) and Mortimer (Don Ameche) Duke in *Trading Places* via access to information. When they discover the Dukes have paid off the shadowy Clarence Beeks (Paul Gleason) to illegally obtain a government crop report prior to its becoming public, Winthorpe and Valentine intercept Beeks and the crop report, and give the Dukes a fake report. With the predictions it contains, they corner the market on orange futures, strike it rich, and send the Dukes to the poorhouse.

In *Wall Street*, Fox and Gekko eventually run afoul of the Securities and Exchange Commission (SEC), which regulates commodity trading. They are jailed for insider trading, illegally gaining access to non-public information. The fact that these two Wall Street players took their pursuit of information too far by breaking the law does not negate the importance of information to business. While he is greedy and corrupt, Gekko is also right: information *is* the most valuable commodity. Follow Brantley Foster's example, and do your homework. Good information helps you make good decisions.

Play to Your Strengths

All of us have strengths and weaknesses. One of the keys to success in business— and life in general—is to emphasize your personal strengths while minimizing your weaknesses. As Cyn (Joan Cusack) tells Tess (Melanie Griffith) in *Working Girl*, "Sometimes I dance around the house in my underwear. Doesn't make me Madonna. Never will." Self-awareness is a valuable asset.

Tess tells Jack Trainor (Harrison Ford), "I have a head for business and a bod for sin. Is there anything wrong with that?" Not at all, Tess, especially if you know how to use them. Tess uses both to her advantage in *Working Girl*, closing a big deal with Trask (Phillip Bosco), landing her man (Trainor), and outdoing rival Katharine Parker (Sigourney Weaver).

Vince (Tom Cruise) in *The Color of Money* (1986) is not blessed with self-awareness. Luckily for him, Eddie Felson (Paul Newman) is "a student of human moves," and knows how to use Vince's personality to both their advantages. "You are a natural character. You're an incredible flake. But that's a gift." Eddie and Vince team up to run profitable pool scams, taking advantage of Vince's quirkiness and pool talent, and Eddie's knowledge of all the angles.

Use Resources at Hand

There's an old saying that "when life gives you lemons, make lemonade." The point is to do the best you possibly can with the resources at your disposal. No movie illustrates that axiom better than *Planes, Trains, and Automobiles* (1987).

In this classic '80s movie, Neal Page (Steve Martin) and Del Griffith (John Candy) are two businessmen desperately trying to get home for the Thanksgiving holiday. Neal and Del end up in a Trailways bus station in St. Louis with almost no money—but necessity is the mother of invention. Del, a shower curtain ring salesman, begins marketing his shower ring samples as custom earrings to denizens of the bus station. It's a remarkable example of salesmanship and of telling the customer what they want to hear to close the sale. Del pitches earrings as Diane Sawyer

autographed, Czechoslovakian ivory, Walter Cronkite moon ring, helium filled, Daryl Strawberry autographed, or "originally handcrafted for the Grand Wizard of China," depending on his audience's tastes. Del tells one group of girls in their early teens "it makes you look older. You could pass for 18 or 19." Sale completed!

Del and Neal raise enough money for their bus tickets, and they're on to their next vehicular adventure. So when life gives you lemons (or shower curtain rings), make lemonade (or sell earrings)!

Hard Work and Persistence

Thomas Edison once said "genius is 1% inspiration and 99% perspiration." In case that quote is too subtle, Edison also said "there is no substitute for hard work." America's economic history is filled with rags-to-riches stories of people who built up successful businesses from nothing—even business empires and vast wealth—through sheer grit and determination. Reagan-era America embraced this vision of the American dream wholeheartedly, and that's reflected in 1980s movies. Seemingly every '80s movie features a musical montage sequence of a protagonist working *really* hard to achieve a goal.

In *The Secret of My Success*, Brantley Foster (Michael J. Fox) works in the mailroom at the Pemrose Corporation, but uses an empty office and his access to intra-company memos to double as junior executive Carlton Whitfield. Brantley's double duty requires not only frequent outfit changes in Pemrose's elevators, but a great deal of hard work. He spends his nights analyzing Pemrose and business trends, hard work which pays off for him at the end.

Working Girl's Tess McGill (Melanie Griffith) pulls similar double duty. Tess ably fulfills her duties as an administrative assistant, and moonlights to close a huge deal with Jack Trainor (Harrison Ford). Tess and Jack even crash a wedding in order to set up a business meeting with elusive business tycoon Oren Trask (Phillip Bosco).

Gung Ho (1986) is about the cultural clashes that occur when a Japanese car company buys and operates a Pennsylvania auto factory. After numerous difficulties, the American crew and the Japanese administration work together to meet an impossibly high production quota and save the plant.

Bud Fox (Charlie Sheen) wants to be a *Wall Street* (1987) player in the worst way, and relentlessly pursues corporate shark Gordon Gekko. Bud calls Gekko's office 59 days in a row to arrange a meeting, finally getting through the coveted doors with the aid of a box of rare Cuban cigars as a birthday gift for Gekko. Once he has his foot in the door, Fox works hard to kick the door in and make it big in the corporate world.

Knowledge, luck, and many other factors are important in the business world. However, as Edison advised, there is no substitute for hard work. So roll up those sleeves and work on that 99% perspiration to make that 1% inspiration into a success.

Dream Big

"Dream no small dreams, for they have no power to move the hearts of men." Goethe was a literary giant, and much smarter than the rest of us, so it behooves us to follow his advice. Though he wasn't specifically thinking about business when he wrote this, the "dream big" maxim is a very applicable one in the business world. Rockefeller, Carnegie, Ford, Trump, Gates—these legends of the business world didn't reach the heights they did by dreaming small. They dreamed big, then worked hard to reach those dreams.

We've already discussed Brantley Foster (*The Secret of My Success*) and Tess McGill (*Working Girl*), who weren't satisfied with their low-level corporate jobs. Both dreamed of big deals and success in the upper levels of corporate America, and worked hard to make it a reality. There's certainly nothing wrong with working in a mailroom or being a secretary, but if you have big dreams of another life and don't strive toward those dreams, you will always be resentful of your situation.

Though he's probably not the best example of business ethics, Tony Montana [Al Pacino, *Scarface* (1983)] certainly has big dreams, and won't let anyone stand in his way. Tony repeatedly meets characters who think his dreams are too big, his

methods too aggressive. Even his best friend and right-hand man Manny (Steven Bauer) doesn't understand.

> **Manny**: I say be happy with what you got.
> **Tony**: You be happy. Me, I want what's coming to me.
> **Manny**: What's coming to you?
> **Tony**: The world, *chico*…and everything in it.

Tony's big dreams, his *cajones*, and some help from his "little friend" take Tony all the way to the top of the Miami cocaine world. Not bad for a common Cuban criminal turned political refugee. Though his success is fleeting, Tony gets a taste of his big American dream. Dream big, or go home.

Millions of dollars are spent in the U.S. each year on get-rich-quick schemes and advice on how to succeed in business & make a fortune. Despite these myriad methods, there is no secret formula out there; there are many *potential* paths to success. So before you drop your hard-earned money on books like *Swim With the Sharks Without Being Eaten Alive* or *Control Your Destiny or Someone Else Will* or *How to Become a Rainmaker*, please consider the business advice of 1980s movies. Take the time and effort to know your market. Appreciate the value of the so-called "little people" to any business. Fill a need in the marketplace. No commodity is more valuable than information. Know your strengths, and use them to your advantage. Make the best use of available resources. Work hard and be persistent. And of course: dream big. Follow this advice and you're sure to be more satisfied and successful in the competitive business world. Good luck!

17. Did Jake Ryan Give a Generation of Women Unrealistic Expectations?

Sixteen Candles (1984) tells the story of Samantha Baker (Molly Ringwald). Samantha's entire family has forgotten her 16th birthday amidst the preparations for her sister's wedding. The object of Samantha's affection, popular high school senior Jake Ryan (Michael Schoeffling), seems unattainable. Jake is dating the hottest girl in school, and Samantha doesn't believe Jake knows she exists. However, Jake Ryan has grown weary of his shallow girlfriend Caroline (Haviland Morris) and is looking for a more serious, sensitive girlfriend. Eventually, Jake and Samantha make that connection, and the movie ends with the two of them kissing above Samantha's birthday cake. Many love *Sixteen Candles* as a wonderful fairy tale romance that inspires viewers to believe in the power of true love. These women see Jake Ryan as the perfect guy. Others deride this John Hughes movie, and its central relationship between Samantha and Jake, as sappy and unrealistic. Did Jake Ryan's perfection spawn a generation of women with unrealistic expectations? Point/Counterpoint takes a look at both sides of the question.

Wake Up, Ladies! Jake Ryan is *Not* Out There Waiting to Sweep You Off Your Feet

Sixteen Candles is an unrealistic female fantasy. More than that, the popular '80s movie is damaging, and creates unreasonable expectations for an entire generation of American women. Jake Ryan is a pipe dream, and the sooner women realize this, the better.

Sixteen Candles is nothing more than a 1980s retelling of the classical fairy tale romance that has obsessed the female psyche for centuries. Instead of a dashing prince, a brave knight, or a rugged cowboy on his trusty steed coming to sweep the damsel off her feet, you have Jake Ryan sweeping Samantha off her feet and into his shiny red Porsche 944.

Jake Ryan is the embodiment of romantic fantasy. He's rich, he's good looking, he dresses well, he's popular, and he

drives a nice car. But wait, there's more! In addition to all that, Jake Ryan is also thoughtful, sensitive, and looking for his true love.

This is completely unrealistic. Guys like Jake Ryan are rarely if ever caring, sensitive types. Sensitivity is a product of one's environment; it's the ability to empathize with others, their lives, and their situations. Jake Ryan leads a very pampered life in suburban Chicago. His parents own a beautiful home, his father drives a Rolls Royce, and although he's still in high school, Jake drives a red Porsche. He is dating Caroline, the prom queen and the envy of all the other girls. Jake's parents are rarely around, and his home is often party central. These are not circumstances which breed a caring, compassionate young man. Jake Ryan has never had to experience want, suffering, hardship, or rejection. The people who might best help Jake develop caring, compassion, and other positive traits—his parents—don't seem to be around very much. Jake's high school friends—the "in" crowd—are only interested in partying and having a good time. In short, it is unrealistic to expect a guy like Jake Ryan to be the thoughtful, sensitive type that so many women dream about.

It is also improbable that Jake Ryan would fall for Samantha. Jake is a popular senior, dating the hottest girl in the school. She's so hot, she even showers in slow motion! If he's no longer interested in dating Caroline, any number of girls would line up to replace her. Why would he notice a sophomore like Samantha, who describes herself as "utterly forgettable?" Teenage boys are controlled by the hormones raging inside them and peer pressure. If a popular senior boy is dating a younger girl, you can be assured that she is either extremely attractive, or promiscuous, or both. Samantha is neither of these things. Looking in the mirror early in the movie, Samantha tells herself that she needs "four inches of bod." Jake asks his friend, the appropriately named Rock, if he would ever go out with Samantha.

> **Rock**: Depends on how much you paid me.
> **Jake**: She's not ugly.
> **Rock**: There's nothing there. It's not ugly, it's just…void.

Rock's views mirror those of typical teenage boys. If a younger girl is not physically remarkable, she will be "void" to older boys and remain unnoticed. Samantha herself admits that she's "this ridiculous dork who's following him [Jake] around like a puppy." But somehow, Jake Ryan sees through all this to Samantha's inner beauty? Not very likely.

Then there's the question of what will happen on Monday morning. Jake and Samantha have gotten together, he's given her a birthday cake (and her panties back), and they've kissed atop the glass table to the Thompson Twins' "If You Were Here". But reality will set in on Monday when they return to school. Jake's friends will harass him for dumping the hottest girl in school to date a rather ordinary sophomore with short red hair and funky fashion sense. John Hughes, the writer and director of *Sixteen Candles*, should know better. Hughes tackled the same subject in his movie *The Breakfast Club*, in which the characters (including Molly Ringwald's Claire) admit that even though they have become friends over the course of Saturday detention, they probably won't remain friends on Monday, when they return to their various cliques. And even if Jake and Samantha somehow manage to overcome this, what happens next year, when Jake heads off to college and Samantha is stuck in high school for two more years? Their fairy tale relationship is doomed and unsustainable.

You might say I'm far too cynical. This is just cinematic fluff—escapist entertainment. How can this harmless fantasy be damaging? I'll tell you. Hundreds of thousands of American women saw and loved *Sixteen Candles*. They saw themselves in the lovable everywoman Samantha Baker. "Why shouldn't I have the very best? I deserve a Jake Ryan for myself", each of these women thought. These ridiculously high expectations have blinded these women to other romantic opportunities and to men who don't necessarily have model-good looks or drive a Porsche. And when the women do deign to date or even marry these "other" men, the men can never live up to the nonsensical expectations Jake Ryan has fixed in these women's minds. Relationships are difficult enough without artificially high expectations spawned by an '80s teen movie and the fairy tale it has perpetuated in the minds of a generation of American women.

Jake Ryan is an Ideal That Women—and Men—Should More Actively Seek

The teenage years are difficult ones to navigate. You're attempting to figure out your place in the world and the kind of person you want to be. This process is complicated by raging hormones, peer and parental pressures, and societal expectations.

As a society, we send our teens mixed or ambivalent signals about what is and what should be important. We rightly laud academic and athletic achievement, good behavior, and community involvement, but we too often neglect teenagers' emotional development.

Jake Ryan, the male lead of *Sixteen Candles*, presents a very different and admirable example for teen boys. In a decade when too many teen male movie characters are portrayed as only interested in sex, sports, and partying, Jake Ryan (Michael Schoeffling) represents a nobler ideal. Like it or not, young people *are* influenced by what they see on television and in movies. Therefore, we should laud mature, sensitive depictions of young men like Jake Ryan—not deride them.

Jake Ryan is a young man who has it all: good looks, a beautiful home, lots of friends, and an attractive girlfriend. But Jake is unsatisfied because his emotional needs are not being met. What's most impressive is that he realizes this and does something about it, fighting against peer pressure to find his soulmate. It is a rare teenage boy who is self-aware and mature enough to admit to a friend, "maybe I'm interested in more than a party," and to do what Jake does in breaking up with the prom queen to seek true love. As Farmer Ted (Anthony Michael Hall) tells Jake, "I think a ton of guys feel the same way you do…[but] they don't have the balls to admit it."

Society is at fault here, not Jake. We have programmed young men to be insensitive. Be tough! Don't cry! And parents would rather not think about or deal with what's going on in their children's love lives. They unreasonably hide their heads in the sand, hoping everything will be all right with their children until they grow up and get married. We should be educating our children emotionally, emphasizing true love and fulfilling relationships (as Jake does) over easy sex and unhealthy

relationships. Jake understands that society's expectations are not in line with his mature feelings. Why else would he add the postscript, "Is that psycho?" after he opens up about love to Farmer Ted?

Some say that Jake is crazy to break up with his girlfriend Caroline, the most attractive girl in school. But why shouldn't he break up with her? She doesn't meet Jake's emotional needs. Caroline is interested only in partying and image. She is completely self-centered and therefore unable to be a true partner in a healthy relationship. Caroline even threatens Jake at the dance: "I could name 20 guys that would kill to love me." All the beauty in the world can't make up for someone who is ugly on the inside.

Samantha Baker (Molly Ringwald) is an exemplary female character. Samantha is a brave and passionate girl who goes after her dream, no matter how many people tell her it's impossible. As Samantha's father (Paul Dooley) tells her, "If this guy can't see in you all the beautiful and wonderful things that I see, then *he's* got the problem." Damn right, Pop! Why should Samantha sell herself short? Why shouldn't she set her goals high? Women settle far too often, and in doing so compromise their dreams and emotional well-being. Samantha Baker doesn't accept that—and neither should other women.

In *Sixteen Candles'* final scene, Jake and Samantha sit across from one another over a birthday cake he has thoughtfully given her. Jake asks her to make a wish, and she replies, "It already came true." They kiss, and our hearts swell with the triumph of true love for these worthy, emotionally aware teens. Jake Ryan is an ideal that men should seek to emulate, and that women should demand from their mates.

18. How to Survive an '80s Horror Movie Part IV: The Possession

Part four of my series on how to survive an '80s horror movie focuses on why you shouldn't split up, why authorities are typically pretty useless in these situations, and how revenge can put you and your friends and loved ones in dangerous positions. Take it from me, Jason Voorhees. I should know!

Don't Split Up

Apparently the phrase "strength in numbers" isn't as well-known as it used to be. If you're facing off against a crazed killer with a sharp weapon, you stand a much better chance if you stick together than if you split up.

For some reason though, people keep convincing themselves that it's a good idea to split up. In *Slumber Party Massacre*, Neil (Joseph A. Johnson) and Jeff (David Millern) show up at the party to get a glance or two at the girls in their skivvies, but soon find themselves the prey. Neil says to Jeff, "Maybe we should split up. One of us will make it, even if the other one doesn't." Wrong, Neil! Both are killed soon after they split up. In *Sorority Babes in the Slimeball Bowl-O-Rama* (1988), one character says, "This might go faster if we split up." Yes, it does make it faster…for the killer to dispose of you! In *The Prowler* (1981), a couple goes down to the deserted basement at the dance hall to have sex, and the guy assures the girl, "That's the beauty. It's difficult to find. That way there's no chance of being interrupted." And also no chance of being saved if you *are* interrupted by, say, a killer in vintage World War II fatigues.

Halloween 4: The Return of Michael Myers (1988) provides a great example of the consequences of splitting up. Seven survivors, including a sheriff and deputy sheriff, hole up in the sheriff's house. They are armed, have secured the house, and have sent an S.O.S. message to the sheriff of a neighboring town. Help is on the way, and all they need to do is sit there and wait—together. But they don't, of course. Dr. Loomis (Donald Pleasence) leaves to go find Michael Myers on his own, and Sheriff Ben

Meeker (Beau Starr) leaves to track down a group of armed vigilante townspeople before they can do more damage. A love triangle then splits up the three teenagers. Kelly (Kathleen Kinmont) goes to the kitchen to make coffee, Brady (Sasha Jenson) goes up to secure the attic, and Rachel (Ellie Cornell) sulks in another room. Young Jamie (Danielle Harris) is left alone upstairs to sleep. The only adult remaining in the house is the deputy guarding the door. With all of them split up, Michael makes quick work of the deputy, Kelly, and Brady, then goes after Rachel and Jamie.

When will we learn? There is strength in numbers. Use it to your advantage should you find yourself in a horror movie situation. Stick together, and you're more likely to survive.

Don't Expect Help from the Authorities

Teenagers and young people are very often the targets in '80s horror movies. These young people look to authority figures—police, parents, camp counselors—to help them in times of need and protect them from those who mean them harm. Unfortunately, these authority figures provide little safety in slasher situations, and very often don't even believe the young people who find themselves in grave danger.

In *Graduation Day* (1981), Principal Guglione (Michael Pataki), teachers, and parents are all clueless as to why members of the track team are disappearing right before graduation. It falls to the older sister of one of the track team's members to figure out who the killer is and dispose of him. Nancy (Heather Langenkamp) from *A Nightmare on Elm Street* (1984) gets no help in dealing with Freddy from her cop father, her drunken mother, or the scientists at the sleep institute her mom takes her to. Neither her father (Lawrence Dane) nor her therapist (Glenn Ford) are able to help Virginia (Melissa Sue Anderson) deal with the fact that she may or may not be killing her friends one by one in *Happy Birthday to Me* (1981). *The Prowler* (1981) takes irresponsible authority figures to a whole new level, as Sheriff Fraser (Farley Granger) turns out to be the killer.

David (David Naughton) has a difficult time getting anyone to believe that he is the werewolf responsible for the string of

deaths in and around London. As another full moon approaches, David attempts to get himself arrested by creating a disturbance in front of a police officer and a crowd in Trafalgar Square, shouting out the worst anti-British insults he can think of: "Queen Elizabeth is a man, Prince Charles is a faggot, Winston Churchill was full of shit, Shakespeare was French, fuck, shit, cunt, shit!" Despite his best efforts, the British cop just waves him along.

In *Hell Night* (1981), four pledges are stalked by a killer at Garth Manor. Seth (Vincent Van Patten) escapes and makes it to the police station. The cop at the desk thinks Seth is playing a college prank and blows him off. Luckily for Seth, the police station's security is horrendous, and he steals a shotgun from the evidence room.

Don't expect authorities to bail you out if you're in a horror movie. More than likely, you're going to have to deal with the situation on your own. Assume no help is coming and formulate a plan of action.

Revenge is a Dish Best Served ... Dead

Shakespeare's Shylock from *The Merchant of Venice* says, "and if you wrong us, shall we not revenge?" Revenge is a passion as old as humanity itself. People become angry when they are wronged and want to make someone pay for their pain. Most '80s horror movie killers are obsessed with enacting their own brand of revenge for wrongs that have been done to them in their past.

- *Friday the 13th* (1980): My mother, Pamela Voorhees, is pissed off that as a child, I "drowned" at Camp Crystal Lake. She blames the slacker camp counselors and returns 20 years later to violently prevent the re-opening of "Camp Blood."
- *Terror Train* (1980): Kenny Hampson (Derek McKinnon) is the victim of a college prank that goes horribly awry and leaves him in a mental institution. Kenny returns for a New Year's Eve party aboard a train, determined to exact revenge on the medical school students who pranked him.

- *He Knows You're Alone* (1980): Ray Carlton (Tom Rolfing) is upset about being jilted by a former lover. He kills her on her wedding day and continues to stalk young brides.
- *A Nightmare on Elm Street* (1984): Freddy Krueger (Robert Englund) is accused of crimes against children, but gets off on a technicality. Angry parents corner Freddy in an old boiler room and burn him alive. Now he's back for revenge by haunting the dreams of a group of teenagers.
- *The Burning* (1981): Speaking of burns, Cropsy (Lou David) is the caretaker at a summer camp who is horribly burned after a kid's prank gets out of hand. Five years later, he returns to a nearby camp for revenge against another group of campers.
- *Christine* (1983): Possessed car Christine strikes out against the bullies who torment its owner Arnie (Keith Gordon), as well as anyone who tries to come between Arnie and his motorized "girl."
- *Sleepaway Camp* (1983): Young Angela (Felissa Rose) turns out to be the killer, and the reason is bizarre. Angela has become unhinged because her loony Aunt Martha (Desiree Gould) forced the orphan boy to dress and act as a girl. The final "reveal" is truly a shocker.
- *Pumpkinhead* (1988): In grief over the death of his son in a hit-and-run accident, Ed Harley (Lance Henriksen) goes to see an old woman with "special powers", who unleashes a demon to exact revenge on the teenagers responsible for Ed's son's untimely death.
- *Prom Night* (1980): The killer wants revenge against the four seniors who years ago were responsible for the accidental death of his sister.

Everyone has skeletons in their closet. Most of those bones aren't worth killing for, but you never know. Own up to your past mistakes and try to make amends. You don't want anyone out there with an (literal or figurative) axe to grind with you. Stay tuned for the thrilling conclusion to my series on how to survive an '80s horror movie!

19. Tips on Toughness: The 1980s Movie Bad-Ass Oscars

Tom Grunick: Good evening, everyone. This is Tom Grunick [William Hurt, *Broadcast News* (1987)] reporting to you live from Los Angeles. I'm standing in the historic Kodak Theater, where '80s Entertainment Tonight brings you its exclusive coverage of the 1980s Movie Bad-Ass Oscars. The Bad-Ass Oscars are an alternative awards show that honors movies and actors that people actually watch. The Bad-Ass Oscars don't feature any movies about Holocaust suffering, painful failed marriages, or gay cowboys coming to terms with their sexuality. Tonight we're honoring the men, women, and movies that kick ass, take names, and maybe drop a tag line or two. What is the definition of a bad-ass, you ask? Well, ask twenty people and you're likely to get twenty different answers. In general terms though, a bad-ass is someone who takes care of business, doesn't put up with any crap, and does it all with cool bravado. Keep in mind, bad-asses don't have to be *bad*; heroes and heroines can be bad-asses too. So without further ado, let's start the show. Stepping to the podium is our master of ceremonies, veteran Hollywood actor and certified bad-ass Charles Bronson.

Charles Bronson: Hey. How ya' doin'? This is no typical Hollywood awards show, so don't expect a song-and-dance or stand-up comedy from me. Let's get right to the first award.

Tom Grunick: That's just great, folks! Vintage, no-nonsense Charles Bronson. We're in for a very different awards show tonight.

Charles Bronson: The nominees for the Best '80s Movie Bad-Ass Supporting Actress Oscar are ... Aunty Entity [Tina Turner, *Mad Max Beyond Thunderdome* (1985)], Carmen [Mary Elizabeth Mastrontonio, *The Color of Money* (1986)], Mystery Woman [Carrie Fisher, *The Blues Brothers* (1980)], Pris [Daryl Hannah, *Blade Runner*

(1982)], and Zula [Grace Jones, *Conan the Destroyer* (1984)].

Tom Grunick: While Mr. Bronson is opening the envelope, let's take a quick look at the nominees for Best Bad-Ass Supporting Actress. There are no clear favorites in this category. Carrie Fisher from *The Blues Brothers* is a bit of a surprise nod, since her character doesn't even have a name, and is known only as "The Mystery Woman." She packs quite a punch though, hounding Jake (John Belushi) with bombs, missiles, a flamethrower, and a machine gun. Another nominee who is quite adept with weaponry is Zula (Grace Jones). Though she's afraid of rats, she's a fearsome warrior who keeps up with the likes of Arnold and Wilt Chamberlain, killing the Grand Vizier (Jeff Corey) and being appointed Captain of the Guard in Shadizar. Pris (Daryl Hannah) is another able warrior. Don't be fooled by the name; this replicant isn't about to be "retired" without a fight. Between the face paint, acrobatic skills, and thighs of steel, Pris gives blade runner Rick Deckard (Harrison Ford) a run for his money. The other two nominees use their minds rather than their fists to control those around them. Carmen (Mary Elizabeth Mastrontonio) is a driven woman who sees pool ace Vince (Tom Cruise) as a meal ticket. Carmen guides Vince through her guile and her feminine wiles: "You win one more game, you're gonna be humping your fist for a long time. Got that, Vincent?" Aunty Entity (Tina Turner) controls the vicious post-apocalyptic world of Bartertown with an iron fist, using the dreaded Thunderdome to cement her power. When she says, "Death is listening, and will take the first man that screams," you had better believe it! Here's Charles Bronson with the winner.

Charles Bronson: The Best '80s Movie Bad-Ass Supporting Actress Oscar goes to … Pris (Daryl Hannah, *Blade Runner*).

Pris: Thank you. This award is dedicated to all the replicants out there. While you humans sit back and drink your cocktails, we replicants live in constant fear because we know that we

have a limited shelf life, and will be disposed of when we're no longer useful.

Charles Bronson: That ain't just replicants, honey, that's everybody in Hollywood. Hey, who does your makeup anyway? You look like that demented clown from Stephen King's *It* (Tim Curry, 1990). Let's move on to the next award. The nominees for Best Bad-Ass Supporting Actor are Cyberdyne Systems Model 101, better known as the Terminator [Arnold Schwarzenegger, *The Terminator* (1984)], Darth Vader [David Prowse and voice of James Earl Jones, *The Empire Strikes Back* (1980)], Gunnery Sergeant Hartman [R. Lee Ermey, *Full Metal Jacket* (1987)], Inigo Montoya [Mandy Patinkin, *The Princess Bride* (1987)], and Wade Garrett [Sam Elliott, *Road House* (1989)].

Tom Grunick: This was a hard-fought category, and as suspected, there are some supporting actors in the audience who feel unfairly snubbed. Ivan Drago [Dolph Lundgren, *Rocky IV* (1985)] is storming by us now. Let's see if we can get a word with him. Mr. Drago, what would you like to say to the Academy voters who didn't give you a nomination?

Ivan Drago: (staring directly into the camera) I must break you!

Tom Grunick: Menacing words indeed. Another Rocky villain is up in arms in the audience. Clubber Lang [Mr. T, *Rocky 3* (1982)] just stood up and called the Academy a bunch of chumps. He said, and I quote, "I pity the fool didn't vote for me." We're also receiving reports from the local shopping mall that upon hearing that he didn't receive a nomination, Genghis Khan [Al Leong, *Bill and Ted's Excellent Adventure* (1989)] began smashing the heads off mannequins with a baseball bat in the sporting goods store and had to be detained by mall security. Here comes another disgruntled supporting actor who didn't receive a nomination, Blain [Jesse Ventura, *Predator* (1987)]. Blain, this snub must feel like an open wound to you, right?

Blain: I ain't got time to bleed. They're in a world of hurt. Ol' Painless is waitin' for some payback!

Tom Grunick: Yes indeed! There are many worthy bad-ass supporting actors, but only five slots available. Some

difficult decisions for the Academy voters. I wouldn't want to be in their shoes. Let's see who they selected as the Bad-Ass Supporting Actor.

Charles Bronson: And the Best '80s Movie Bad-Ass Supporting Actor Oscar goes to ... Cyberdyne Systems Model 101, the Terminator.

Terminator: I'll be back!

Tom Grunick: Very interesting acceptance speech. One has to wonder whether Schwarzenegger was referring to the Best Bad-Ass Actor category, which is coming up later in the show. Is he hoping to sweep the Bad-Ass actor awards? Time will tell. Let's analyze the Terminator's win a bit. Many felt that Darth Vader was a shoe-in for this award. Inigo Montoya was a surprise selection because *The Princess Bride* is a fairy-tale comedy. You have to respect his tenacity though. "My name is Inigo Montoya. You killed my father. Prepare to die." Wade Garrett brought bad-ass cool to his role as a bouncer in *Road House*, but as an older nominee, voters may have felt Wade was past his prime. R. Lee Ermey was memorable as the drill instructor in *Full Metal Jacket*, but he doesn't even make it to the second reel of the movie. In the end, it was a two-horse race between a machine from the future and a man who became mostly a machine. The Terminator takes home the prize, and Darth Vader is not pleased. I understand that Darth Vader used the Force to choke out an awards show subordinate backstage, saying "Apology accepted" to his crumpled, lifeless form. Let's head back to Charles Bronson on stage.

Charles Bronson: O.K., here we go. Next up is Best '80s Movie Bad-Ass Actress. The nominees are Alex Forrest [Glenn Close, *Fatal Attraction* (1987)], Ellen Ripley [Sigourney Weaver, *Aliens* (1986)], Matty Walker [Kathleen Turner, *Body Heat* (1981)], Princess Leia [Carrie Fisher, *Return of the Jedi* (1983)], and Sarah Connor [Linda Hamilton, *The Terminator* (1984)].

Tom Grunick: Pretty much what entertainment experts expected. Lana [Rebecca de Mornay, *Risky Business* (1983)] is upset about the snub and has tweeted that she plans to sic Guido

the killer pimp (Joe Pantoliano) on any Academy voters she finds. Oh, my! Wait one minute, viewers. We have quite a ruckus down on the floor of the Kodak Theater. Apparently, nominee Alex Forrest (Glenn Close) went after early favorite Sarah Connor (Linda Hamilton) with a kitchen knife, screaming, "I'm not going to be *ignored*!" Fellow nominee Ellen Ripley (Sigourney Weaver) intervened, telling Ms. Forrest, "Get away from her, you *bitch*!" Security has stepped in and apparently no one was hurt. While they're sorting out that melee, let's take a look at the odds in this category. As I mentioned, the early favorite is Sarah Connor, based on the fact that she took out Best Bad-Ass Supporting Actor winner The Terminator, quipping, "You're terminated, fucker!" Some critics have pointed out though that Sarah Connor is much more of a bad-ass in *Terminator 2: Judgment Day*, a 1991 movie that is ineligible for an award tonight. Princess Leia marks the second nomination tonight for Carrie Fisher. In *Jedi*, Leia chokes Jabba the Hut to death with a chain, and is sure to garner some male votes for that sexy bikini outfit she sports. Ellen Ripley faces some nasty aliens, squaring off with one in a giant metal skeleton and flushing it into space. Matty Walker is perhaps the least-known nominee, starring in the sultry noir film *Body Heat*. "My temperature runs a couple of degrees high," she tells Ned Racine (William Hurt—hey, that's me), and after watching Matty in action, our temperatures skyrocketed too. Alex Forrest scared every man in America as the vengeful spurned lover in *Fatal Attraction*. She gives a new menace to the old adage, "Hell hath no fury like a woman scorned." Back to the podium and Charles Bronson to find out the winner.

Charles Bronson: And the Best '80s Movie Bad-Ass Actress Oscar goes to ... Ellen Ripley, *Aliens*.

Ellen Ripley: (holding the statue aloft triumphantly) I will never leave you. I promise.

Tom Grunick: Wow, a stirring acceptance from Ellen Ripley, newly crowned Best Bad-Ass Actress. Congratulations, Ms. Ripley. Next up is Best Bad-Ass Actor. There were a lot of male-oriented bad-ass action flicks in the 1980s, so

the Academy will have a difficult time narrowing the field to five. There are certain to be some worthy bad-ass actors left out in the cold. Back to Charles Bronson at the podium.

Charles Bronson: O.K. Quiet down, now. (One man in front continues talking). Hey, you. Yeah, you. Do you believe in Jesus?

Man: (nervously) Yeah, yeah.

Charles Bronson: Well, you're going to meet him, unless you shut your trap. Got it?

Man: (with a wet stain forming in the front of his pants) Yes, sir.

Charles Bronson: I'll be watchin' you. Now, here are the nominees for Best '80s Movie Bad-Ass Actor. Indiana Jones [Harrison Ford, *Raiders of the Lost Ark* (1981)], John McClane [Bruce Willis, *Die Hard* (1988)], John J. Rambo [Sylvester Stallone, *Rambo: First Blood Part II* (1985)], Snake Plissken [Kurt Russell, *Escape From New York* (1981)], and Tony Montana [Al Pacino, *Scarface* (1983)].

Tom Grunick: An impressive group there. A notable omission is Arnold Schwarzenegger, who was not nominated for *Conan the Barbarian* (1982) or *Commando* (1985). Perhaps the Academy felt that his win in the Supporting category would suffice. I can see some other actors who are not happy with being snubbed. Jake LaMotta [Robert DeNiro, *Raging Bull* (1980)] is standing at the back of the arena, punching a stone wall and yelling, "Why?!" Martin Riggs [Mel Gibson, *Lethal Weapon* (1987)] is at the bar, ranting drunkenly about being denied a nomination because of a Jewish conspiracy in Hollywood. Sebastien de Valmont [John Malkovich, *Dangerous Liaisons* (1988)] just sent a text message in which he announced his intentions to exact revenge upon Academy voters by seducing their wives. Dalton [Patrick Swayze, *Road House* (1989)] was more philosophical about the snub. He is currently doing tai-chi shirtless in the lobby of the Kodak Theater, which explains why many women have vacated their seats and will miss the announcement of the Best Bad-Ass Actor Oscar winner. Indiana Jones (*Raiders of the Lost Ark*) is undoubtedly the most bad-ass college professor any of us have ever seen. The fedora, the whip, the swagger—he's got it all, and

some experts think he's a lock for the Bad-Ass Oscar tonight. John McClane (*Die Hard*) may not have invented the tough-as-nails wise-ass cop, but he certainly perfected the role as he fought terrorists in Los Angeles—"Yippee-ki-yay, mother fucker!" Oops, the boys in the truck are telling me I can't say "mother fucker" on the air. Oh no, I just did it again. My apologies. John J. Rambo starred in every installment of the *First Blood* trilogy in the 1980s, but is nominated tonight for the second, in which he single-handedly rescues American POWs from a Vietnamese camp controlled by the Soviets. Snake Plissken (*Escape From New York*) oozes bad-ass from every pore, from his eye patch to his "I don't give a damn" contempt for authority. He still manages to overcome the Duke (Isaac Hayes) and rescue the president (Donald Pleasance). Tony Montana (*Scarface*) takes us on a ride through the Miami cocaine world. As he says, "You fuck with me, you fuckin' with the best. You wanna play rough? Say hello to my lil' friend!" The boys in the truck are on me again; sorry guys, I'm just quoting, blame the bad-asses. Let's see who our winner is.

Charles Bronson: The Best '80s Movie Bad-Ass Actor Oscar goes to ... John J. Rambo.

John J. Rambo: (holding the statue) You should give it to the POWs. They deserve it more. I want what they want, and every other guy who went over there and spilled his guts and gave everything he had, wants our country to love us as much as we love it! That's what I want! And Murdock (Charles Napier) ... I'm still coming to get you!

Tom Grunick: Vietnam war hero and decorated veteran John J. Rambo, dedicating his acceptance speech to our troops—true bad-asses indeed. Congratulations, Mr. Rambo, and a heartfelt thank you to all our servicemen and servicewomen.

Charles Bronson: Alright, last award, so sit down and shut up. The nominees for Best '80s Movie Bad-Ass Motion Picture are *The Dirty Dozen, Death Wish, The Magnificent Seven, The Great Escape,* and *Mr. Majestyk.* Oh wait, those are five of *my* bad-ass movies. (Laughter from the audience,

followed by applause.) Just kidding. The real nominees are *Die Hard* (1988), *Lethal Weapon* (1987), *Raiders of the Lost Ark* (1981), *Rambo: First Blood Part II* (1985), and *The Terminator* (1984).

Tom Grunick: We've talked about most of these movies already tonight. The early favorite is *The Terminator*. Time travel, cyborgs, Arnold—it will be hard to top that. But will Sly Stallone ride the wave of his Best Bad-Ass Oscar win to a victory for *Rambo*? *Raiders of the Lost Ark* has adventure, romance, Nazis, and a showdown of biblical proportions—can it overcome the high octane thrills and high body counts of its competition? Can Riggs (Mel Gibson) and Murtaugh (Danny Glover) partner up to beat the lone wolf bad-asses of the other nominated movies? Can John McClane and *Die Hard* drop their competition out of the Nakatomi Building? Only Charles Bronson and the nerds at Price-Waterhouse know for sure. Let's go down to the podium for the final award of the evening.

Charles Bronson: Hey, thanks for havin' me here tonight. The Best '80s Movie Bad-Ass Motion Picture Oscar goes to … *Raiders of the Lost Ark*!

Tom Grunick: So there you have it, America. It was a wild evening, complete with thrills, spills, and even a few surprises. We hope you enjoyed '80s Entertainment Tonight's live coverage of The 1980s Movie Bad-Ass Oscars. It was a fitting tribute to everything that is bad-ass about '80s cinema. Congratulations to all the nominees, and especially to tonight's winners. For our host Charles Bronson, I'm Tom Grunick (*Broadcast News*) signing off. Stay brave, stay true, and stay bad-ass!

20. Tips on Romance

Let's face it: we could all use more romance in our lives. We get caught up in day-to-day affairs—working, paying bills, doing laundry, cooking, cleaning, changing diapers—and too often we forget to take the time to stop and smell the roses and to enjoy our loved ones. Romance is the forefront of the courtship process, but it gets shoved aside once the courtship is over. So how do we add more romance to our relationships and our daily lives?

Let's take a closer look at five of the most romantic relationships from 1980s movies. *Sixteen Candles* (1984) centers on high school sophomore Samantha Baker (Molly Ringwald), who dreams of romance with popular senior boy Jake Ryan (Michael Schoeffling). In *Can't Buy Me Love* (1987), Ronald Miller (Patrick Dempsey) wants to be popular and sees cheerleader Cindy Mancini (Amanda Peterson) as his ticket to instant popularity. *Dirty Dancing* (1987) takes place at a Catskills resort, where privileged Frances "Baby" Houseman (Jennifer Grey) falls for working-class dancer Johnny Castle (Patrick Swayze). *Bull Durham* (1988) is a movie about minor league baseball, but features an unconventional romance between Crash Davis (Kevin Costner) and Annie Savoy (Susan Sarandon). Underachiever Lloyd Dobler (John Cusack) and school valedictorian Diane Court (Ione Skye) develop an unlikely yet sweet romance in *Say Anything* (1989). What tips can we take from these five classic 1980s romances?

Share Your Dreams and Passions

We all have dreams and passions. Those dreams and passions are what make life worth living. Our dreams become much closer when we share them with loved ones who support us in our efforts in turning those dreams into reality. Sharing your passions with a loved one strengthens your bond. And what can be more romantic than dreams?

Can't Buy Me Love is built on a fictional relationship between nerdy Ronald Miller (Patrick Dempsey) and uber-popular Cindy Mancini (Amanda Peterson). The fictional romance develops into a real romance though, because Ronald and Cindy

open up and share their dreams and passions with one another. Ronald introduces Cindy to the wonders of astronomy and stargazing, and Cindy shows Ronald the poetry she has written but never shared with anyone. After seeing her poetry, Ronald tells Cindy "thank you for trusting me with these." Ronald is right; it takes a lot of courage and trust to share your dreams and passions. However, the upside of potentially gaining a partner to help fulfill your dreams can be well worth the risk of rejection.

Johnny Castle (Patrick Swayze) and Frances "Baby" Houseman (Jennifer Grey) are from vastly different socioeconomic classes. Johnny is a working-class dancer, struggling to make ends meet, and Baby is the privileged daughter of a wealthy doctor. Nevertheless, they share the same dream of living in a world in which their socioeconomic differences don't matter. Johnny tells Baby, "I dreamt we were walking along and we met your father. He said 'Come on,' and he put his arm around me, just like he did with (Ivy League student) Robbie." Together Johnny and Baby make their dream a reality, even if it is only in microcosm at a Catskills resort.

Be Yourself

Honesty is the best policy, as the saying goes. It's also the best way to present oneself to the world. As Oscar Wilde said, "Be yourself; everyone else is already taken." Being honest and up-front about who you are—warts and all—can be very attractive to a romantic partner.

The '80s movie poster child for "being yourself" is Lloyd Dobler (John Cusack) in *Say Anything*. Lloyd talks too much, he wears his heart on his sleeve, and he doesn't know what he wants to do with his life. So he should have nothing in common with motivated valedictorian Diane Court (Ione Skye), "a brain...trapped in the body of a game show hostess." Romantic feelings develop between them when they open up and get past society's labels. Lloyd and Diane show each other their true selves, and love what they see, despite the fact that no one else understands. Lloyd tries to explain it to the guys in the Gas-n-Sip parking lot: "The girl made me trust myself, man. I was walking around, I was feeling *satisfied*. Can you imagine that?" As Lloyd

and Diane leave for Europe at the end of the movie, Diane says, "Nobody really thinks it'll work, do they?" Lloyd responds, "You just described every great success story." Confidence in yourself and who you are is sexy, and makes others believe in you too.

The relationship between Jake Ryan (Michael Schoeffling) and Samantha Baker (Molly Ringwald) in *Sixteen Candles* works because they are both honest about who they are and what they want. Jake is Samantha's dream man, but she doesn't try to be something she's not to get him. Jake is honest with himself about what he wants too. Though he's very popular and dates the prom queen (Haviland Morris), he's not happy. Jake tells Ted (Anthony Michael Hall): "I want a serious girlfriend, somebody I can love, and that's gonna love me back." Ted replies, "It's beautiful, Jake. I think a ton of guys feel the same way you do…they don't have the balls to admit it." Ted is right; too many people aren't brave enough to be honest with themselves or with others. That's why it's so refreshing—and romantic—to find someone who can comfortably be himself or herself.

Communication is the Ultimate Aphrodisiac

If you're a guy who just read the title of this section, tell us truthfully—did you cringe when you read it? Men are molded by society to be tough, to hide their feelings, and to deal with things internally. Women, on the other hand, are more willing to let their feelings and emotions out—sometimes to a fault. Men must be more willing to express themselves and their emotions to their romantic partners. To men, foreplay is a purely physical act; for women, it's much more mental and emotional. Honest communication between equal partners is the cornerstone of a successful romantic relationship.

Veteran baseball catcher Crash Davis (Kevin Costner) and veteran baseball fan Annie Savoy (Susan Sarandon) have both been around the block a few times. With age and experience comes wisdom and self-awareness. Before they get together, Annie asks Crash what he believes in and Crash has a thorough answer ready. "Well, I believe in the soul, the cock, the pussy, the small of a woman's back, the hanging curve ball, high fiber, good Scotch, that the novels of Susan Sontag are self-indulgent, overrated crap. I

believe Lee Harvey Oswald acted alone. I believe there ought to be a constitutional amendment outlawing Astroturf and the designated hitter. I believe in the sweet spot, soft-core pornography, opening your presents Christmas morning rather than Christmas Eve, and I believe in long, slow, deep, soft, wet kisses that last three days." Annie is clearly turned on, and can only say, "Oh, my!" Crash is a man who knows what he wants, and how to articulate it. After that exchange, it's not a question of *if* Annie and Crash will get together, but *when*. Communication is the ultimate aphrodisiac.

Baby's efforts to communicate with Johnny get off to an awkward start in *Dirty Dancing*. Her first words to him are, "I carried a watermelon." It's not exactly a great romantic pick-up line, but it does break the ice. Baby and Johnny communicate well in the movie as they break down the social barriers that keep them apart. Johnny explains to Baby, who has never known hardship, how tenuous his economic existence is, and Baby makes her feelings clear to Johnny. "I'm scared of walking out of here and never feeling for the rest of my life…the way I feel when I'm with you." Their honest, open communication is every bit as essential to them getting together as Johnny's sultry dance moves.

Be Spontaneous

A romantic night out to dinner on a birthday, or flowers on an anniversary, are wonderful. We all love when people remember the important events in our lives, but it's also somewhat expected. Spontaneous, unexpected expressions of love can be even more romantic.

After finally consummating their relationship, Crash and Annie (*Bull Durham*) are eating cereal in Annie's kitchen, with Crash dressed in one of Annie's silky robes. Annie looks at him and says, "God, you are gorgeous. Wanna dance?" They toss their bowls of cereal aside, Crash abruptly clears the kitchen table with a sweep of his hand, and Annie and Crash engage in spontaneous, passionate lovemaking atop the table. The mood can strike anywhere and anytime and spontaneity can be truly sexy.

Ronald and Cindy's entire relationship in *Can't Buy Me Love* begins with a spontaneous decision. Ronald works hard the entire summer mowing lawns so he can buy an expensive telescope

to support his astronomy passion. However, while he's at the mall to purchase the telescope, he sees Cindy in a tight spot. She has inadvertently ruined an expensive outfit her mother loaned her, and can't afford to replace it. Ronald makes a spontaneous decision to use his money to help out Cindy if she pretends to be his girlfriend for a month in exchange. Ronald's spontaneous decision leads to real romance once they spend time together and get to know one another.

It's the Little Things that Count

Unless you're a member of the royal family or a Disney princess, you probably don't have the time or the means to lead a carefree romantic life all the time. The grind of our daily lives relegates us to having only occasional romantic interludes. But romance doesn't have to be an expensive, carefully orchestrated break from our daily lives; it can be a *part* of our daily lives. You can say "I love you" and "you're very special to me" in a million tiny acts or gestures in the course of a day.

Lloyd Dobler (*Say Anything*) may be inexperienced, but he "gets" romance. On their first date, Lloyd and Diane are walking across the parking lot of a convenience store. He stops to point out some broken glass in their path and kicks it aside. Diane later recalls this small gesture to her father Jim (John Mahoney) as what she thinks of when people ask her why she is dating Lloyd Dobler. Lloyd also sends Diane a letter after they first have sex that reads: "Dear Diane, I'll always be there for you. All the love in my heart, Lloyd." It's not a diamond necklace or dinner at an expensive restaurant, but the letter and kicking the glass aside are heartfelt gestures from a good person who truly cares about her. Diane understands that these small tokens mean much more than grandiose romantic gestures, even if her father and friends don't understand.

In *Bull Durham*, we see Annie, disrobed and tied to her headboard, writhing in ecstasy. The camera pans down as The Dominoes' "Sixty Minute Man" plays, and we see that instead of performing a sex act, Crash is painting Annie's toenails. Annie and Crash both understand that a small gesture like that can be as romantic as a kiss…or the small of a woman's back.

Like Lloyd and Crash, Jake Ryan (*Sixteen Candles*) "gets" romance. Toward the end of the movie, Jake is waiting for Samantha outside the church after her sister's wedding. Sweeping her into his Porsche in her bridesmaid's dress is every bit as romantic for Samantha as any fairy tale romance.

Don't Let Anyone Put Your Baby in the Corner

We all want to feel special. Our loved ones should be special to us and make us feel special in return. So men, put your woman up on a pedestal and let her know she's the only one for you. And women, placate our manly egos and remind us we're your knight in shining armor.

Baby and Johnny (*Dirty Dancing*) lift each other up, both literally and figuratively. Baby vouches for Johnny that he didn't steal a wallet, even though it exposes their relationship and disappoints her disapproving father (Jerry Orbach). Johnny returns the favor at the closing dance by telling her parents, "Nobody puts Baby in the corner." Johnny proceeds to sweep her off her feet, holding her up and showing everyone how special Baby is.

Say Anything's most famous scene occurs when a lovelorn Lloyd holds a boombox over his head outside Diane's house, blaring Peter Gabriel's "In Your Eyes," a song that is special to them. Lloyd is letting Diane and everyone else within earshot know that she is special and that he's not going to let her go.

Sixteen Candles ends with lovebirds Jake and Samantha sitting atop a glass table to the Thompson Twins' "If You Were Here." Though her entire family has forgotten Samantha's sixteenth birthday, Jake remembered, and has a birthday cake for her. "Make a wish," Jake says. "It already came true," Samantha replies. Jake has made Samantha feel special, and romance blossoms as a result.

Gertrude Stein once said "romance is everything." Ol' Gert may have overstated it a bit, but it's undeniable that romance is an essential—albeit lacking—element of human interactions. Romance makes our lives richer, more exciting, and more fulfilling.

Five great '80s movie romances offer us amateurs some tips on how to put more romance in our lives. Share your dreams and passions with your loved ones; shoot for the stars and make the world a better place…together. Be honest and be yourself; self-confidence is a huge turn-on. Open up and talk to one another about the good, the bad, and the ugly; communication is the ultimate aphrodisiac. Be spontaneous; you don't need a reason to express how you feel. It's the little things that count. Show your loved one how much you love them in little ways every day. Make your loved one feel special, and don't let anybody put your baby in the corner.

You don't need to be the captain of the cheerleaders (Cindy), the school valedictorian (Diane), a great dancer (Johnny), sexy and provocative (Annie), or impossibly handsome with a Porsche (Jake) in order to lead a more romantic life. Just follow these tips from some of your favorite '80s movies, and you're on your way to your own romantic Hollywood ending!

21. How to Get the Job Done
Why You Shouldn't Mess with Chuck Norris

Chuck Norris has had a truly remarkable career. Born Carlos Ray Norris in Oklahoma in 1940, Norris joined the Air Force after high school. He was stationed in Korea, where he learned martial arts. After his service, Norris returned home and began teaching karate. He was soon running a number of martial arts schools in California and fighting professionally. Norris became the World Middleweight Karate Champion in 1968 and held that title until he retired from professional fighting in 1974. One of his students, actor Steve McQueen, encouraged Norris to get into acting. After losing to Bruce Lee in *The Way of the Dragon* (1972), Norris began a very successful career as an action movie star in the 1970s and 1980s. Norris had a successful small-screen run on the popular T.V. show *Walker, Texas Ranger* (1993-2001). He is also famous to T.V. viewers for his long-running cable T.V. infomercials—alongside fellow '80s icon Christie Brinkley—advertising Total Gym home fitness equipment. Within the last decade, Chuck Norris has become a cultural icon to a new generation in a series of brief jokes celebrating Norris' legendary abilities, including:

> Chuck Norris doesn't cheat death. He wins fair and square.
> Chuck Norris' tears cure cancer. Too bad he has never cried.
> Chuck Norris does not sleep. He waits.

Recently, Chuck Norris returned to the big screen in *The Expendables 2* (2012), alongside a collection of legendary action movie heroes.

But what really makes Chuck Norris tick? A bunch of cutesy sayings don't really capture what makes Chuck Norris such a true legend. Let's take a closer look at Norris' movies from the 1980s to unwrap the enigma that is Chuck Norris.

Even the *Names* of Chuck Norris' Movies and Characters Can Kick Your Ass

Chuck Norris didn't star in any heartwarming romantic comedies. He didn't star in any period pieces about manners and unspoken passions. Chuck Norris starred in ass-kicking action movies! Even the titles of his 1980s movies and his characters in those movies are bad-ass.

Movie	Character
The Octagon (1980)	Scott James
An Eye For an Eye (1981)	Sean Kane
Silent Rage (1982)	Sheriff Dan Stevens
Forced Vengeance (1982)	Josh Randall
Lone Wolf McQuade (1983)	J.J. McQuade
Missing in Action (1984)	Colonel James Braddock
M.I.A. 2: The Beginning (1985)	Colonel James Braddock
Code of Silence (1985)	Eddie Cusack
Invasion U.S.A. (1985)	Matt Hunter
The Delta Force (1986)	Major Scott McCoy
Firewalker (1986)	Max Donigan
Braddock: M.I.A. III (1988)	Colonel James Braddock
Hero and the Terror (1988)	Danny O' Brien

With movies like *The Delta Force*, *Silent Rage*, *Forced Vengeance*, and *An Eye For an Eye*, you know exactly what you're getting when you watch a Chuck Norris movie. So grab your popcorn, and enjoy the action!

Chuck Norris Puts the "Art" Back in Martial Arts

High-octane action movies are logistically demanding. They require a great deal of timing, precision, and coordination. Fight sequences are every bit as complex and choreographed as dance routines. As a longtime teacher of martial arts, Chuck Norris brought an artistic flair to his action sequences in '80s movies.

Sure, there are punches, leg sweeps, and roundhouse kicks, but there's much more in Chuck Norris' arsenal. As crooked cop McCoy (Matt Clark) says about him in *An Eye For an Eye*, "he *is* a weapon!" Perhaps his most effective weapons aren't his hands or feet, but his eyes. The Chuck Norris Staredown is enough to break the will of a foe without a single punch or kick. That stare lets you know that Chuck Norris means business…and business is good.

Norris' special move—one he uses in almost all his films—is a flying kick that sends a bad guy hurtling backward through a door, a window, a wall. If none of those are available, he'll improvise. In *An Eye For an Eye*, he uses a flying kick to propel the humungous Professor (Toru Tanaka) backwards through a glass coffee table.

But these are just his everyday moves. Chuck Norris has many more creative ways to deal with an enemy, as he demonstrates in his '80s movies. *Missing in Action* features an axe fight on a boat, which ends when Braddock (Norris) drives the blade of the axe into Vinh's (Ernie Ortega) chest with a karate chop. Later in the movie, he emerges from shallow water in slow motion to blow away Vietnamese soldiers with a machine gun. In the second installment, Braddock is tortured in a prison camp by the sadistic Colonel Yin (Soon-Tek Oh), who hangs Braddock up by his feet and ties a bag with a live rat around his head. Braddock manages to bite the rat to death. The third installment goes back to the tried-and-true strategy of slo-mo, as Braddock blows the hell out of everyone and everything at a Vietnamese prison camp where his son is being held. Rogue cop Eddie Cusack (Norris) takes on an entire warehouse of bad guys in *Code of Silence*, with some assistance from a heavily armed police robot called the Prowler. Danny O'Brien (Norris) of *Hero and the Terror* beats up deranged serial killer Simon Moon (Jack O'Halloran), then throws him through a skylight to his death on the floor of a theater. *Lone Wolf McQuade* features a fight between a bulldozer driven by McQuade (Norris) and a tank driven by Rawley Wilkes (David Carradine). The bulldozer wins—though if Chuck Norris had been driving the tank, the tank probably would have won. Scott James (Norris) wins a showdown with head Ninja Kyo (Richard Norton) in the titular *Octagon*, a martial arts obstacle course. James then kills head bad guy Seikura (Tadashi Yamashita) as the morning sun comes up

behind him. *The Delta Force* offers some great action sequences for McCoy (Norris). His team blows a hole in the floor, then emerges wearing night vision goggles to blow away the terrorists and save the hostages. McCoy then slides down a wire with one hand while shooting a machine gun at terrorists with the other. Finally, McCoy squares off against head terrorist Abdul (Robert Forster), kicking the crap out of him and then pulverizing him into tiny pieces with a rocket launched from a motorcycle. Of all his great fight scenes in '80s movies, the most artistic might have been a stairway hand-to-hand fight with a Hong Kong assassin in front of a giant neon sign in *Forced Vengeance*. The scene is beautiful to watch, and is an apt demonstration of how Chuck Norris puts the "art" back in martial arts.

Chuck Norris Can Get Away with Saying Things that Chuck Norris Would Slap Someone Else for Saying

When you're as much of a bad-ass as Chuck Norris, you can get away with pretty much anything. That includes saying things that would be simply unacceptable coming out of the mouth of a lesser man. Here are a few examples from his '80s movies.

- *Code of Silence*: If I want your opinion, I'll beat it out of you.
- *Forced Vengeance*: Hong Kong is like a slap in the face…that makes you feel good.
- *Missing in Action*: **Ann** (Lenore Kasdorf): What a day! **Braddock** (Norris), while removing his boots and unbuttoning his shirt: Yeah, should be quite a night too.
- *Hero and the Terror*: **Cop**: We've checked it out from top to bottom. **O'Brien** (Norris): Then I'll check it out from bottom to top.
- *Missing in Action III*: I don't step on toes. I step on necks.
- *Firewalker*: Stop acting like a dad-gum sissy.

- *Lone Wolf McQuade*: (to a dwarf in a wheelchair) It may be a game to you, Falcon (Daniel Frishman), but if I find out you're playing, I'm gonna have your little ass.
- *Hero and the Terror*: (to his pregnant fiancée) You're pregnant. You're supposed to be fat.
- *The Octagon*: (in casual conversation) I ran into some Ninjas last night.
- *Firewalker*: I'm in charge of charm.
- *Forced Vengeance*: If I were a tree, I'd hide in the forest. But where do you hide in Hong Kong with two beautiful women? I know…a cathouse!
- *Silent Rage*: (calmly, after a woman steps up and slaps him) How you been?
- *Invasion U.S.A.*: If you come back in here, I'm gonna hit you with so many rights, you're gonna beg for a left.
- *Lone Wolf McQuade*: My kind of trouble doesn't take vacations.

Chuck Norris' Chest Hair Needs to Breathe

Chuck Norris has a remarkable propensity for taking off his shirt in '80s movies. Perhaps this is a little something for all the ladies whose husbands or boyfriends make them watch Chuck Norris action fare. But the real reason Chuck Norris can't seem to keep his top on is that his rippling pecs, washboard abs, and manly chest hair just can't be contained for the entire running time of a motion picture.

There are numerous scenes in his '80s movies of Chuck Norris working out shirtless with a body bag, often as he contemplates heinous shit that occurred earlier in the movie or in his deep, dark past. His characters also typically sleep without a shirt on. This comes in handy in *An Eye For an Eye* when love interest Heather (Maggie Cooper) checks in on him after a nightmare, but not as handy in *Firewalker* when a Native American woman wants to stab him.

Other topless scenes seem less vital to the plot of the movie, as in *Invasion U.S.A.* when Matt Hunter (Norris) is driving a fanboat around the Everglades with an open denim shirt. Or when Hong Kong police give him an unnecessary strip search in

Forced Vengeance. In *Silent Rage*, Dan (Norris) is wounded, and stands around the hospital shirtless, but still wearing his jeans and gun belt. *Missing in Action III* features a torture scene in which the bad guys inexplicably remove Braddock's shirt. The most egregious example occurs in *Invasion U.S.A.* when authorities arrest him, handcuff him, and parade him in front of the media with his shirt still open. We're still checking on whether or not that's a violation of Chuck Norris' Miranda rights.

Chuck Norris is His Own Back-up

In *Hero and the Terror*, fellow cop Dwight (Jeffrey Kramer) emphatically orders Danny O'Brien (Norris) "You wait for your back-up!" Oh Dwight, don't you know who you're dealing with? Chuck Norris is his *own* back-up. A partner just slows him down.

In *Code of Silence*, Chicago cop Eddie Cusack's (Norris) long-time partner Dorato (Dennis Farina) is shot and wounded in the line of duty. His commanding officer issues Cusack a young partner named Nick Kapalas (Joe Guzaldo). "I don't need a partner!" Eddie tells his boss—then he proves it. Every time he goes somewhere to investigate in the movie, he tells poor Nick to wait in the car.

Others who attempt to team up with Norris' characters meet similar resistance. Texas Ranger J.J. McQuade (*Lone Wolf McQuade*) is assigned a partner, Kayo Ramos (Robert Beltran), by his P.R.-minded chief, but tells Kayo, "Forget it, kid. I work alone." He even goes out of his way to lose Kayo when Kayo follows him in a car, and pulls a gun on Kayo when he shows up at McQuade's home. James Chan (Mako) is Sean Kane's (Norris) martial arts teacher (*An Eye For an Eye*) and the father of Sean's partner's murdered girlfriend, but Kane still avoids James' efforts to help him track down the killers. In *The Octagon*, Scott's (Norris) buddy A.J. (Art Hindle) wants to help bust the international terrorism ring, but Scott rebuffs A.J. repeatedly.

Matt Hunter (*Invasion U.S.A.*) tells the CIA representative "I'll take the assignment, but remember, I work alone." Colonel James Braddock (Norris) of the *Missing in Action* trilogy works alone —to single-handedly find and rescue American POWs in I,

break out of and destroy the POW camp in II, and rescue his son and other Vietnamese orphans in III. *M.I.A. III*'s final scene particularly demonstrates his preference to go it alone. American military forces must wait on the other side of a bridge while Braddock defeats the enemy by himself and brings the children to freedom.

Even when Norris has an active partner or partners, he still handles almost all the dirty work on his own. Sheriff Dan Stevens (*Silent Rage*) hunts axe murderer John Kirby (Brian Libby) on his own, with no significant help from his goofy deputy Charlie (Stephen Furst: Flounder of *Animal House* fame). Max Donigan (*Firewalker*) partners with Leo (Lou Gossett Jr.), but Max is always responsible for planning and for getting them out of fixes. Max is constantly harassing Leo to "hurry up" or to "get moving". *The Delta Force* is an elite military unit led by Colonel Nick Alexander (Lee Marvin). Nonetheless, Delta member Scott McCoy (Norris) conducts much of his mission solo, including stopping a convoy carrying American hostages and disposing of head terrorist Abdul (Robert Forster).

Partners simply slow Chuck Norris down. No worries, though—Chuck Norris is fully capable of serving as his own back-up.

Chuck Norris' Thoughts Are so Powerful, They Must be Whispered

Books and movies often use internal monologue to allow readers or viewers access to what a character is thinking. In movies, this typically takes the form of the character doing a voice-over that the audience (but not the other characters) can hear.

In *The Octagon*, we hear Scott James' (Chuck Norris) internal monologue during various points of the movie. Unlike typical movies though, his voice-over is whispered—and has an echo. Is James afraid of other characters listening in on his thoughts? Does he suspect that among the many skills of the Ninja is the ability to read minds? No, no, Chuck Norris has far too much experience with Ninjas and their training to believe that. The only reasonable explanation is that Chuck Norris' thoughts are too powerful to be spoken aloud. They must therefore be whispered. A

clue to the power of his thoughts comes in the fact that even though they are whispered, they still echo.

So when Scott James whispers lines like, "There's someone here. I can feel it," rest assured that it is not out of fear of detection. Chuck Norris' thoughts are simply too powerful, and *must* be whispered.

Chuck Norris Only Drives Vehicles that Match His Rugged Personality

Can you picture Chuck Norris driving a Yugo, a hybrid, or a station wagon? No, neither could we. Luckily, Chuck Norris is a self-aware man, and only drives trucks or muscle cars (American-made, of course) that befit his rugged, manly movie characters. Chevy Blazers, Pontiac Firebird Trans Ams—these are the types of vehicles Chuck Norris should—and does—drive in his 1980s movies.

Sometimes though, he needs specialized help to take out the bad guys. In *Missing in Action*, Braddock uses an assault raft to get in and out of Vietnam to free prisoners of war. Braddock amps it up in *M.I.A. III* with a custom jet-powered boat. J.J. McQuade (*Lone Wolf McQuade*) has a super turbo charger in his 1983 Dodge Ram Charger, helping him outrun anyone, and escape from the bad guys' efforts to bury him (and his truck) alive. In the same movie, McQuade defeats Rawley Wilkes (David Carradine) in a game of chicken by using a Caterpillar D6-B bulldozer. Major Scott McCoy (*The Delta Force*) sits calmly atop a Suzuki SP600 motorcycle (sorry, not American-made) in the middle of the road to stop a convoy containing American hostages. "You stopped because of one man on a motorcycle?" head terrorist Abdul screams at his subordinates. You bet, if that man is Chuck Norris, and if that motorcycle is tricked out with rocket launchers.

To be fair, Chuck Norris does make small concessions. In *Hero and the Terror*, Danny O'Brien (Norris) is engaged to be married, and his fiancée Kay (Brynn Thayer) is extremely pregnant. Muscle cars get trumped by domestic bliss, as Danny drives a more sensible—if not sporty—1988 Chevrolet Chevette.

Loving Chuck Norris is a Dangerous Proposition

Chuck Norris appeals to both men and women. Men want to be him, and women want him. Be forewarned though, ladies. Loving Chuck Norris is a dangerous proposition.

Alison (Toni Kalem) is wary of getting back together with Sheriff Dan Stevens (Norris) in *Silent Rage*, but can't resist his manly charms. Alison ends up finding the dead bodies of her brother and sister-in-law, killed by a madman who Stevens arrested. The killer later chases her through a hospital and throws her roughly to the ground before Dan disposes of him.

Sean Kane's (Norris) love interest in *An Eye For an Eye*, Heather Sullivan (Maggie Cooper) has her best friend killed and her apartment ransacked. As Kane investigates the murder of his partner and partner's girlfriend, Heather is kidnapped and held at gunpoint.

Max Donigan (Norris) falls for client Patricia Goodwin (Melody Anderson) in *Firewalker*, and they go on a quest for treasure. Patricia flirts with both Max and danger during the movie. She is nearly stabbed, kidnapped, raped, and is almost sacrificed on a Mayan altar.

In *Missing in Action II*, James Braddock (Norris) discovers that the Vietnamese wife he long thought had been killed was still alive, and living in poverty in Vietnam with their young son. Braddock illegally sneaks into Vietnam and reunites with his wife Lin Tan Cang (Miki Kim). When General Quoc (Aki Aleong) discovers Braddock, he shoots and kills Lin in front of Braddock and their young son.

J.J. McQuade (Norris) and his buddy Dakota (L.Q. Jones) see sexy widow Lola Richardson (Barbara Carrera) at the racetrack (*Lone Wolf McQuade*).

Dakota: Shame…all that fruit just rottin' on the vine.
J.J.: Doesn't look too rotten to me.

Hooking up with J.J. proves deadly for Lola. She is shot at as she sleeps next to J.J., then is shot to death later by bad guy Rawley Wilkes (David Carradine) during his stand-off with McQuade. To

add insult to injury, the *Lone Wolf McQuade* budget was apparently too tight to afford bras for Ms. Carrera; she doesn't wear one through the entire movie.

Forced Vengeance may be the best (or worst) example of the toll loving Chuck Norris can exact on a woman. His beautiful girlfriend Claire (Mary Louise Weller, better known as Mandy Pepperidge in *Animal House*) has to abandon their houseboat when the Hong Kong mob comes after Josh (Norris). Claire is then raped and killed while Josh is out investigating.

That's a pretty rough track record. One can only assume that the honor of loving Chuck Norris is worth the inherent risk.

Chuck Norris Enjoys a Beer, but Only Domestic, Damnit!

Along with flying kicks and his omnipresent chest hair, another recurring theme in Chuck Norris movies from the 1980s is his characters' appreciation for beer. What better beverage for an all-American action movie star?

Max (Norris) and Leo (Lou Gossett Jr.) are staked to the ground in the desert by bad guys in the beginning of *Firewalker*. Leo frets about their predicament, and Max says, "All I can think of is a beer from Tub's Bar"—their hangout back in Arizona. In *An Eye For an Eye* and other Norris movies, his characters are seen enjoying a beer at their homes or watering holes.

The *Missing in Action* trilogy takes place primarily in Vietnam, and much of it concerns prison camps and prisoners of war. Not exactly an ideal story line for the presence of beer, right? Wrong! In the first installment, Braddock (Norris) drinks beer at the Vietnamese embassy, then with his old Army buddy Tucker (M. Emmet Walsh) at Madame Pearl's Whorehouse. In III, Braddock is tracked down by Reverend Polanski (Yahuda Efroni) while drinking alone at a bar; he later meets his buddy Mik (Ron Barber) at a shady Bangkok bar. *Missing in Action 2* is set entirely in a Vietnamese POW camp, but Braddock still manages to have a beer smuggled in for him.

J.J. McQuade (*Lone Wolf McQuade*) loves his beer, too. J.J. attends the retirement ceremony for his fellow Texas Ranger Dakota (L.Q. Jones), popping open a couple cans of Pearl beer for

them right there at the ceremony. J.J. is fiercely loyal to the San Antonio-based brewing company. At a party, he requests a Pearl beer, and is told by the bartender that they only have Heineken, Michelob, and Dos Equis. J.J. tells the bartender, "Forget it!" The normally stoic J.J. flips out when Lola removes the Pearl beer from his fridge in a misguided effort to "clean him up." Bad guy Rawley Wilkes (David Carradine) has J.J. beaten up and buried alive in his truck. When J.J. comes to, he calmly opens a beer he has stashed in his truck, drinks some, and pours the rest over his head before he cranks up the turbo drive in his truck. Once J.J. and his truck escape from their early grave, J.J. tells Kayo (Robert Beltran), "Get me a beer, kid."

So don't worry, guys. Crack open a brewski and enjoy. Even hard-working action heroes like Chuck Norris like to enjoy a beer now and then.

Chuck Norris: a Modern-Day Cincinnatus

Cincinnatus was a legendary Roman civic leader. As legend has it, Cincinnatus was plowing his field in 458 B.C. when a group of Roman Senators came to ask him to be the dictator and help repel an invasion. Out of civic duty, Cincinnatus accepted the role of dictator and defeated the invading forces. What's more remarkable is that once the crisis was averted, Cincinnatus immediately resigned as dictator and returned to his farm. The same thing happened in 439 B.C. when Cincinnatus put down a conspiracy, then again gave up his power. Cincinnatus' ability to step up in times of crisis, then fade back into private life is truly impressive.

Chuck Norris' 1980s movie characters reveal him to be a modern-day cinematic Cincinnatus. Chuck Norris steps in to take care of business and save the day, then he goes back to his simple private life as an ordinary citizen.

James Braddock (Norris) is a former POW who escaped from a Vietnamese prison camp in *Missing in Action*. As a public relations ploy, Braddock is asked to join a U.S. government delegation to Vietnam to discuss the POW issue. It quickly becomes clear that the Vietnamese have no intention of cooperating, so Braddock takes matters into his own hands. He

finds the POWs himself, breaks them out, and brings them to the sham "negotiations" as proof the Vietnamese are lying.

In *Silent Rage*, Sheriff Dan Stevens (Norris) takes down and apparently kills a crazed axe murderer named John Kirby (Brian Libby). Doctors use a new experimental wonder-drug to revive Kirby, who soon breaks loose and starts killing people again. Stevens is forced to step away from his newfound domestic bliss with Alison (Toni Kalem) to hunt down and dispose of Kirby.

The Delta Force begins with a botched mission to free U.S. hostages in Iran. Major Scott McCoy (Norris) retires to his North Carolina horse ranch. When terrorists hijack a plane filled with American tourists, McCoy leaves retirement and his ranch to rejoin Delta Force and take down the terrorists—again.

Danny O'Brien (Norris) picks up the nickname "Hero" after he single-handedly apprehends serial killer Simon Moon (Jack O'Halloran), also known as "The Terror." Danny is engaged to marry his pregnant girlfriend Kay (Brynn Thayer) and preoccupied with his domestic life when Moon escapes from a mental institution and goes on another killing spree. Danny must leave Kay's bedside shortly after the birth of his baby daughter to track down Moon—again.

Matt Hunter (*Invasion U.S.A.*) is a retired C.I.A. agent, living happily in the Florida Everglades. When a bad guy from his past—Mikhail Rostov (Richard Lynch)—returns to wreak havoc on the U.S. and revenge himself on Hunter, the C.I.A. asks Hunter to come out of retirement and take Rostov out. Hunter doesn't want the assignment, but grudgingly accepts it out of civic duty.

Chuck Norris is a modern-day Cincinnatus. He can be counted on to meet the call of duty and quietly resume his life as a private citizen afterwards. We salute you, Chuck Norris!

Even after five decades in the public eye, the legend of Chuck Norris remains as vital as ever. For those younger generations who only know Norris as a T.V. pitchman or the subject of a series of one-liners, it's instructive to look back at Norris' 1980s movies to reacquaint us with the traits that made him legendary in the first place.

Chuck Norris made ass-kicking action movies with bold titles and characters upon whom you could depend. He brings a choreographed mastery of martial arts to his action movies. Chuck Norris is so tough and cool that you can forgive him for occasionally saying silly things and for his showing off his chest hair at every opportunity. Chuck Norris works alone; a partner only slows him down. His thoughts are so powerful that they can't be spoken aloud. Chuck Norris only drives vehicles tough enough to meet the demands of his rugged lifestyle. Women love Chuck Norris, even though it is often a dangerous proposition. Like any authentic all-American male, Chuck Norris enjoys a beer…but only domestic beer. We should all appreciate Chuck Norris as a modern-day Cincinnatus—a regular citizen who steps up in times of crisis and ably protects the greatest nation in the world…with a flying kick to the chest of all those who threaten our freedom!

22. Tips to Make a Good Restaurant
Diners, Drive-Ins, and Dives

(Guy Fieri pulls up to the camera in a classic convertible.)

Guy: What's shakin', folks! Welcome to another exciting episode of *Diners, Drive-Ins, and Dives*. I'm your host with the most, Guy Fieri. Tonight we're experiencing a blast from the past as we check out some diners, drive-ins, and dives from '80s movies. We'll swing by a classic diner in Baltimore (*Diner*, 1982), stop into the seaport town of Mystic, Connecticut (*Mystic Pizza*, 1988), cruise a drive-in in Beverly Hills, California (*The Hollywood Knights*, 1980), and visit an Italian pizzeria in the Bedford-Stuyvesant neighborhood of Brooklyn (*Do the the Right Thing,* 1989). So hop in and join me for a wild cross-country culinary ride through the 1980s. Along the way, we'll get some ideas on what qualities make a slammin' restaurant experience!

Fells Point Diner: Baltimore, Maryland

Guy: Baltimore is famous for its blue crabs, but the Inner Harbor can wait. Tonight we're visiting a classic eatery, the Fells Point Diner (*Diner*). Baltimore residents have been eating here for years, and it's become a Baltimore institution. Let's head inside and talk to the owner, George (Ted Bataloukos). George, thanks for inviting us into your diner.

George: Everyone is welcome here. We're always open.

Guy: Wow George, I'm looking at your menu, and I gotta tell you, it's pretty extensive.

George: It has to be. We're open 24 hours a day. We serve breakfast, lunch, dinner, and everything in between. Our customers come from every walk of life—working men, students, hustlers, families. We cater to all their tastes and demands. Just the other day, one of our regulars, Earl (Mark Margolis), sat down and ate the whole left side of the menu: 22 sandwiches and the fried chicken dinner.

Guy: Man, I've got a healthy appetite, but no way I'd try to tackle all that.
George: How about we get you a classic B.L.T., then?
Guy: Now you're talking, George. (Guy takes a bite). Mmm—that's a fantastic sandwich. George, let me ask you something. What makes a great restaurant?
George: In our case, I'd say **dependability**. Just like that B.L.T. you're eating, you know what you're getting you walk in here. You slide into a booth and order an old, familiar dish.
Guy: Comfort food, huh?
George: More than just comfort food. A comfortable place to hang out, eat some good food, and spend time with friends.
Guy: So a comfort *diner* then.
George: Yeah, you could say that. Look around tonight. Bagel (Michael Tucker) is here after a long day at the construction site. There's Eddie (Steve Guttenberg), working on the Baltimore Colts trivia test his fiancée has to pass before he'll marry her. Modell (Paul Reiser) is sneaking a bite of Eddie's roast beef sandwich. Shrevie (Daniel Stern) is arguing with Fenwick (Kevin Bacon) about whether Sinatra or Johnny Mathis is better music for making out. Billy (Tim Daly) is pining for Barbara (Kathryn Dowling) over a Cherry Coke. Boogie (Mickey Rourke) is placing a bet on the basketball game while he scarfs down some french fries with gravy. The diner's like a second home to these guys. It's *better* than their home—they actually *like* everybody here, and the food is tastier.
Guy: Next time you're in Baltimore, folks, stop into Fells Point Diner. It's a dependable bet, whether you're looking for a late-night sandwich, a wager on the Colts game, or great conversation with friends.

Mystic Pizza: Mystic, Connecticut

(Guy leans against his car in front of the harbor, filled with fishing boats.)
Guy: I know what you're thinking. I'm here in this beautiful seaport town to introduce you to a great little local seafood place. Well guess again gang, because we're here for pizza

(*Mystic Pizza*). Right across the street is Mystic Pizza, the pride of Mystic, Connecticut. Let's head in and meet the proprietor, Leona (Conchata Ferrell). Hi Leona. Visitors to Mystic Pizza can find you here in the kitchen pretty much anytime making some great pizza, right?

Leona: Not *great* pizza, Guy, the *best* pizza.

Guy: Pardon me, Leona. My mistake. Why don't I take a slice and judge for myself. (Guy takes a big bite.) Oh man, that is killer! My apologies, Leona, that *is* the best. What's the secret to this amazing pizza?

Leona: It ain't goat cheese, I can tell you that. The girls that work here- Daisy (Julia Roberts) Kat (Annabeth Gish), and Jojo (Lili Taylor)- are always trying to talk me into making "designer" pizzas, with all sorts of fancy ingredients. But we have the real thing here, spices directly from Portugal. My grandfather taught my father how to make it, and my father taught me. And one of these days, when I retire, I just might teach one of these girls my secrets.

Guy: So this recipe has been passed down from generation to generation?

Leona: You bet it has. **It's tradition, and you don't monkey with tradition**. Food fads may come and go, but a time-tested traditional recipe will *always* be good. We get the fishermen and all the locals in here to eat, and we also get the tourists. Tourists! You can't live with 'em, and you can't live without 'em. Even that jackass food critic on the TV, the Everyday Gourmet (Louis Turenne), loves our pizza. He called it "superb."

Guy: Leona, he may be a jackass, but he's got excellent taste in pizza. Thanks for having us here today. Just between you and me, any chance you'll share that secret recipe with me?

Leona: Not on your life!

Guy: Hey, you can't blame a guy for trying. Well guys, the ingredients might be a mystery, but it's clear as day that you'll enjoy your trip to Mystic Pizza.

Tubby's Drive-In: Beverly Hills, California

(Guy pulls his convertible into a parking space, where Suzie (Michelle Pfeiffer), a female bellhop, approaches his car.)
Suzie: Welcome to Tubby's, home of "The Big One." (*The Hollywood Knights*) What can I get you today?
Guy: How can I pass up something called "The Big One?" Set me up, Suzie.
Suzie: One Big One, coming right up.
Guy: While Suzie fills my order, let's go talk to Tubby (Harold "Red" Keller) in the kitchen. (Guy opens a side door to the kitchen and enters). Hey Tubby, how are we doing tonight?
Tubby: Great, Guy, thanks for comin'.
Guy: Now when people think of Beverly Hills, they usually think of "swimming pools and movie stars." But Tubby's isn't some ritzy place catering only to the well-to-do, is it?
Tubby: Hell no. We serve good, simple American food- burgers, dogs, fries, shakes. That's why the kids love Tubby's. **Good food and good times**. We get the surfers, the squares, the gearheads, everybody in here. Smitty's Car Shop is next door, so Tubby's has become the unofficial home of the local car club, the Hollywood Knights.
Guy: Sounds like my kind of crowd. Not to mention those fine-looking bellhops in the skimpy white shorts! But I understand not everyone around here is a big fan of Tubby's Drive-In.
Tubby: No, we always have those straight-laced stiffs from the Beverly Hills Residents Association on our ass. They call Tubby's a "social disease." From them, I take that as a compliment. And then there's the local police, Officer Bimbeau (Guilard Sartain) and Officer Clark (Sandy Helberg), who are constantly busting all the kids for harmless offenses like drag-racing, skateboarding, smoking, and drinking. These kids aren't hurtin' nobody. I think a lot of these straight arrows have forgotten what it's like to be a kid and have some fun.

Guy: And food should always be fun.
Tubby: You ready for that Big One?
Guy: You know it! Tune up your classic car, and cruise on in to Tubby's Drive-In for some good food and good fun.

Sal's Famous Pizzeria: Bedford: Stuyvesant, Brooklyn, New York

(Guy is standing in front of a brownstone.)
Guy: There's nothing like a buzzing neighborhood to make you feel at home. Just look around. There's some girls playing double dutch on the sidewalk. The neighborhood kids rigged the fire hydrant for a makeshift water park. Radio Raheem (Bill Nunn) is pumping Public Enemy out of his ginormous boombox. M.L. (Paul Benjamin), Coconut Sid (Frankie Faison), and Sweet Dick Willia (Robin Harris) are carrying on on the corner. Mister Senor Love Daddy (Samuel L Jackson) is spinning the tunes on We Love Radio, FM 108. Da Mayor (Ossie Davis) is buying a beer at the Korean grocer. Mother Sister (Ruby Dee) is in her window, watching it all. And here comes Mookie (Spike Lee), delivering a pizza from Sal's (*Do The Right Thing*). That's what brings us to this vibrant Brooklyn neighborhood—food. **Food can be a big part of a neighborhood and its culture**, as we'll learn today from Salvatore Fragione (Danny Aiello). Here we are at Sal's Famous Pizzeria. Let's go in and talk to Sal. Hey Sal, how about a slice?
Sal: One slice, comin' up.
Guy: Sal, can I get some extra mozzarella on that bad boy?
Sal: I usually charge two dollars for extra cheese, but for a fellow *paisan* with a name like Fieri, it's on the house.
Guy: Thanks, Sal. I understand your Italian-American heritage is very important to you.
Sal: It sure is. All the pictures on my wall of fame are famous Italian-Americans.

Guy: I heard you got some flak about that from one of your African-American customers.

Sal: Ah, he's nothin' but a trouble-maker. I've been here 25 years. I never had trouble with these people. They grew up on my food, and I'm very proud of that. Sal's Famous Pizzeria is here to stay. One day maybe I'll retire, and turn it over to my sons Pino (John Turturro) and Vito (Richard Edson).

Guy: So you feel like your food is a vital part of this community.

Sal: It may sound silly, but yeah I do. This ain't about money. I built this place myself, with my bare hands—every light socket, every tile. I've watched these kids grow up, seen the old folks get older, and all on Sal's pizza.

Guy: Doesn't sound silly to me at all. How about a chicken parm hero for the road, Sal?

Sal: You got it!

Guy: Next time you're in Bed-Stuy, stop in for a pizza pie. Hey, I'm a poet and I didn't even know it. Thanks for tuning in to tonight's episode of Triple D. We got a good sense of what makes a restaurant successful. Dependability and comfort. Tradition and family. Good times and good food. All that can make a diner, drive-in, or dive an important part of a community and the lives of its residents. Join me next time when I visit a futuristic '80s-themed diner (*Back to the Future 2*), a Queens fast-food joint named McDowell's that might seem pretty familiar to you (*Coming to America*), a California dive called Senor Pizza that specializes in pizzas with extra anchovies (*Loverboy*), and a New York City delicatessen where the sandwiches are orgasmic (*When Harry Met Sally*). Catch you next time on *Diners, Drive-Ins, and Dives*.

23. How to Handle Social Standing
Class in '80s Movies and How It's Handled

Rich versus poor, the haves and the have-nots, the elite and the *hoi polloi*—class distinctions are almost as old as history itself, and have been an important theme in the history of the United States. The recent Occupy Wall Street movement is an indication that socioeconomic class and the distribution of wealth are still major issues in America.

The 1980s were a decade of increased class consciousness and conflict. The 1980s have become known as the "me decade," as upwardly mobile Baby Boomers were far more interested in the accumulation of wealth and "keeping up with the Joneses" than their more civic-minded parents of the Greatest Generation. Economic policies of the Reagan administration favored corporate America and the business elite. Reagan's economic theoreticians espoused a trickle-down theory of economics that what's good for those at the top will benefit everyone as money and services magically trickle down from the wealthy to the rest of the economy. Only they didn't; wealth remained largely concentrated in the hands of the few at the expense of the middle and lower classes. In addition, non-revenue-generating social and federal programs were drastically slashed, disproportionately impacting the lower classes.

The result of these social and economic trends was a growing class polarization, as differences between the classes became more glaringly obvious. Hollywood was quick to take notice. The degree to which class distinctions serve as major themes in '80s movies is startling. As America deals with another economic recession, it is worthwhile to take a look back at class distinctions in '80s movies, how they affected the characters, and how those characters handled the class issues.

Maintaining the Status Quo: How Elites Handle Class Distinctions

In any society or economy, the people at the top of the system—social, economic, political, or military elites—benefit

disproportionately from the system. Therefore, they work very hard to maintain the status quo, constantly tweaking the system to ensure the continuation of those benefits. Movies from the 1980s feature a number of elites using tradition and the biased power structure to protect their elite status.

- *Caddyshack* (1980): The slobs battle the snobs at Bushwood Country Club, where betting is illegal and co-founder Judge Elihu Smails (Ted Knight) "never slices." The divide between country club members and "the help" is both wide and obvious, as golf caddy Danny Noonan (Michael O'Keefe) discovers while angling for a college scholarship. Smails and company use Bushwood's tradition to keep out "the wrong type", like *nouveau riche* construction magnate Al Czervic (Rodney Dangerfield), and to keep the caddies and other employees at their beck and call. Smails attempts to convinced Danny to "abide by the rules of decent society"—to help maintain the status quo in return for the college scholarship and a Fresca.
- *Scarface* (1983): Emerging drug kingpin Tony Montana (Al Pacino) quickly discovers that the cops are as dirty, if not more so, than his fellow drug dealers. Miami narcotics detective Mel Bernstein (Harris Yulin) doesn't really care who runs the drug trade or how, as long as he gets his cut. Mel's police power to arrest Tony at any time gives him power over Tony, and ensures a steady cash flow for him and the other dirty cops in his unit.
- *Trading Places* (1983): Randolph and Mortimer Duke (Ralph Bellamy and Don Ameche) are bastions of old money and Wall Street. Their status and money allow them to maintain a very privileged lifestyle—from their limousine, to the snobbish club at which they cool their heels, to the inside information on an upcoming orange crop report that they purchase. The Dukes believe they are so secure that they don't think twice about conducting a nature-versus-nurture "social experiment" in which they switch the fortunes of Ivy League-educated yuppie Louis Winthorp (Dan Aykroyd) and down-on-his-luck vagrant Billy Ray Valentine (Eddie Murphy).

- *Sixteen Candles* (1984), *Pretty in Pink* (1986), and *Some Kind of Wonderful* (1987): These three John Hughes-scripted movies feature uber-popular blonde characters who represent the social status quo in clique-dominated high schools. Prom queen Caroline Mumford (Haviland Morris) is so hot in *Sixteen Candles* that even the girls salivate over her in the shower. Caroline uses her sex appeal and popularity as a threat to her boyfriend Jake (Michael Shoeffling)—"Just remember one thing. I could name 20 guys that would kill to love me."—to keep him in line and keep the party jumping.

 Steff (James Spader) is the epitome of the over-privileged rich kid in *Pretty in Pink*. Steff gets anything—and anyone—he wants until Andie Walsh (Molly Ringwald) turns him down cold. When Steff's best friend Blane (Andrew McCarthy) starts dating Andie, Steff uses peer pressure and everything else in his arsenal to split the two of them up. Steff's primary argument is a class-based one. "If you want your little piece of low-grade ass, fine, take it, but if you do, you're not gonna have a friend."

 In *Some Kind of Wonderful*, Hardy Jenns (Craig Sheffer) is the most popular guy in school, dates the most popular girl Amanda Jones (Lea Thompson), and treats the school as his own private fiefdom. Hardy rubs their class differences in the face of blue collar Keith (Eric Stoltz) by harassing him as Keith provides service to Hardy's expensive vehicle. Hardy later uses the threat of social ostracization to discourage a potential relationship between Amanda and Keith.

- *Easy Money* (1983) and *Brewster's Millions* (1985): In both movies, cantankerous old multi-millionaires (Geraldine Fitzgerald and Hume Cronyn, respectively) use the promise of huge inheritances to change the behavior of working class schlubs Monty Capuletti and Monty Brewster (Rodney Dangerfield and Richard Pryor). They're using their wealth and influence not only to maintain the status quo, but also to "civilize" the two working-class Montys by forcing their own social mores and behaviors on them.

- *Wall Street* (1987) and *Working Girl* (1988): Wealth breeds more wealth, as the saying goes. Business elites tend to be very entrenched and territorial. The infamous Gordon Gekko (Michael Douglas) of *Wall Street* has become a symbol of '80s excess and the maxim that "greed is good." Gekko uses inside information and unethical practices to maintain his position as a Wall Street shark. "We make the rules, pal. The news, war, peace, famine, upheaval, the price per paper clip. We pick that rabbit out of the hat while everybody sits out there wondering how the hell we did it. Now you're not naïve enough to think we're living in a democracy, are you buddy? It's the free market." Gekko takes working class Bud Fox (Charlie Sheen) under his wing, teaches him these questionable practices, and uses him to make more money for himself.

 Tess McGill (Melanie Griffith) of *Working Girl* has big hair and even bigger ambitions. Her boss Katharine Parker (Sigourney Weaver) protects her territory by stealing a profitable business idea from Tess and passing it off as her own.

 As Tess says, "You can bend the rules plenty when you get upstairs, but not when you're trying to get there." Bending the rules to suit their needs is how elites like Gordon Gekko and Katharine Parker maintain their privileged positions.

Violence and Anger

Resentment over class differences and the unfair realities they engender can often boil over into anger and violence. A number of '80s movies show angry or violent reactions by characters to class realities.

- *The Breakfast Club* (1985): Poor kid John Bender (Judd Nelson) comes from an abusive household that presents him with few opportunities in life. Bender is very resentful of Claire (Molly Ringwald), the rich girl prom queen who brings sushi for lunch and is serving detention for skipping school to go shopping. Bender angrily taunts Claire: "You

got everything, and I've got shit. Fucking Rapunzel, right? The school would probably fucking shut down if you didn't show up. Queenie isn't here. I like those earrings, Claire. Are those real diamonds, Claire? I'll bet they are. Did you work for the money for those earrings? Or did your daddy buy them for you?"

- *The Outsiders* (1983): Class tensions in Tulsa, Oklahoma lead to ongoing rumbles between the rich, preppy Socs and the poor, rough Greasers. The anger and class resentment of the Greasers is embodied in Dallas Winston (Matt Dillon), who pulls a gun on a convenience store owner, robs him, and is then shot to death by the police.
- *Dirty Dancing* (1987): Working-class dancer Johnny Castle (Patrick Swayze) complains to rich girl Baby (Jennifer Grey) about his tenuous economic existence. "You don't understand the way it is, I mean for somebody like me. Last month I'm eating jujubes to keep alive, this month women are stuffing diamonds in my pockets. I'm balancing on shit, and quick as that, I could be there again." Johnny's resentment over the fact that the wealthy hold all the cards boils over when he punches slimy rich kid Robbie (Max Cantor).
- *Mystic Pizza* (1988): Working-class waitress Daisy (Julia Roberts) reluctantly starts dating rich college boy Charles Gordon Windsor, Jr. (Adam Storke). However, when she mistakenly thinks Charlie is cheating on her, Daisy's class resentment explodes and she dumps a huge load of fish guts into Charlie's Porsche convertible—the glaring symbol of their class difference.
- *Porky's* (1982): The denizens of rural Wallacetown, Florida are resentful of their wealthier neighbors from Seward County. When wealthier high school students from Angel Beach High go to Wallacetown's titular shady hideaway for some action, the locals harass the "Angel Beach pussies," steal their money, and trash their car. "This here's a *man's* county," the Sheriff (Alex Karras) tells the boys before sending them back to Angel Beach with their tails between their legs.

- *Pretty in Pink* (1986): Duckie (Jon Cryer) and Andie (Molly Ringwald) are best friends who grew up on the wrong side of the tracks, and are treated as second-class citizens in their own high school. Duckie is defiant in the face of the class prejudice, physically confronting rich jerk Steff (James Spader) when he badmouths compatriot Andie. Duckie also reacts angrily when Andie crosses class lines to date rich kid Blane (Andrew McCarthy). "So when you're feeling real low and…and dirty, and your heart is splattered all over hell, don't look to me to pump you back up 'cause…'cause…'cause maybe for the first time in your life *I won't be there!*"
- *The Accused* (1988): A group—including a couple of college boys—rapes white trash Sarah Tobias (Jodie Foster) at a bar. Her class becomes a major issue in the subsequent trial as her character is questioned by a well-to-do prosecutor who seems more inclined to side with the more "respectable" college boy rapists.
- *Some Kind of Wonderful* (1987): Watts (Mary Stuart Masterson) practically seethes with class resentment. She's not quite able to hide her disdain for rich, popular kids like Hardy (Craig Sheffer) and Amanda (Lea Thompson). The threat of underclass violence also helps keep a revenge-minded Hardy in check when Keith's (Eric Stoltz) detention buddies (most notably Elias Koteas) crash Hardy's rich kid party.
- *Scarface* (1983): Tony Montana (Al Pacino) is determined to grab his share (and then some) of the American dream. A poor Cuban immigrant, Tony lacks the education, resources, or connections to succeed in a more traditional way, so he secures his fortune the only way he knows how—through violence. Tony's efforts to climb the social ladder leave a trail of chainsawed Columbians, murdered competitors, and gut-shot cops. Tony's answer to a challenge is to "say hello to my little friend", and let a hail of bullets sort things out.
- *Raising Arizona* (1987): A poor childless couple, Hi and Edwina McDunnough (Nicolas Cage and Holly Hunter) are resentful of all that wealthy Nathan Arizona and his family

have, particularly their children. Hi and Edwina justify their kidnapping of one of the babies in terms of the Arizonas' abundance. Edwina tells Hi, "I need a baby, Hi. They got more than they can handle."

- *Valley Girl* (1983): A modern-day retelling of Romeo and Juliet set in California, *Valley Girl* has preppy valley girl Julie (Deborah Foreman) and Hollywood punk Randy (Nicolas Cage) falling for one another, despite their class and lifestyle differences. When Randy crashes a Valley party to see Julie, her preppy friends protect their turf, beating up Randy and his friend Fred.

Humor

Sometimes you have to laugh to keep from crying. Humor can often be used as a defense mechanism to protect one from unpleasant realities. Some '80s characters employ humor to deal with class issues. The relative lack of characters using this approach (compared to other methods) suggests how serious an issue class differences were in the 1980s.

- *Caddyshack* (1980), *Easy Money* (1983), and *Back to School* (1986): How else would you expect Rodney Dangerfield to deal with issues if not with humor? In all three movies, his characters are working-class everymen who use humor to deal with their outsider status. It doesn't matter to the elites in *Caddyshack* and *Back to School* that his characters are successful and have lots of money; he's still not "the right type." The country club elites of Bushwood ostracize Al Czervic as a *nouveau riche* boor (*Caddyshack*), and Dr. Barbay (Paxton Whitehead) and the other educational snobs at Grand Lakes University (*Back to School*) look down on him as crass and uneducated. Rodney's self-deprecating characters spew a constant stream of one-liners that poke fun at the pretensions of the elites. In *Caddyshack*, wealthy Ty Webb (Chevy Chase) also uses humor to distance himself from the pretensions and other negative aspects of Bushwood's class divide.

- *Pretty in Pink* (1986): Duckie (Jon Cryer) uses humor to mask the pain he feels in being a social outsider. When Andie tells Duckie she's going out with rich kid Blane, Duckie counters, "Blane? That's a major appliance; that's not a name!"
- *Brewster's Millions* (1985): Monty Brewster (Richard Pryor) is a minor league baseball pitcher who stands to inherit a large sum of money if he can toe the line. Monty and his best friend/catcher Spike Nolan (John Candy) use humor in dealing with the new class of people that his wealth attracts. Spike: "Monty, this is Hackensack, New Jersey. No scout comes here—you understand that. Trains are going through the outfield right now. But if you strike this guy out, I'll take you with me tonight and get you drunk, I promise."

We Shall Overcome

If you can't beat 'em, join 'em. If the system is set up to protect elites and perpetuate wealth and privilege, find a way to beat or join the system. Once you're in, you can be one of those who control the system for your own benefit. Several '80s movie characters either attempt to work their way into the system or beat the rigged system entirely.

- *Back to School* (1986): Thornton Melon (Rodney Dangerfield) is a self-made millionaire lacking a college education. He uses his wealth to buy his way into Grand Lakes University, donating the funds for a brand new business school.
- *Wall Street* (1987): Bud Fox (Charlie Sheen) is an ambitious young Wall Street stockbroker who desperately wants to play with the big boys. Bud weasels his way into the office of heavy-duty player Gordon Gekko (Michael Douglas) by calling the office 59 days in a row and giving Gekko a gift of rare Cuban cigars. Once Bud gets his foot in the door, he lies, cheats, and steals to stay in the big time. As Gekko tells him, "money never sleeps."

- *All the Right Moves* (1983): Stefen Djordevic (Tom Cruise) lives in a small Pennsylvania town where football is the only way out. After running afoul of his coach (Craig T. Nelson), Steff must do all he can to secure a college scholarship and his ticket out of a lower-class existence.
- *Easy Money* (1983): Monty Capulleti (Rodney Dangerfield) has to act "civilized"— no smoking, drinking, drugs, poker, or junk food—in order to earn a huge inheritance. Once the money is his, though, Monty adopts the façade of "civilization" while returning to his old ways.
- *Working Girl* (1988): The business world refuses to take Tess McGill (Melanie Griffith) seriously. They take one look at her big hair and big…um…personality, and decide that she's destined for a life as a secretary. Tess takes matters into her own hands by sidestepping her boss to set up a profitable deal on her own. Her moxie is rewarded with a promotion and an office with her own secretary.
- *Cocktail* (1988): Working-class bartender Brian Flanagan (Tom Cruise) uses his charm to find a sugar mama who can support him financially and help introduce him into the business world.
- *Scarface* (1983): Though he is a poorly educated Cuban immigrant, Tony Montana (Al Pacino) shrewdly analyzes American society. "In this country, you gotta make the money first. Then when you get the money, you get the power. Then when you get the power, then you get the woman." Tony goes after the money, the power, and the woman (Michelle Pfeiffer) by muscling his way into the cocaine trade. His money buys Tony entrance into a social class (and the accompanying benefits) he never could have imagined in Cuba.
- *Trading Places* (1983): Winthorp (Dan Aykroyd) and Valentine (Eddie Murphy) beat the Dukes at their own game by using Wall Street to defeat the Wall Street tycoons. They intercept the crop report the Dukes have illegally procured and replace it with false information. They then use that information to corner the market on orange futures and earn a huge financial windfall.

Compassion, Communication, and Contact

Perhaps the bravest—and trickiest—approach to class differences is to try to overcome them by reaching out across class lines. The hope is that understanding and communication will help ease (and maybe even erase) class distinctions.

- *The Outsiders* (1983): Ponyboy Curtis (C. Thomas Howell) epitomizes this approach. Ponyboy has had enough of the class warfare between the Greasers and the Socs. He emphasizes their commonalities in a heated exchange with a Soc:

 > **Soc**: You know what a Greaser is? White trash with long, greasy hair.
 > **Ponyboy**: You know what a Soc is? White trash with Mustangs and madras.

 Ponyboy reaches out to Socs Cherry Valance (Diane Lane) and Randy Anderson (Darren Dalton). After Ponyboy talks to Randy, fellow Greaser Two Bit (Emilio Estevez) asks Ponyboy: "What did Mr. Supersoc have to say?" "He ain't a Soc," Ponyboy responds, "just a guy who wanted to talk, that's all."

- *The Breakfast Club* (1985): Carl the janitor (John Kapelos) is emptying trash in the library during Saturday detention when Bender (Judd Nelson) makes a wisecrack about becoming a janitor. Carl counters with, "Oh, really? You guys think I'm just some untouchable peasant? Peon? Huh? Maybe so, but following a broom around after shitheads like you for the past eight years I've learned a couple of things. I look through your letters, I look through your lockers…I listen to your conversations, you don't know that, but I do…I am the eyes and ears of this institution, my friends. By the way, that clock's twenty minutes fast!" Bender smiles with a newfound respect for the "peon" janitor.

- *Some Kind of Wonderful* (1987): Keith (Eric Stoltz) is determined to date popular Amanda (Lea Thompson) regardless of their differences in social status or the fact that she already has a boyfriend. Keith leverages everything he has, including his college savings, in an effort to defy class lines and win his dream girl.
- *Caddyshack* (1980): Wealthy New York City socialite Lacy Underall (Cindy Morgan) has "a certain zest for living." She practices her own version of inter-class contact by sleeping around—with members and caddies alike.
- *Valley Girl* (1983): Hollywood punk Randy (Nicolas Cage) and preppy Valley girl Julie (Deborah Foreman) defy social convention and ignore the hang-ups of their friends by beginning a cross-class romantic relationship.
- *Sixteen Candles* (1984): Wealthy, popular high school senior Jake Ryan (Michael Schoeffling) is fed up with the pretensions of popularity and his insensitive prom queen girlfriend Caroline (Haviland Morris). Jake admits to nerdy Farmer Ted (Anthony Michael Hall) that he wants a serious girlfriend who he can love and will love him in return. Ted replies that "I think a ton of guys feel the same way you do…They don't have the balls to admit it." Jake does have the balls, and the maturity, to see beyond cliques and popularity to find sophomore Samantha Baker (Molly Ringwald).
- *Dirty Dancing* (1987): Baby (Jennifer Grey) takes the time and effort to get to know "the help" at a Catskills resort. Baby intervenes to help out dancer Penny (Cynthia Rhodes) after a botched abortion, and dates dancer Johnny (Patrick Swayze) despite her parents' disapproval, and even carries a watermelon!
- *Say Anything* (1989): Wealth and popularity are not the only characteristics that can cause social differences in a high school. Education and ambition serve as major social barriers between Diane Court (Ione Skye) and Lloyd Dobler (John Cusack). Diane is the school valedictorian and plans to study in England on a prestigious fellowship. Lloyd, on the other hand, enjoys kickboxing and only knows that he doesn't want to "buy, sell, or process"

anything for a living. Nevertheless, Lloyd reaches out to start an unlikely romance between them.
- *Pretty in Pink* (1986): As in *Some Kind of Wonderful* and *Dirty Dancing*, *Pretty in Pink* deals with an inter-class romance. Rich kid Blane (Andrew McCarthy) makes the effort to contact and woo poor girl Andie (Molly Ringwald), despite the protestations of their friends Steff (James Spader) and Duckie (Jon Cryer).
- *The Breakfast Club* (1985): Communication between members of social cliques is essentially forced on the five kids who serve Saturday detention together at Shermer High School. The brain, the princess, the criminal, the jock, and the basket case are forced together by circumstance. Once they begin talking to one another and getting beyond the "convenient labels," they realize they have more in common than they previously thought. Though it appears doubtful their newfound friendships will survive Monday morning, at least they have broken down those social status barriers and gained a better understanding of themselves and others. The last scene in the movie—Bender's (Judd Nelson) triumphant fist in the air to the strains of Simple Minds' *"Don't You Forget About Me"*—gives us hope that at least these five high school kids will be better people for having reached out and invited understanding.

So what lessons have we learned about handling class distinctions from our analysis of '80s movies? Those with all the money, power, and status will use tradition and their influence over the system to maintain the status quo that benefits them personally. Anger and violence can be a natural reaction to frustration over class differences. However, violence often begets violence, and accomplishes little as demonstrated by Dallas Winston (*The Outsiders*) and Tony Montana (*Scarface*), who both end up dead. Humor can serve as a defense mechanism to mask the realities of class differences. Rodney Dangerfield's quips might entertain the audience, but they do nothing to improve inter-class relations and may in fact serve as barriers to understanding.

Trying to work the system for your own benefit is one possible way to escape living on the losing end of the class structure. The cards are stacked against you though, and gaming the system is a daunting challenge. If you succeed, you've only become "one of them" and haven't improved anything except your own welfare. The most effective way to handle class distinctions may also be the hardest. It involves reaching out across classes to communicate with and better understand people from different social or economic classes. This approach may be a difficult one—involving many obstacles—but the rewards are compelling. Ponyboy (*The Outsiders*), Carl the janitor and the five detention students (*The Breakfast Club*), and Baby (*Dirty Dancing*) each gain the respect of people from different social classes. Jake and Samantha (*Sixteen Candles*), Blane and Andie (*Pretty in Pink*), Randy and Julie (*Valley Girl*), and Lloyd and Diane (*Say Anything*) find true love—or at least the potential for true love. Even when things don't work out as planned, as with Keith and Amanda in *Some Kind of Wonderful*, there are still rewards from inter-class communication. Both Keith and Amanda gain self-respect and a better idea of who they are, Keith realizes that Watts is the girl for him after all, and along the way he makes some new friends in detention.

24. How to Avoid the Perils of Time Travel

Suppose you could travel through time. What would you do? Would you hang out with your favorite historical figures? Or would you see what your parents were like in high school? If you come from a war-torn future, would you journey into the past to save humanity from catastrophe?

Regardless of your motives for time travel, '80s films have established that messing with the space-time continuum is risky business, especially if you don't know the trouble you can cause. In the *Back to the Future* series, scientist Doctor Emmett Brown (Christopher Lloyd) chides his assistant Marty McFly (Michael J. Fox) for "not thinking fourth-dimensionally", basically implying that Marty never considers the impact of time travel on his current surroundings. '80s movies like *Back to the Future*, *The Terminator*, and *Bill and Ted's Excellent Adventure* show us that if you travel through time without thinking fourth-dimensionally, you'll be subject to serious consequences.

The most obvious danger of time travel is that you could interfere with the past enough to alter the future. You could also suffer damage to life and limb by villains in other eras or bad people from your own time who don't want your mission to succeed. However, the most frightening peril of time travel is that your equipment could malfunction. Should your time machine break down, you'd be trapped whenever you are with no means of escape.

By exploring the hazards our protagonists face in the '80s films *Back to the Future*, *The Terminator*, and *Bill and Ted's Excellent Adventure*, you can learn from their experiences. Take stock of their mistakes and you'll be prepared to avoid the perils of time travel, should you ever get lucky enough to explore the space-time continuum.

Interfering with the Past

When you interact with the past, there's always the danger that you could alter the course of history. Everything that you say and do can have ramifications on the future, especially if you base your actions on knowledge of events to come.

In the 1985 film *Back to the Future*, teenager Marty McFly travels back in time to 1955—when his parents were in high school—and unwittingly endangers his own existence. Marty bumps into his father George (Crispin Glover), so he decides to follow him. But when Marty saves George from getting hit by a car, he unintentionally prevents his parents from meeting. Because Marty's grandfather hits him with the car, Marty's mother Lorraine (Lea Thompson) falls for *him* instead of George.

Marty quickly realizes that he must repair the damage he's caused, or he'll never be born. So he's forced to assist his nerdy father in wooing his mother, which is no easy task. At the same time, Marty must fight off advances from his mother. Unfortunately for him, he's unable to avoid a kiss on the lips with her. However, he does manage to get his parents together in the end. Marty learns the hard way that if you're not careful, you could be forced to make out with your mom, or—even worse—you could prevent your own birth. Don't be like Marty: leave your parents and other ancestors alone if you travel through time.

The Terminator (1984) largely takes place in the present day, exposing post-apocalyptic elements through prologue, dialogue, and dream sequences. A supercomputer known as Skynet has become sentient and produced a mechanical army in order to eradicate mankind—which it views as a threat to its continued existence. The machines come close to annihilating humanity, but one man—John Connor—figures out how to fight them. John leads the humans to victory. As a last resort, Skynet sends a deadly cyborg called the Terminator (Arnold Schwarzenegger) back in time to kill John's mother Sarah (Linda Hamilton), so that John is never born. In response to this Skynet plot, John sends his trusted soldier Kyle Reese (Michael Biehn) back in time to protect Sarah.

Kyle is well aware of the disastrous consequences if he fails in his mission. What Kyle does not count on though, is falling for Sarah. The two bond over their traumatic attempt to defeat the

Terminator and create a connection which leads to a night of passionate love-making and in turn John's conception. While some might say that Kyle was always *meant* to be John's father, it can also be argued that by thinking with his loins, Kyle has created a time paradox. Now his trip is necessary to ensure that John grows up to fight against the machines. We can only hope for humanity's sake that Kyle's actions didn't affect any other key elements to the timeline in which John defeats Skynet. Don't follow Kyle's example: keep it in your pants even if your friend's mom is really hot when you meet her in the past.

At the beginning of *Bill and Ted's Excellent Adventure* (1987), Rufus (George Carlin), a dude from the future, reveals that the band Wyld Stallyns unifies his society. Wyld Stallyns' two members, Bill S. Preston Esq. (Alex Winter) and "Ted" Theodore Logan (Keanu Reeves), create music that unites the Earth's people—although that almost didn't happen. The film transitions to the present day, where Bill and Ted are flunking their high school World History course. If they fail, they'll be unable to graduate and Ted's father will ship him off to military school.

Thankfully Rufus drops in to save the day—with a time traveling phone booth. He tells Bill and Ted that they can use it to collect figures from history in order to pass their final report. Our hapless heroes climb in and start bouncing around through history, abducting notable people. Their collected personages of historical significance include Billy the Kid, Socrates, Abraham Lincoln, Joan of Arc, Genghis Khan, Napoleon, Sigmund Freud, and Ludwig van Beethoven. Once Bill and Ted arrive back in the present, though, their guests are arrested. Bill and Ted realize that to rescue their friends from jail, they will need to do additional time traveling *after* their report, to prepare escape plans for *before* the report.

Because Bill and Ted carelessly gallivant around, they almost screw up their own plan. To fix it, they have to travel into the past again *after* their report, which further risks ruining their scheme. The scary thing is that neither Bill nor Ted is concerned about the impact of their time travel on history. All of the important figures collect knowledge on the future that could dramatically impact the course of human events, and not always in a positive way. Unless you're a carefree dude like Bill or Ted, you

probably should be cautious about what you share with people you bring home from the past.

When it comes to meddling in the past, the key takeaways for Marty from *Back to the Future*, and Kyle from *The Terminator*, are that things can get romantically complicated if you're not careful. You could accidentally prevent your own conception or even become your best friend's father. Bill and Ted's influence on historical figures might shape the course of world events in a negative way. If you tell an important person too much about their destiny, they could make completely different decisions; if you steal an important possession of theirs, you could prevent a historical event that is dependent on that item. Always think fourth-dimensionally when it comes to statements and actions that could disrupt the past and alter the future. When it doubt, play it safe.

Bad Guys Messing with Your Mission

You're probably familiar with the expressions "There's no such thing as a free lunch," and "If it looks too good to be true, chances are that it is." Both apply to another serious peril of time travel: bad guys. When you travel back to accomplish a particular mission, it won't just be peaches and cream. You'll have to deal with baddies looking to hurt you. To survive, you'll need quick thinking, a dash of bravery, and a sprinkle of luck.

In *Back to the Future*, Marty McFly's nemesis is Biff Tannen (Thomas F. Wilson)—the bully that terrorized his father George in high school. Biff is oafish, crass, and hotheaded—some of the worst possible qualities in a person. After Marty travels back to 1955, it's no surprise that they instantly clash. Marty stands up for his mother Lorraine when Biff makes unwanted advances, and he fights back against Biff's cronies when they pick on George. Marty really messes up when he forces Biff to crash his car into a manure truck, prompting Biff to exact payback that nearly ruins Marty's careful plot for uniting George and Lorraine.

Marty plans for George to rescue Lorraine in a fake brawl that will prove George's bravery. Unfortunately, Biff kidnaps Marty before that can happen, getting his cronies to lock him in a trunk. This almost foils Marty's scheme, but as George sees how

frightened Lorraine is, he musters the courage to slug Biff—winning her heart. Everything turns out fine for Marty, although it almost doesn't because he isn't on his guard. It's good to stand up to bullies like Biff, but you should pick your battles. Don't antagonize them too much, because they could get to you when you least expect it and foul up your mission.

The bad guy Kyle faces in *The Terminator* is rather obvious: the Terminator. What's so tricky about the Terminator is that it wears living human flesh to help it blend in. To make matters worse, the Terminator is proficient with many weapons, has extensive files on operating vehicles, and can imitate voices. This emotionless cyborg is the perfect killing machine because it does not "feel pain or remorse, and it won't stop until you're dead," as Kyle puts it. Going up against the Terminator puts Kyle at a disadvantage because he does feel pain and he's highly susceptible to injury. The only way Kyle can level the playing field is with fiery determination and brute force assault techniques. However, all of these methods involve putting his life at great risk. If you encounter a powerful foe like the Terminator, your best bet is to use your wits as an equalizer in battle—and don't be afraid to fight dirty. Make sure whatever you're doing isn't too dangerous, unless like Kyle you plan to sacrifice yourself for the greater good.

Strangely enough, Bill and Ted's most powerful enemy in *Bill and Ted's Excellent Adventure* is Ted's father. Police officer Captain Logan thinks that his son needs order and discipline, which is why he wants to ship Ted off to military school. Captain Logan hopes to break up the Wyld Stallyns, so that Ted will quit screwing around and become a successful adult. Because he is bent on his plan, Captain Logan tries to prevent his son from working on his World History report, and attempts to keep Bill and Ted's historical figures behind bars. Ted's father is one tough guy to beat, but with a little planning and juvenile tricks, Bill and Ted take him down. Don't be afraid to use adolescent pranks to dodge your foes while time traveling. React quickly and use resources around you to get the job done—do whatever it takes. Escape and success are paramount.

Captain Logan isn't the only enemy found in this excellent adventure. While they are in the Middle Ages, Bill and Ted come across two lovely princesses who they attempt to rescue. Sadly, a

group of "royal ugly dudes" catch them, and threaten to put them in the iron maiden. When Bill and Ted appear ecstatic about this punishment—because they are fans of the heavy metal band Iron Maiden—the ugly dudes sentence them to death instead. Luckily, Billy the Kid and Socrates intervene in the nick of time. As Bill and Ted find out, it pays to be kind to strangers, since their new friends save the day. Although you should always be excellent to each other, you can't rely on other people to get you out of sticky situations when you're time traveling. Prepare a plan before you try to rescue any medieval babes.

Time travel usually comes with some conflict and bad guys who want to mess with your mission. These enemies may be easy to identify, but they could also be the person who you least expect to have it out for you, like your father. If you aren't on your guard, you could ruin a careful plan or end up staring death in the face. When you put your life in the hands of Lady Luck, there's no guarantee that she'll be kind. Use your wits, develop a plan, and employ whatever means necessary to defeat difficult adversaries.

Faulty Time Travel Equipment

If you manage to preserve the past and get past the bad guys, you're almost golden. However, there's still one more big danger with time travel: faulty equipment. Should your machinery malfunction, you could be stuck somewhere for the rest of your life. This is a frightening concept if you're far from your loved ones and you're forced to forgo technology for more primitive methods of survival.

In *Back to the Future*, Doctor Emmett Brown creates a DeLorean time machine that requires 1.21 gigawatts (*jig-ah-watts* as he pronounces it) of electricity to function. Early on, Doc explains to Marty that he uses plutonium to generate the 1.21 gigawatts. Doc then reluctantly admits to Marty that he stole his plutonium from a group of Libyan terrorists, who soon attack them. Marty flees from the Libyans in the DeLorean, but accidentally triggers the car's time circuits, which sends him back to 1955. Since Marty can't grab replacement plutonium for his return trip, he realizes that he's now stuck in 1955.

Never one to give up hope, Marty seeks out Doc's younger self, to figure out an alternate way home. After Marty locates Doc in the past, and gets the incredulous Doc to believe his story, Doc's 1955 counterpart does not have encouraging news. He reveals that the only other thing that can generate 1.21 gigawatts of electricity aside from plutonium is a bolt of lightning, also adding that it's impossible to predict where and when lightning will strike. Fortunately, Marty is already aware of a lightning strike that will hit the town's courthouse clock tower one week later, so Doc figures out how to channel that electricity into the DeLorean. Running a time machine on nuclear fuel is dangerous, especially when you don't have enough for a return trip, but as Marty soon discovers, using lightning is just as difficult. Marty ends up in a bad situation because he has to leave in a hurry; whenever possible, you should plan ahead with spare fuel for your time machine. That's just the smart thing to do.

Kyle in *The Terminator* uses terrible time travel equipment. Non-organic material can't be transported with it, so he can't bring cool futuristic guns and ammunition that make fighting easier. Annoyingly, non-organic material also includes clothing; meaning Kyle must travel naked. The poor guy is immediately prone to injuries, as he's dropped into his destination with nothing for protection. Probably the worst aspect of this time travel equipment is that all of it is destroyed in the future, meaning that Kyle's trip is one-way. Even if Kyle succeeds in protecting Sarah and lives to tell about it, he's permanently trapped in the past. Try not to smash your equipment if you want to get home again, and if you have the option, choose a method of transportation that lets you keep your clothes and your guns. There's no reason you should have to be inconvenienced and embarrassed by the indignity of time traveling nude.

Although Bill and Ted's time traveling phone booth is hilarious, it has several weaknesses. The booth's most obvious shortcoming is its size. If you want more than two dudes in there, you'll have to seriously squeeze. Somehow during the film, Bill and Ted manage to get 10 people in it, which just doesn't seem possible even in movie logic. Since the machine is activated by dialing numbers into the phone, mistyping the number is a serious concern. Fat fingering the buttons when you don't need to get

somewhere in a hurry is okay, but those extra few seconds of caution could mean life or death.

While they're escaping the Middle Ages, Bill and Ted accidentally dial a nonexistent number, and almost get clocked by a knight's mace. The weapon doesn't hit them, but it does damage the time machine's antennae, which causes issues for the guys later. They have to make a stop in the Stone Age to perform repairs, needlessly endangering lives and sacrificing valuable time. If something more serious happened, Bill and Ted could be trapped in another time—with important historical figures—unable to live their normal lives or change the future. Would you want to be responsible for depriving history of Genghis Khan? Probably not—which is why you shouldn't cram any more people into your time traveling phone booth than necessary and why you should always memorize the next number you need to dial before you leave. It could save valuable seconds—and maybe even your life.

Now that you know the major perils of time travel, you can be sure to avoid them if ever you find yourself meandering through the space-time continuum. Be careful not to mess up events directly tied to your past, watch out for bad guys, and make sure you have some dependable equipment to get you home with plenty of extra fuel. By following these rules, your probability of surviving the time travel intact is much higher, and also minimizes the damage that you can do to history. For anything that hasn't been covered here, just keep your wits about you and remember to always think fourth-dimensionally. It will never steer you wrong.

25. How to Survive an '80s Horror Movie Part V: The Final Chapter

It's been great fun, but like any movie franchise, you have to know when to call it quits. This is the final installment of my advice on how to survive an '80s horror movie. I hope you've been paying attention so far. Here are my final few pieces of advice—on the benefits of clean living, and the dangers of trust, karma, and assumption.

Live Straight-Edge ... or You'll Get a Straight Edge

Sex isn't the only vice that you should avoid in a horror movie. Alcohol and drugs can also get you into trouble. They cloud your judgment and leave you vulnerable to a crazed killer.

- *He Knows You're Alone* (1980) and *Friday the 13th* (1980): Both Nancy (Elizabeth Kemp) and Jack (Kevin Bacon) are smoking pot when they're killed. Nancy has her head chopped off and Jack gets an arrow through his throat.
- *Hell Night* (1981): slutty Denise (Suki Goodwin) sneaks whiskey and quaaludes into the house during their Halloween pledge hazing. Denise is even dressed as a flapper—the embodiment of wanton excess. Sure enough, Denise is the first of the four pledges to be killed.
- *Terror Train* (1980): The action in this movie takes place aboard a train filled with New Year's Eve revelers. Everyone is drinking, partying, and otherwise sinning. When her best friend Mitchy (Sandee Currie) is sliced up by the killer, a distraught Alana (Jamie Lee Curtis) asks the conductor Carne (Ben Johnson), "Who did that to her?" Carne responds, "Probably some kid...messed up on dope, alcohol."

- *Friday the 13th* (1980): The camp counselors are supposed to be helping the new owner Steve (Peter Brouwer) get the camp set up, but they spend most of the movie drinking, smoking, fornicating, and even playing strip Monopoly. They all end up dead, except for Alice (Adrienne King), who I take care of first thing in the sequel.
- *The Prowler* (1981): The heroine Pam (Vicky Dawson) is the only one of her circle of friends who is not drinking or smoking up before or during the graduation dance—and is the only one of them to survive.

Famous New York Yankee pitcher Lefty Gomez once said, "The secret of my success was clean living and a fast outfield." You probably won't have Hall of Famers like Babe Ruth, Joe DiMaggio, and Earle Combs to back you up, but you can do your best to fulfill the clean living part.

Don't Trust Anyone: He or She Could Be the Killer

One of the greatest aspects of a whodunit mystery or a well-crafted horror story is not knowing who the culprit is until the very end. If you're trapped in a horror movie though, not knowing the killer's identity is a decided disadvantage. So don't trust anyone—he or she could be the killer.

- *Child's Play* (1988): Cute little doll Chucky turns out to be possessed by a psychopathic killer.
- *Motel Hell* (1980): Kindly Farmer Vincent (Rory Calhoun) is setting traps on the highway to collect the human ingredients for his smoked meats.
- *The Evil Dead* (1980): An ancient book of the dead unleashes demons that possess a group of college friends. Poor Ash (Bruce Campbell) is forced to fight off his possessed buddies, who often act "normal" to try to fool him.

- *The Howling* (1981): Dr. Waggner (Patrick Macnee) convinces distraught Karen (Dee Wallace) to come to a group therapy resort, only to find out the good doctor and the others are actually werewolves.
- *Graduation Day* (1981): Sweet little Kevin (E. Danny Murphy), who pines for the memory of his dead girlfriend Laura, turns out to be a little *too* obsessed with her memory and hunts down her old teammates with fencing swords.
- *Happy Birthday to Me* (1981): Throughout the whole movie, we wonder whether nice girl protagonist Virginia (Melissa Sue Anderson) is offing her classmates, but we discover that it's really her best friend Anne (Tracey Bregman).
- *Prom Night* (1980): The killer turns out to be Kim's (Jamie Lee Curtis) angelic little brother Alex (Michael Tough), who just can't let bygones be bygones.
- *Dead and Buried* (1981): Not only is the kooky old mortician Dobbs (Jack Albertson) secretly regenerating corpses, but the whole town—the nurse, the waitress, the gas station attendant, the teacher—are walking corpses, albeit *very well preserved* corpses.
- *Sleepaway Camp* (1983): Doe-eyed Angela (Felissa Rose), for whom we're rooting the entire movie, turns out to be the killer in one hell of a twist ending.
- *Friday the 13th* (1980): The mother of all unlikely killers is Pamela Voorhees. She seems kind and motherly when she shows up in her sweater. Alice (Adrienne King) is relieved, until she finds out mommie dearest is the killer who has been stalking her and her friends.

You can't afford to trust anyone in a horror movie, no matter how well you know them or how harmless they seem. Trust yourself—and keep a close eye on everyone else.

Karma is a Bitch

I'll be honest. Killing has been a rewarding vocation for me. Mostly it's just business, but sometimes it's personal. Most slashers will tell you that their work is far more enjoyable when you kill people who really *deserve* it.

In *The Funhouse* (1981), four teens behave very poorly at the carnival; they're rude to a bag lady and the fortune-teller, smoking pot, and breaking into the funhouse and having sex. This behavior makes it more difficult to sympathize with them as they're stalked by a carnival killer. The home of the Freeling family in *Poltergeist* (1982) was built on an old cemetery. The real estate developer simply removed the headstones, while leaving the bodies behind, desecrating the burial ground. While the Freelings aren't to blame, one can certainly understand why the spirits of the dead are pissed off. In *Hell Night* (1981), it's not enough for fraternity president Peter Bennett (Kevin Brophy) to force pledges to spend the night in a spooky haunted house. He and his buddies want to mess with the pledges by wiring the house for some artificial scares. Peter and his two assistants are the first three victims of the killer. We sympathize with painfully shy Angela (Felissa Rose) in *Sleepaway Camp* (1982), so we're not too upset when people that picked on her—from the pedophile cook to the bitchy camp counselor—start dropping like flies. With a title like *Sorority Babes in the Slimeball Bowl-O-Rama* (1988), we're not surprised when the characters are all pretty sleazy and stupid. Thus, we care very little about their efforts to steal a bowling trophy, or about the carnage it unleashes. The targets of the killer in *Prom Night* (1980) were responsible for the death of a young girl and a years-long cover-up of the crime. Even the characters who are collateral damage, like school bully Lou (David Mucci), are very unsympathetic—so when Lou's head is lopped off and rolls out on stage during the presentation of the prom king and queen, we can't help but laugh instead of cry.

Everyone is raised to believe that human life is precious, and it's a tragedy when anyone dies. But admit it—your human empathy is rarely tested when some jerk is offed. That's one reason people love horror movies: you can secretly root for the psychotic killer without getting your own hands bloody.

Never Assume the Killer is Dead

Fingers twitch, eyes open, and then the supposedly dead killer lunges back to life. It's a horror movie cliché, but a guilty pleasure in which I indulge. There's nothing more satisfying than offering a victim the hope and relief that they've finally gotten rid of you, and then yanking that hope and relief out from under them by standing up and retrieving your axe.

- *Slumber Party Massacre* (1982): Killer Russ Thorn (Michael Villela) falls into a pool after a machete attack by heroine Valerie (Robin Stille). The remaining girls relax until Thorn comes up out of the pool after them. Luckily, Valerie thinks quickly, and impales him with the machete.
- *Terror Train* (1980): Alana (Jamie Lee Curtis) knocks killer Kenny (Derek McKinnon) off a moving train. She believes he's dead, and goes to a sleeping car for a nap, but Kenny hangs on and climbs back aboard the train for another go at Alana.
- *Friday the 13th, Part 2* (1981): That pesky Ginny (Amy Steel) buried a machete in my shoulder. Thinking I was dead, a relieved Ginny and Paul (John Furey) relaxed in another cabin…until I crashed through the window. That'll show Ginny. I stuck around for 10 more movies. What's she doing now?
- *Child's Play* (1988): Killer doll Chucky is burned in the fireplace and everyone lets their defenses down. A charred Chucky emerges from the fire to torment them some more.
- *The Prowler* (1981): Otto (Bill Hugh Collins) shoots the deranged killer as he's attacking Pam (Vicky Dawson). Happy music starts to play and all is well— that is, until the killer sits up and shoots a distracted Otto.

- *Halloween II* (1981): Dr. Loomis (Donald Pleasence) shoots Michael Myers several times and he collapses on the floor of the hospital. A state trooper leans over Michael's "dead" body and has his throat slit with a scalpel.
- *He Knows You're Alone* (1980): Detective Gamble (Lewis Arlt) shoots the killer to "death". Gamble focuses on consoling Amy (Caitlin O'Heaney) and his empathy is rewarded with a knife in the back once the killer gets back up.

Never assume the killer is dead. *Expect* him (or her) to get back up for more. Don't let your guard down. Don't try to walk by the outstretched body of the killer. Don't console one another. Make damn sure your nightmare is over. I recommend chopping off the killer's head, just to be on the safe side. Chickens may be able to run around with their heads chopped off, but humans don't have that ability.

I realize this is a great deal to digest. I've given you quite a few rules, and a lot to remember. But if you're faced with life or death, wouldn't you prefer to be well informed? So read over my rules. Read them again and again. They could very well be the difference between living and dying. I'll be down in Florida, playing shuffleboard and bingo, and enjoying a Margarita on the beach, but there are still many crazed killers out there. Be careful, and good luck!

26. How Video Game Skills Can Help You Save the World

Has your mom ever scolded you for playing video games all the time? Does she tell you that playing too many will rot your brain? Normally your mother would know best, but in this particular case, '80s movie wisdom will prove her wrong. Films of the era show us that one day your very survival or even the fate of mankind may rely on your ability to defeat the final boss without dying. According to these movies, video games teach you important life skills that will aid you in saving the day and reaching your princess.

Four motion pictures from the 1980s illustrate the benefits of being a video game master: *Tron*, *WarGames*, *The Last Starfighter*, and *The Wizard*. While they each have their own unique stories, there are four key lessons that you can learn from each of them: high scores help you save the world, problem solving teaches you survival strategies, fortune favors the bold, and your friends are your greatest allies.

Disney's *Tron* (1982) focuses on Kevin Flynn (Jeff Bridges), the proprietor of a local arcade. Before his Encom co-worker Ed Dillinger (David Warner) stole his video game ideas, Flynn used to work as a computer programmer. Now that Dillinger controls the company, Dillinger does the bidding of the MCP (Master Control Program), a dangerously intelligent program that runs Encom's computer systems. With the help of his friends, Flynn is able to hack into Encom so that he can find proof of Dillinger's treachery. However, the MCP finds him and sucks him into the digital world to neutralize the threat he poses. Flynn must rely on his quick reflexes to survive the MCP's deadly games so that he can return to real life.

In *WarGames* (1983), high school slacker David Lightman (Matthew Broderick) spends more time at his local arcade than paying attention in class. He befriends his classmate Jennifer (Ally Sheedy) and changes school computer records to give her a better grade in their biology course. Jennifer encourages David to hack into a video game company's computer to play the latest games for free. Instead of finding games, David accidentally activates a

military supercomputer called the W.O.P.R, which is designed to predict various outcomes of nuclear war. The W.O.P.R kicks into action, simulating a conflict with the Soviet Union, which provokes the U.S. government to prepare for a counterattack. This forces David to seek out the supercomputer's creator so that he can prevent the W.O.P.R. from causing World War III.

The Last Starfighter (1984) starts out in a trailer park, where a college-bound teen named Alex Rogan (Lance Guest) lives. Rogan splits his time between his girlfriend (Catherine Mary Stewart) and the Starfighter arcade machine located on the premises. After beating the game, Alex is contacted by aliens who identify themselves as the makers of the game. A fellow pilot named Grig (Dan O'Herlihy) asks Alex to fly in their fleet of spacecraft to prevent an invasion of the galaxy. At first Alex is reluctant to help them, but when he discovers he truly is the galaxy's last hope of survival, he steps up to the challenge.

The Wizard (1989) is about a troubled boy by the name of Jimmy Woods (Luke Edwards). Scarred by a serious tragedy, Jimmy keeps to himself, barely speaking and mysteriously wandering off. Unsure how to handle him, Jimmy's mother and stepfather throw up their hands in frustration and commit him to an institution. Meanwhile, Jimmy's real father Sam (Beau Bridges) and his two sons Corey (Fred Savage) and Nick (Christian Slater) are struggling to get by. Sam tries hard to be a good dad, but he's constantly fighting with his older son Nick. When Corey hears that his half-brother Jimmy is being committed, he grows angry that neither his father nor his brother seem to care. He sneaks away to rescue Jimmy from the institution. Jimmy and Corey hit the road together, where they meet Haley (Jenny Lewis), another runaway child. After Corey and Haley accidentally discover that Jimmy plays the video game Double Dragon, they decide to enter Jimmy in a Los Angeles video game tournament which boasts a hefty cash prize. Sam and Nick set out in search of Jimmy and Corey, but find themselves competing with a child bounty hunter hired by Jimmy's mother. Meanwhile Haley, Corey and Jimmy must figure out a way to avoid capture by the bounty hunter and get Jimmy trained to win the tournament.

High Scores Help You Conquer Your Enemies

Bet you never thought that being able to get the high score in Donkey Kong or Pac-Man would help you save your own skin—or even the world —from total disaster! Our heroes in these '80s movies are completely clueless that their mastery of video games will help them triumph until their very existence depends on beating the boss with their only life.

In Disney's *Tron,* the power-hungry Master Control Program has become a self-aware computer. This hyper-intelligent program has slowly been gobbling up weaker programs to increase its own power. The MCP has become so arrogant that it brags that it can run governments more efficiently than people: "With the information I can access, I can run things 900 to 1200 times better than any human." It is this overconfidence that leads the MCP to take Flynn out of the real world when he poses a threat.

After Flynn is thrust into the computerized world, the MCP conscripts him to compete in a series of deadly games against other programs it has captured from systems around the world. In this gladiatorial combat, it's either win or be "de-rezzed." At first when he's told that he will be playing games, Flynn confidently states, "No sweat. I play video games better than anybody."

Once Flynn is actually forced to play jai alai and drive lightcycles (motorcycles) against henchmen for the MCP like Sark (David Warner), he learns that things are a little more complicated. Realizing he has bitten off more than he can chew, Flynn says with a sigh, "On the other side of the screen, it all looks so easy." Flynn's reflexes and the skills he has acquired playing arcade games like Space Paranoids ultimately allow him to defeat the MCP, which prevents its plans for world domination and frees the system from its tyranny.

Cold War fears of nuclear conflict between the United States and the Soviet Union are a primary focus of *WarGames.* In this film, U.S. government authorities nervous about leaving missile launch in the hands of fallible human beings place their faith instead in a supercomputer called the W.O.P.R. They hook this computer into the defense network and place it in control of their missiles because they believe its programming—to simulate all possible outcomes of armed conflict—gives it a strategic

advantage against the enemy. Unfortunately, after the clumsy computer hacker David accidentally activates the nuclear simulation on the W.O.P.R, war becomes a very real threat.

David seeks help from the W.O.P.R.'s creator Dr. Falken, and as the seconds tick down to the seemingly inevitable nuclear conflict between the U.S. and the Soviet Union, David uses his video game knowledge to trick the computer into playing tic-tac-toe. Since the W.O.P.R was designed to learn based on its experiences, its simulation of tic-tac-toe causes it to realize the futility of the game. Through assessing the pointless nature of the game, it in turn realizes that there is no ideal outcome for nuclear war between the U.S. and the Soviet Union, and it stands down from the heightened alert that it has caused.

Alex really has no idea the galaxy is in grave danger in *The Last Starfighter* until he is approached by the aliens who built the Starfighter video game. The alien Centauri spells out for him that his abilities in the game directly translate into piloting skills that could be used to save the galaxy. "Well, you may have thought it was a game, but it was also a test. Aha, a test! Sent out across the galaxy to find those with the potential to be Starfighters. And here you are, my boy! Here you are!" At first, Alex is intimidated, and responds, "Right, here I am, about to be killed!" In time though, Alex comes to accept his destiny. When he realizes that all the other Starfighters have been wiped out by the evil Lord Kril, he joins forces with his fellow pilot Grig. The two fly against Kril and Alex uses his video game prowess to save the galaxy from invasion.

Where *The Wizard* differs slightly from the other films in this list is that the main character Jimmy Woods does not literally save the world with his gaming abilities. However, Jimmy's skills become a form of therapy for the traumatized boy—in a sense he saves his own world. As his brother Corey and their friend Haley encourage his preparation for the video game tournament and train him, Jimmy slowly comes out of his shell. He begins speaking in full sentences and directly addresses his friends, which is tremendous progress. His victory in the video game tournament gives him the confidence to confront the source of his grief and put it to rest.

If you can achieve high scores in video games, through skill and the sheer persistence it takes to keep playing, you will succeed in the moment of truth. The winning attitude and determination that make you a good gamer can help you overcome your enemies or your personal demons.

Problem Solving Teaches Survival Strategies

Video games can be simultaneously addictive and frustrating because of the difficult puzzles that they make you solve. You could waste hours trying to figure out where to use the right item in an RPG, or deciphering how to reach a certain ledge in a platformer. The most important reward that these types of dilemmas offer is not the satisfaction of beating the level, but rather the problem-solving skills that they teach us. It is these powers of deduction that you can use to survive in tricky situations. Because the main characters in *Tron*, *WarGames*, *The Last Starfighter*, and *The Wizard* play a lot of video games, they have learned important lessons that allow them to outwit and outlast their opponents outside of the games themselves.

Despite being brought to the game grid by the MCP in *Tron*, Flynn uses his quick thinking to escape through a hole in the wall he creates during the lightcycle games. He makes a speedy exit with his friends Ram and Tron to the outskirts of the computerized world where they are freed from the deadly grip of the MCP. Things look grim for Flynn when he is separated from his friends, but he realizes that his powers as a user give him the capability to build his own Recognizer (an armed hovering ship used by the MCP's patrols). Flynn pilots his Recognizer back toward civilization so that he can proceed with his plan to take down the MCP. In his most clever maneuver, Flynn steals the uniform coloring of one of Sark's soldiers so that he can sneak through them undetected. His disguise is so convincing that even his friend Tron does not recognize him at first.

When U.S. government authorities trace the intrusion into the W.O.P.R. computer back to David in *WarGames*, they take him into custody and bring him and Jennifer to a secure NORAD fortress. Even though he's just a teenager, David's problem-solving capacities aid him in breaking out of his prison cell. He

wisely takes a combination of metal pieces and a tape recorder from a medical room he's stuck in to pry open the electronic lock on his door. Then he manages to creep out of the headquarters with a tour group without the military noticing.

In *The Last Starfighter*, Alex possesses absolutely zero experience with space travel or piloting a space ship until he steps up to battle Lord Kril. Thanks to logical reasoning and common sense, Alex is able to figure out how to fly a Starfighter successfully. His cool, calm demeanor helps him use strategy to take on hordes of Ko-Dan fighters without being destroyed. Alex carefully bides his time until his weapons are depleted to use his secret weapon—the "Death Blossom"—to destroy the remaining enemy fighters.

Jimmy, Corey, and Haley utilize their video game problem solving expertise in *The Wizard* to help find money to finance their trip after they are robbed. They do this by betting in arcades that Jimmy can beat other players in challenges. Their quick thinking also allows them to effectively dodge capture by the bounty hunter pursuing Jimmy on several occasions. One particular instance of Haley's quick thinking comes when the bounty hunter literally has Jimmy in his arms, and she cries out in a crowd that the man touched her inappropriately. This brings security guards down on the bounty hunter, which allows the three friends to escape.

If you are able to solve the riddles that video games present, your talents will aid in your real-world survival. This is because you will be able to think your way out of any tough situations that life throws at you. See Mom? Video games don't actually rot your brain.

Fortune Favors the Bold

In video games, just like in real life, you can't always play it safe. If you stand around in a level waiting for the exact moment to jump, you may run out of time on the clock, or the baddies may overtake you. Sometimes a leap of faith is needed to accomplish your mission—even if it puts you in significant danger of losing your life. Taking the safest route in life can also be incredibly boring, because the road can become predictable and therefore uninteresting.

The Latin proverb *"Fortes fortuna adiuvat"*, which translates to "fortune favors the bold," succinctly summarizes that philosophy. Each one of the main characters in our video game films find themselves in situations where they could play it safe, but they ultimately decide to take risks. Their bravery is rewarded by good fortune, enabling them to reach their goals.

As Tron fights Sark at the climax of *Tron*, Flynn decides that the only way to save the system is to jump into the bottomless pit of light surrounding the MCP. Flynn's friend Yori warns him that jumping into the energy beams will cause him to be de-rezzed (killed), but Flynn decides to take the risk anyway. He knows that if Tron is defeated by Sark, his chances of survival are a lot slimmer, so he makes a bold move. Flynn is pleasantly surprised though—when he destroys the MCP—and he's released back into the real world with proof that Dillinger stole his ideas.

After being captured by the military for hacking into the W.O.P.R. in *WarGames*, David probably would be wise to sit in his prison cell and await his punishment. Hacking into a government computer is a serious enough offense, but escaping custody and becoming a fugitive could create further charges against him. David unselfishly decides that his fate is less important than the pending nuclear war if he sits on his hands. That's when he makes a daring escape from the base so that he can locate the W.O.P.R's creator. Because he takes this risk, he's able to locate Dr. Falken and figure out how to stop a nuclear apocalypse.

When Alex decides to accept his fate as a Starfighter pilot in *The Last Starfighter*, he learns that he is the galaxy's last hope.

> **Alex**: And where are the Starfighters?
> **Grig**: In the hangar!
> **Alex**: You mean they're dead?
> **Grig**: Death is a primitive concept. I prefer to think of them as battling evil, in another dimension.
> **Alex**: In another dimension? How many are left?
> **Grig**: Including yourself?
> **Alex**: Yeah!
> **Grig**: One!
> **Alex**: *One?*

Despite Alex's terrified response, he continues bravely ahead with his mission. Most logical people would turn around and run if they learned they were one lone ship against a horde of enemy fighters. Alex understands that if he retreats, he is sealing his own fate by letting Lord Kril invade the galaxy. In this case, he must put his own life in jeopardy in order to save his galaxy. His decision turns out to be a fortuitous one, as he is successfully able to prevent Kril from succeeding in his dastardly plot.

Probably the biggest gamble that Corey makes in *The Wizard* is running away from home to rescue his brother Jimmy from a mental institution. Even though Corey realizes he could get into serious trouble for this, he forges ahead with his plan. Once he teams up with Jimmy and Haley, the gang takes a series of chances as they attempt to reach the video game competition in L.A. They bet against older people in video games and accept rides from strangers. There are times when fate does not smile on them, like when adults rob them of their money, and a group of older boys beats up Corey. Ultimately, their quick thinking and bravery is rewarded when they safely reach the tournament and Jimmy is able to compete.

Sometimes playing it safe is not the best way to go. In taking risks, we may encounter challenges, but the payoffs can outweigh the consequences of losing. As the saying goes "You can't win if you don't play the game." Our 1980s video game movie heroes discover that "fortune favors the bold" because even though they take on immense dangers, they are rewarded by good fortune.

Your Friends Are Your Greatest Allies

Most of us would be lost without our friends. They inspire us and motivate us to become better people through their support and encouragement. Let's face it: they can also bail us out of some rough spots as well. Just like most video games are easier when you have a second player to help defeat the enemies, real life's challenges are much more manageable when we can lean on our friends. Flynn, David, Alex, and Jimmy all learn that their friends are their greatest allies when the going gets tough.

When Flynn hacks into the Encom computer systems in *Tron*, his friends Lora and Alan provide him with their access to get into the system so that he can find proof that Dillinger has betrayed him. Once Flynn is stuck inside the computer, Alan's program Tron helps protect him and aids him in the fight against the MCP. Tron's girlfriend Yori helps them both download vital information they need to their data discs so that they can defeat the MCP. Tron's greatest contribution is distracting Sark and the MCP so that Flynn can jump into the MCP's energy beams to shut it down for good. Without the assistance of his friends, Flynn would not have been able to return to the real world, and would have most likely remained trapped.

David escapes the authorities in *WarGames* so he can track down Dr. Falkner, the creator of the supercomputer W.O.P.R. However, he has no money or means of transportation once he reaches the outside. He's able to phone his friend Jennifer, who wires him money for a plane ticket and joins him in his search. Together, the two are able to successfully locate Falkner and convince him to help. Had Jennifer not been there to save the day, there's a good chance David would never have found Falkner in time to prevent nuclear disaster.

Without the encouragement of his friends there is no way Alex would have had the confidence to take on Lord Kril. Alex tries to run from his destiny because he feels unworthy, but Centauri helps pick him up though and persuades him to aspire to more.

> **Centauri**: Alex! Alex! You're walking away from history! History, Alex! Did Chris Columbus stay home? Nooooo. What if the Wright Brothers thought that only birds should fly? And did Galoka think that the Ulus were too ugly to save?
> **Alex**: Who's Galoka?
> **Centauri**: Never mind.
> **Alex**: Listen, Centauri. I'm not any of those guys, I'm a kid from a trailer park.
> **Centauri**: If that's what you think, then that's all you'll ever be!

If Alex gave in to his insecurities and cowered from his responsibility to save the galaxy, he would not have stopped Lord Kril. In the end, his friends gave him the confidence to succeed in his mission, and as a result, Alex decided to stay behind to help train a new fleet of Starfighter pilots.

If Jimmy had no one to look after him in *The Wizard*, he'd still be in the mental institution. Because Corey cares about him, and knows that his brother does not truly belong in an institution, he helps Jimmy escape. Once Jimmy and Corey join forces with Haley, she helps them travel and train for the tournament. If Jimmy did not have his brother and Haley to look after him, he would have taken much longer to become rehabilitated and most likely would be confined to a mental institution for years before he faced his inner demons.

The next time your mom is scolding you for playing too many video games, remind her of all the important lessons that they can teach you: high scores help you save the world, problem solving teaches survival strategies, fortune favors the bold, and your friends are your greatest allies. Then she will understand why video game nerds will save the world, and she'll think twice about lecturing you.

Conclusion: Life Moves Pretty Fast

We know what you're thinking. Sure, movies from the 1980s are fun, but if we want answers to the mysteries of life, shouldn't we seek them in more serious, more elevated, or more inspirational sources? Nah, we don't think so. Modern humans have been around for 200,000 years, and throughout that time period, we have sought answers to the questions of our existence and the meaning of life. People *way* smarter than us have pondered and agonized over life's great questions. They've searched for answers everywhere—on mountains and in caves, in churches and in taverns, on Earth and in the stars. They've studied every book ever written, traveled the world, experimented with anything and everything imaginable, become hermits and demagogues, lived and suffered, all in hope of achieving enlightenment. Yet we still have no definitive answers.

So with that in mind, why *not* 1980s movies? They're as good a place as any to search for wisdom. For whatever the reason, '80s movies have a lasting appeal, and not just for their entertainment value. Films from the 1980s remain in the public consciousness, despite their faults and imperfections, because they deal with the human condition, in all its messy, goofy, and wondrous glory. And let's face it, would you rather pore over the works of Plato and Hegel, or spend a couple hours with Michael J. Fox, Molly Ringwald, or John Hughes?

Hopefully our analysis of movies from the 1980s has helped to guide you in your own personal search for meaning in life. If not, we'll be sure to cover anything we might have missed in Volume 2, so stay tuned. As that greatest of '80s movie philosophers, Ferris Bueller, once said: "Life moves pretty fast. If you don't stop and look around once in a while, you could miss it." We hope you enjoyed this look around!

About the Authors

Bryan Krull has been teaching history at the secondary and college level for the past 15 years, since earning his Ph.D from the University of Wisconsin-Madison. He previously authored the award-winning historical novel *Lil' Choo-Choo Johnson, Bluesman* and currently lives in Akron, New York with his wife and two children.

Evan Crean has been a film critic in Boston, Massachusetts for over seven years. He has written hundreds of articles about film for Starpulse.com and for his own site ReelRecon.com. He is also a founding member of the Boston Online Film Critics Association (BOFCA) and a co-host of the weekly film podcast Spoilerpiece Theatre. He currently lives in Somerville, Massachusetts with his fiancé.

Bryan and Evan met at Canterbury School in New Milford, Connecticut, where Bryan was Evan's history teacher and the faculty advisor to his '80s Movie Club. Their continued friendship and mutual appreciation for films from the 1980s inspired them to create *Your '80s Movie Guide to Better Living, Volume 1*, which they hope to be the first in a series of books about life lessons that can be learned from '80s films.

www.ingramcontent.com/pod-product-compliance
Lightning Source LLC
Chambersburg PA
CBHW070316190526
45169CB00005B/1642